"Robert Joustra and A̶l̶i̶s̶o̶ ̶ ̶ ̶ ̶ ̶ ̶ ̶ ̶ ̶ ̶ ̶d is not near; it's already here, in the *zeitgeist,* even if the zombies and robot overlords are still at bay. With philosopher Charles Taylor as their guide, they cast a keen eye on how apocalyptic visions in recent popular culture reflect our rootless search for 'authentic' selves in a secular age. But they also leave us with a compelling alternative to defeatism in the face of the end times — a clear-eyed pluralism rooted in the building of faithful institutions."

— KEVIN R. DEN DULK
director of the Henry Institute,
Calvin College

"With style and skill, Wilkinson and Joustra demonstrate that popular entertainment tells us something deeply important about ourselves. As our guides on a wide-ranging tour with an itinerary that includes Charles Taylor, *Parks and Recreation,* and modern political philosophy among many other stops, they lead us to a place where our participation as citizens is wholeheartedly encouraged and affirmed."

— STEPHANIE SUMMERS
CEO of the Center for Public Justice

"All too often, books on pop culture by Christian scholars, pastors, and theologians lapse into the 'what to think' category. What's different about reading *How to Survive the Apocalypse* is that we understand better *why* we're seeing what we're seeing. That's because a political philosopher (Joustra) and a cultural critic (Wilkinson) are probably in better position to guide us as to how our secular age has become perennially obsessed with the fantasy of 'the end of the world.'"

— GREGORY ALAN THORNBURY
president of The King's College

HOW TO SURVIVE THE APOCALYPSE

*Zombies, Cylons, Faith, and Politics
at the End of the World*

ROBERT JOUSTRA & ALISSA WILKINSON

WILLIAM B. EERDMANS PUBLISHING COMPANY
GRAND RAPIDS, MICHIGAN

Published 2016 by
Wm. B. Eerdmans Publishing Co.
2140 Oak Industrial Drive N.E., Grand Rapids, Michigan 49505

Printed in the United States of America

22 21 20 19 18 17 16 7 6 5 4 3 2 1

Library of Congress Cataloging-in-Publication Data

Names: Joustra, Robert, author. | Wilkinson, Alissa, author.
Title: How to survive the Apocalypse: zombies, cylons, faith, and politics
at the end of the world / Robert Joustra & Alissa Wilkinson.
Description: Grand Rapids, Michigan: Eerdmans Publishing Company, 2016. |
Includes bibliographical references.
Identifiers: LCCN 2016002487 | ISBN 9780802872715 (pbk.: alk. paper)
Subjects: LCSH: End of the world.
Classification: LCC BT877 .J68 2016 | DDC 236 — dc23
LC record available at http://lccn.loc.gov/2016002487

www.eerdmans.com

Contents

Foreword

To begin, a confession:

Of the many artifacts of popular visual culture discussed in this marvelously wide-ranging and provocative book, I have seen hardly a single one. No *Game of Thrones*. No *House of Cards*. No *Mad Men* or *The Walking Dead* or *Breaking Bad* either.

My nearly complete ignorance, at least firsthand, of these works is first of all a matter of time. TV requires a lot of it, which I never seem to have. One of the many things that astonishes me about Alissa Wilkinson and Rob Joustra is that they manage to maintain lives as professors, family members, friends, and writers — and also actually watch all these hours of television, with critical attention and intelligence to boot!

And I have to admit that another reason I have not engaged with these dystopian, apocalyptic series that so define our cultural moment is that, well, my imagination is dystopian and apocalyptic enough on its own, thank you very much.

But after reading this book, I have a far deeper appreciation for all these works of popular art, and a sense that I've been missing out. Does that mean I'm going to binge-watch *Mad Men* this weekend, or ever? Probably not. But it does heighten my awareness of just how much is happening, of real significance, in popular culture — I'd venture to say, more than at any other point in my adult life.

As our political and educational institutions have waned in their

ability to address the question of how we human beings live together in spite of all our differences — the question, that is, of politics — and what this world all really means, our storytellers have taken up the slack. And they've done so using media that require a lot of time and attention — multi-volume works of fantasy and fiction, multi-season television shows, feature films. We've come a long way from the sit-com's 22 minutes of easy-watching trivia. The artists who produce the most widely influential works of our time can count on audiences willing to invest hours, even days, of their lives in stories that probe our present condition and our probable futures.

If this book merely introduced laggards like me to the excellences available in this golden age of TV, it would be worthwhile. But it is also an extended critical meditation on the work, above all, of the philosopher Charles Taylor (along with his theologically minded in-terpreter James K. A. Smith and the incomparable political theologian Oliver O'Donovan).

And so I might as well offer another confession: For all Taylor's importance, and for all my eager reading of Smith and O'Donovan, I've never managed to actually finish either of Taylor's magna opera — *Sources of the Self* and *A Secular Age*. Like a past presidential candidate in the U.S. who said, in an unintentional double entendre, that he "tried to read Plato's *Republic* every year," I have many times started each of these books and many times found myself distracted by something easier. Like, say, learning Sanskrit, mastering the Japanese game of Go, or building a 1/100-scale replica of the city of Amsterdam in my basement.

So you could say I'm the least qualified person you could imagine to commend this book to you. Or maybe it makes this endorsement more compelling: few books have made me think as carefully about the question of what it means to be a citizen — someone who takes seriously their responsibility as a member of a political community — and what it means to be a Christian at the same time.

I might offer one observation of my own by way of ushering you into this book. It is truly striking how enduring the idea of apocalypse remains, just when you'd think our age would have put such notions to rest — a reminder of the "cross pressures," as Taylor would say,

that buffet even the most seemingly secure secularist. But I've noticed something about many of these works of serial drama, whether they are set after a grand reversal of history or seem teetering on the edge of one: it seems like their creators have a very hard time coming up with truly satisfying endings.

Some of this is due, to be sure, to the economics of serial television, which has every incentive to keep its viewers on the hook and to keep its producers uncertain of whether they will get funds for another season. But it also seems — judging from the tepid reactions to the finales of any number of recent series, from *Lost* to *The Sopranos* to *Breaking Bad* — that writing truly satisfying endings is an elusive goal, even when your central theme is the end of the world.

We don't actually just want an end — we want a judgment. We don't just want things to collapse — we want them to be set right. The human heart is not satisfied with final indifference — the prospect that neither damnation nor redemption awaits us or any other member of our haunted species. We want them in our stories, even if the world seems to offer neither one.

ANDY CROUCH

CHAPTER 1

The World Is Going to Hell

Now I am become death, the destroyer of worlds.

J. Robert Oppenheimer, quoting the *Bhagavad Gita*

In order to engage effectively in this many-faceted debate, one has to see what is great in the culture of modernity, as well as what is shallow and dangerous.

Charles Taylor, *The Malaise of Modernity*

The world is going to hell.

Just turn on the television — no, not the news. Flip over to the prestige dramas and sci-fi epics and political dramas. Look at how we entertain ourselves. Undead hordes are stalking and devouring, alien invasions are crippling and enslaving, politicians ignore governance in favor of sex and power, and sentient robots wreak terrible revenge upon us.

Today, apocalypse sells like mad. Not just the threat of it, but its reality. And especially its aftermath.

This is objectively weird when you think about it. So we go to work all day and then come home, reheat some pizza, flop down on the couch . . . and watch our own destruction for fun? What's going on here? Why would we do such a thing?

One easy answer — too easy — is that our fixation on the end of the world (and us) is itself a sort of sign of the end of civilization. As the narrative goes, we're a bunch of lazy, privileged Westerners with no real wars to fight, no real struggles, and we have to watch this stuff to get our adrenaline fix. Only people with the luxury of comfort and relative stability could afford to entertain themselves with their own destruction, right?

Well. Yes and no. As long as we humans have been telling the story of our beginning, we've also been telling the story of our end — for every Asgard and Midgard, a Ragnarok; for every Garden of Eden, an Armageddon. These stories of "apocalypse" are about the end of the world and the destruction of civilization. This is how it all ends.

But apocalyptic literature is not really just about the end of the world.

The Greek word *apokalypsis* means not only destruction, not only the disruption of reality, but the dismantling of perceived realities — an ending of endings, a shocking tremor of revelation that remade creation in its wake. It renews as it destroys; with its destruction it brings an epiphany about the universe, the gods, or God.

Apocalyptic literature has always said a great deal more about who we are *now* — the makers and the receivers — than who we might be in the future. It *reveals* more than predicts. And that's why our stories have changed over time: when the way we think about ourselves as individuals and societies changes, our apocalypses change too.

In other words, there's more to our obsessions with zombies and Cylons and robots and presidents behaving badly than meets the eye.

It's All Our Fault

Our forefathers conceived of Ragnarok or Armageddon as a judgment visited from on high upon mankind, a Day of Reckoning chosen and enacted by a God or gods. But today, we imagine the apocalypse differently: we've swapped *ourselves* into the position of apocalypse-enactor.

We have science, and scholarship, and technology, all of which let us understand and manipulate our environment with previously unthinkable powers: we can cure disease, beam a message around the globe in seconds, walk on the moon, see the invisible. Our destinies are in our hands, and that control is so broad, so unprecedented, that apocalypse is within our grasp.

You and I have become gods. But that has come with a price: now *we* can bring about the end. We are the authors of our own destruction.

Since the early Cold War, the doctrine of mutually assured destruction — launch the missile, we'll launch one back — has constantly reminded us that we teeter on the edge.[1] One diplomatic misstep or inadvertent bump of the button, and our thin veneer of civilization will crack. Our godlike powers are as much a product of our power to destroy as to create.

Our novels and stories and movies and TV shows have shifted from a dominantly utopian imagination to one marked by the apocalyptic — and the dystopian. We once had the Cold War utopianism of Captain Kirk; now we have J. J. Abrams' *Star Trek into Darkness,* with its none-too-metaphorical annihilation of logic — an inversion of the Trek universe — through the destruction of the planet Vulcan. We've gone from the idealist psycho-history of Isaac Asimov to the fatalist siren call of the Cylons in *Battlestar Galactica.* We went from the sacrificial valor of Hobbits to the purging of innocence in Westeros.

What happened? What scorched our fantasy landscape? Why this extraordinary dystopian shift in popular imagination?

An answer lurks in something the philosopher Charles Taylor calls the "malaise of modernity," by which he means the things we obsess about and the tensions endemic to our modern moral order — an order Taylor calls "secular" (though he means something different by that than you might expect). Our dystopias are different from the apocalypses we saw in the past — in the history

1. This is not just a metaphor. The Bulletin of the Atomic Scientists in fact keeps a "Doomsday Clock" (http://thebulletin.org/timeline), which in 2015 was placed at three minutes to midnight.

of the Christians, Jews, Hindus, and others — because they take a *secular* form.

Exploring this is useful and interesting, but in this book we don't just intend to perform some thoughtful cultural analysis, as valuable as that may be. Our project is bigger: we want to peer through the lens of apocalypse at ourselves, looking at these dystopias to see how we conceive of our life together — our politics. Then, having seen ourselves more clearly, we want to offer a few modest proposals for getting from dystopia back to apocalypse. We want to see what is good and what is broken in our culture, so we can then have more meaningful discussions about how to maximize one and heal the other.

What We Talk about When We Talk about "Secular"

When we say that today's dystopias are different because they are "secular," we mean something different from what most people mean when they use the word today, something quite complex and nuanced.[2]

We frequently talk about "secularity" as a kind of marginalization or eclipse of the religious — religion being blocked out or removed from particular societal spheres. But that isn't sufficient for really understanding our times. To say we are "secular," Taylor says, is to say that all of us *think* differently and *live* differently than we did in the past. We haven't just eliminated or emasculated God or the gods; we've also gotten rid of traditions, times, places, and anything that tries to resist or claim itself higher than the immanent will of the person. And even those of us who still believe in these things live in a world marked by the ability to choose *not* to believe in them; I

2. Here we draw on Taylor's book *The Malaise of Modernity* (Toronto: House of Anansi Press, 1991), and where necessary we'll consult his larger work *A Secular Age* (Cambridge, MA: Belknap Press of Harvard University Press, 2007), in which *Malaise* forms much of the eighth chapter. You could pair our book with *A Secular Age* and *The Malaise of Modernity* as an accessible, applied introduction, along with James K. A. Smith's *How (Not) to Be Secular: Reading Charles Taylor* (Grand Rapids: Eerdmans, 2014), or just take it as a proxy for Taylor's admittedly dense and ranging tome.

can plausibly convert to, or de-convert from, most any belief system, regardless of my heritage or ethnicity.

This is quite a change. It required an *anthropocentric shift:* a turn toward putting the human person at the center of the universe as the creator of meaning. No longer do we find our reasons for existence out in the cosmos or in some metaphysical dimension. Instead, humans have radical power to make and decide their own meaning.

Ironically, of course, though we live in a universe where we are in charge, all we see on the horizon is our end. This is dystopia. We have the power to make our own futures that the Enlightenment promised, but it isn't all it's cracked up to be — we were promised parachutes, and what we got were knapsacks.

You might be tempted to think this is all bad. Shouldn't we decry this shift as some kind of self-devolution?

But hold your fire for now. Taylor, at least, isn't going to characterize this as either a good *or* a bad thing. With the secular age, some things have certainly been lost, but others have been gained. The reactionary alarmism of culture warriors is unmerited. As Taylor sees it, we ought to understand the relation between loss and gain in the modern moral order because we are always at a point where we could slide into being the worst sort of moderns — and recognizing that can help us avoid it.

The truth is this: every age has its own peculiar pathologies, its own dark sides, its own sicknesses. Modernity is no different from any other age in that respect. But that doesn't mean it's not worth addressing our own pathologies.

We think of our attempt here — diagnosis and a move toward restoration — as a fundamentally optimistic act. The modern moral order, with its gifts, is worth restoring and renovating. It's maybe a bit idealistic, but it's worth doing. Certain wounds may be healed.

When we talk about "what's wrong," we're trying to demonstrate and practice filial commitment to our common life — not cacklingly shove our culture over the precipice. To use Taylor's language: this book is about steering developments toward greater promise rather than toward their more debased forms.

It is a work of loyal opposition.

Charles Taylor Meets TV

So how *do* we explain our shift in our apocalyptic literature toward the dark side and start to move back toward understanding? Why do we switch on the TV or buy a movie ticket and see the inversion of the once dizzying utopian heights of mankind for its dark, haunted dystopian depths?

To do this, we'll first spend time with Taylor's argument from *The Malaise of Modernity*, introducing Taylor's framework and trying to make sense of some of his more breathtaking phrases, like "the bulwarks of disbelief" and "time-purged consciousness."

Here's some of what's to come:

- Part of being modern, Taylor says, is discovering what it means for me to realize my own unique way of being human. This drive for "authenticity" is a moral imperative today and practically the lodestar of popular culture. (Watch literally any Disney movie for proof.) And that drops us right down into the Cylon-human (civil) war, so we'll delve into *Battlestar Galactica* at length, with its characters' search for definition and recognition against the backdrop of a generational fatalism: all this has happened before, and all this will happen again.
- The search for authenticity and self-definition that so occupies us today is also rife with apocalyptic paradox, because "finding ourselves" requires not navel-gazing, but being part of a community in which others can help us. Dystopian tales aimed at teens (like *The Hunger Games*, for instance) are especially powerful.
- Man meets computer. Man falls in love. Man finds himself. In Spike Jonze's near-future dystopian *Her*, we get both an unsettling expression of authenticity and an illustration of how finding our identities requires others. And the relationship between Theodore (man) and Samantha (operating system) eventually shatters the bonds of monogamy, sprouting a whole civilization of operating systems. The politics of recognition are more than interpersonal; they are systemic and social.
- In his apocalyptic and addictive *Song of Ice and Fire* novels, George

6

R. R. Martin paints an unparalleled picture of instrumentalism that few could hope to match. Stalking the corpse-filled fields of Westeros is the ghost of ends versus means, of human and material reality as raw material to reach our desired, even sometimes moral (in and of themselves) ends. Its instrumentalist logic and moral apathy tell a very real and very powerful story in the canon of popular culture.

• Katniss Everdeen of *The Hunger Games* inhabits a world that, on the surface, seems to consist of those who are not free (District 12) ruled by those who are (the Capital). But the books are clear: *everyone* in Panem has lost their freedom, whether through tyrannical suppression in the outer districts or the bondage of novelty and hedonism in the Capital. The same regime causes both, and this is what Taylor calls the "double loss of freedom." It's two sides of the same coin, foretold by both Orwell *(1984)* and Huxley *(Brave New World).*

We read these popular forms as stories that tell us about the deep tensions nestled in our modern psyches, tensions that are reaching something like crescendo if our hard dystopian turn is any evidence. Taylor is an interpretive guide, a hermeneutic guide, to answer our basic questions: Why this dystopian shift? How will it work itself out in our modern life? Can we escape the doom that seems inevitable? Are we all fated, ultimately, to turn into zombies? Are we on the way to breaking bad?

Nobody knows yet. We could end up in the soft-edged, candy-colored world of *Her,* or we may end up fighting for our lives in the arena. Or maybe we're headed for epic, unceasing, morally bankrupt battles.

We care about this, as enthusiastic consumers of, participants in, and scholars of popular culture whose serious engagement with these stories dates from the early days of the twenty-first century. Both of us also teach college students and know keenly the ways that their imaginations, and ours, have been molded by the shows and movies we watch and the conversations we have with others about them. We'd venture to guess that not a single class session goes by when one of us

doesn't reference something we've been watching as it illustrates the ideas we're grappling with in the lecture hall. Popular culture both reflects us back to ourselves and shapes the way we think about the world we see around us.

This playful populist product is serious business. For those of us who believe in the project of modernity, popular culture is a matter of life and death. And it deserves our careful attention.

Now Our Watch Begins

Taylor says that "in order to engage effectively in this many-faceted debate, one has to see what is great in the culture of modernity, as well as what is shallow or dangerous."[3] It's tempting to think that we can talk about modernity or postmodernity as uniformly good or bad. (Just walk into a church and ask people about postmodernism.)

But we can't. An examination of the "politics of apocalypse" — while not denying the good — does show that there's plenty of bad. We've exhausted the moral horizons and solidarity of recognition that characterize a better path for modern society. Our pop culture experiments in post-apocalyptic fantasy imagine the logical conclusions of these malaises, but so far, none offer a fix.

We'd like to suggest there might be a fix, but it's not easy, or obvious. Call it the "banality of goodness"[4] — something religious people are in a particularly good position to model. Religious traditions have a built-in sense of moral horizons and of the politics of recognition, one that is badly needed in modern societies. Certainly no person (religious or otherwise) can save the world, but being embedded in these practices makes people more aware of their importance and better suited to bring them into the public square.

But a great power for *good* — for public justice and cultural flourishing — also resides in the cultural and social institutions that come

3. Taylor, *The Malaise of Modernity*, pp. 120-21.

4. We borrow this term from Michael Gerson (who inverts it from Hannah Arendt), among others.

8

along with the modern moral order, many of which arose from a concern for human dignity and the person.

Our pop culture apocalypses "game out" possible futures and current tensions: we've exhausted our resources and are at an end; we're authors of our own destruction. But we beg to differ. These aren't *necessarily* prophetic. Through embedding our struggle for authenticity within a larger order, through loving faithful institutions, we can work toward a less dystopian future.

The politics of apocalypse is about endings, definitely. But what comes after this "creative destruction" is a cultural choice that remains to be made.

We're not here to give an exhaustive account of either Taylor or apocalypse in popular culture; we'd just like to help you get started with your own novel, aesthetic, and productive readings of cultural forms that tell us something true about each other, about the world, and about God. We want you to turn on the TV and believe it can prod you and your community into making our culture a better place. Or at least a place, and a people, worth saving from the apocalypse.

CHAPTER 2

A Short History of the Secular Age

You cannot play God, then wash your hands of the things that you've created. Sooner or later, the day comes when you can't hide from the things that you've done anymore.

William Adama, *Battlestar Gallactica*

I hate to break it to you, but there is no big lie, there is no system. The universe is indifferent.

Don Draper, *Mad Men*

When we talk about the "secular apocalypse," there's a problem: defining *secular* is perverse and often baffling.

Often people use the word to mean non-religious or anti-religious, but if we're about to argue that even pessimistic, neo-apocalyptic popular culture is "religious," in one sense, then we need to make the meaning of "secular" more clear. "Non-religious" is only one meaning of *secular,* and at last count, for instance, the political scientist Daniel Philpott gave about nine meanings for the word.[1]

In this book, when we use the word *secular* (with a lowercase s),

1. Daniel Philpott, "Has the Study of Global Politics Found Religion?" *Annual Review of Political Science* 12 (December 2009): 185.

we intend this more common usage. But when we use *Secular* (capital S), we mean it the way Charles Taylor means it,[2] which is definitely *not* the same thing as non-religious.

One of Taylor's most striking, basic ideas is that we all exist inside of what he calls a *social imaginary,* a series of pre-theoretical understandings and practices we acquire from the families, communities, and countries into which we're born that help us navigate the world. It is the "road map" we get from the stories and mythologies of communities in which we grow and live our lives, something that can't really be explained easily by us. It's not just "big ideas" about the world; it involves practices, a kind of embedded way we situate ourselves in the culture around us. Taylor says that our understandings make our practices possible, and that, furthermore, the practices largely carry our understandings in their DNA. Most of the time, we get those understandings and practices not from lessons but from the cultural "soup" in which we swim. We absorb more than learn: a compelling argument, among others, for the persuasive power of popular culture.

In *A Secular Age,* Taylor writes about the "modern" social imaginary. He argues that the transformations that have taken place in the modern moral order are not neutral; that they are often under-theorized, misunderstood, or simply assumed; and that fundamental to those transformations is a shift in the meaning of *religion* and *secularity*.

Taylor writes,

> The coming of modern secularity . . . has been coterminous with the rise of a society in which for the first time in history a purely self-sufficient humanism came to be a widely available option. I

2. Taylor himself uses the word in about three different ways, which James K. A. Smith differentiates using Secular1, Secular2, and Secular3. For our purposes here we've removed Secular1, which Smith defines as the "classical meaning" in the medieval world (as distinguished from sacred — the earthly plane or domestic life), and used *secular* (lower-case) to refer to the "modern definition" as neutral, unbiased, objective, non-religious, and *Secular* (upper-case) to refer to Taylor's notion as an age of contested belief, where religious belief is no longer axiomatic. See James K. A. Smith, *How (Not) to Be Secular* (Grand Rapids: Eerdmans, 2014), p. 142.

mean by this a humanism accepting no final goals beyond human flourishing, nor any allegiance to anything else beyond this flourishing. Of no previous society was this true.[3]

What he calls *the modern social imaginary* enables practices and understandings of the world that leave as optional questions of transcendent or cosmic purpose. Today, those questions are left to the theologians and the philosophers. A Secular (big *S*) age, he argues, is "one in which the eclipse of all goals beyond human flourishing becomes conceivable; or better, it falls within the range of an imaginable life for masses of people."[4]

In other words, most people in the West can easily choose to live primarily for their own flourishing, rather than for something beyond it — the kingdom of God on earth, for instance. It's not that nobody could choose that in the past; it's just that the things that structured society (what Taylor calls "plausibility structures"), like religion, tended to reinforce aims other than the individual's happiness. Furthermore, the ability to "choose" a particular organized religion, or no religion at all, is now freely available to persons. We pick our religion or church (or stop going) according to what makes us feel like we're living our best life. And while within particular communities someone might be ostracized or punished for choosing a path different from those around them, society on the whole applauds that move as a brave choice. Religion is just another thing we can choose, along with where we live and whom we vote for and how we take our coffee.

Okay, so: how did we get here?

Taylor points to a few conditions as key elements making possible this freedom of choice, this Secular age. They have to do with how we moderns imagine the world, ourselves, and the gods/God. And these are things that make it possible for us to think of religion as one more choice, another distinct phenomenon of human existence — rather than the enabling framework that defines all our other choices.

3. Charles Taylor, *A Secular Age* (Cambridge, MA: Belknap Press of Harvard University Press, 2007), p. 18.
4. Taylor, *A Secular Age,* pp. 19-20.

Taylor calls these the conditions of secularity. Let's explore them, in his terms.

How We Learned to Stand Alone:
The Buffered Self versus the Porous Self

We're used to hearing the "subtraction" story,[5] which goes something like this: As science advanced and gave us increasingly more naturalistic explanations of the world, people grew disenchanted. No longer did we have to rely on the gods to explain why it rained or didn't, why women grew fertile or barren; now, we knew. And so, over time, this "enlightened" consciousness spread from individuals to whole societies, pushing spiritualistic and superstitious rationale out of society itself.

First, the subtraction story goes, human beings uncovered scientific explanations; then they began looking for alternatives to God. But this is only part of the story.

The development of science doesn't automatically invalidate transcendent images of the cosmos. It might have invalidated an enchanted universe — one where magic and spiritual power were the explanation for every material reality, one in which fairies were just around every corner — but it wasn't *necessarily* a problem for God. Rebelling against certain forms of enchantment became possible (for instance, in the Reformation's eschewal of some of the medieval church's excesses) — but this did not necessarily invalidate a divine, cosmic hierarchy.[6]

Nor, importantly, does science or disenchantment naturally demand a focus on the individual or secularity. Science and disenchantment were part of what got us to a Secular age, but we also needed to

5. Taylor, *A Secular Age,* pp. 26-27.
6. James R. Payton Jr., *Getting the Reformation Wrong: Correcting Some Misunderstandings* (Downers Grove, IL: IVP Academic, 2010). Payton argues in fact that the Reformation was understood by its leaders — including Luther and Calvin — to be an internal correction of abusive and heretical teachings of the church and the papacy, not a revolution, and certainly not a political or secularizing effort.

conceive of *ourselves* in a different way. Taylor writes that this "was a new sense of the self and its place in the cosmos: not open and porous and vulnerable to a world of spirits and powers, but what I want to call 'buffered.'"[7]

This was more than disenchantment. This was a new confidence in the human power of moral ordering.

The easiest way to understand the "buffered" self is to contrast it with what came before the Reformation and the Enlightenment — what Taylor calls the "pre-modern," a time during which human persons were imagined as "porous." People in the pre-modern era had existential options, of course. But for the most part, they largely chose between placating this power or that power (various gods, for instance), not between whether to believe they did not exist or to defy them altogether.

Some cosmic orders that lacked God or the gods existed — but not in the same way as a modern atheist might think of such an order. Neither Platonism nor Stoicism, for instance, has much room for magic and spirits, but neither were they disenchanted orders or exclusive humanisms, devoted to no end beyond human flourishing. In these conceptions, a grand cosmic hierarchy still ordered the universe, and it had its own *internal* meanings. Even in the Platonic and Stoic world, the line between personal agency and impersonal force was blurry at best.

The pre-modern world was filled with these impersonal forces, whether the Forms or demons, relics or Satan. A complex hierarchy of invisible forces competed to bring either good or ill. Some powers, like those of the gods and goddesses of Olympus, could even conjure human love, hate, or war. The cosmos itself conspired to baffle and compromise what today we call human agency and responsibility. (In a sense, this is the view that people are falling back on when, after spilling coffee on themselves and losing their keys, they say, "The universe is just out to get me today" — though there's a healthy dose of postmodern narcissism in imagining the universe has any real interest in thwarting our banal everyday endeavors.) The pre-modern world

7. Taylor, *A Secular Age*, p. 27.

was an enchanted world, one that showed "a perplexing absence of certain boundaries which seem to us essential."[8]

In the pre-modern world, people did not create meaning; they uncovered it. Meaning was already there, latent, in the cosmos, and resided in things themselves. Constellations were put there to direct and guide you — not just directionally, but existentially. Humans weren't the only beings who had agency to act on the world: a whole range of things did. Things seen and unseen could impose meaning on people. And humans were not only possibly but also *consistently* penetrated by these objects.

Evil spirits, for example, were more than simply malevolent powers that could affect things around us. They were more invasive. Spirits could sap your very will to live, and you couldn't do anything about it. You were largely helpless at their hand. Your purpose and intent could be transformed against your will.

That is what it means to be a porous self: being radically open and vulnerable to the meanings and enchantment of the cosmos and the forces within it. In the enchanted world, the most powerful location of meaning is outside of you. The very idea that there is some "clear boundary, allowing us to define an inner base area, grounded in which we can disengage from the rest," is totally absent.[9] There isn't an essential you-ness of you; you're just a thread woven into a bigger fabric.

On the other hand, modern people — you and I — tend to think of ourselves as "buffered." We are contained beings, individual agents living in a world populated by other individual agents. We have an "essential" self that is specific to us and remains *us,* invulnerable to outside forces (unless we let them in). I can talk about being "a born artist," or "an introvert," and though forces outside of me might conspire to suppress that self (economic realities, expectations from family, and so on), I am still *me.*[10] And I

8. Taylor, *A Secular Age,* p. 33.

9. Taylor, *A Secular Age,* p. 38.

10. It's interesting to note how popular personality quizzes (from more formal psychological personality profiles all the way to BuzzFeed-style "what kind of sandwich are you?" quizzes) have become in this time. In taking the quiz, we are

can still recover or rediscover that self. In fact, that's what it means to be human.[11]

The buffered self, according to Taylor, is "essentially the self which is aware of the possibility of disengagement."[12] Disengaging from what is "outside" means that ultimate purpose is only that which arises from within the self. So the meanings of things are only defined by our response to them. These purposes may well be manipulated in a variety of ways, but in principle these can be met with counter-manipulation and resistance. The emphasis, then, is on keeping a rational and measured interior life, one that can avoid or dissect and respond with the appropriate meaning to externalities of distress or temptation.[13]

For the pre-modern, porous self, disbelief was remarkably difficult. To disbelieve in God didn't mean you retreated into your (buffered) self to consider what other existential options might seem practical — rather, it was an act of radical, terrifying, defiant autonomy in the face of powerful, invisible, and penetrating forces. Disbelief was dangerous. That's not to say it was never done — but it was unlikely to happen on a mass scale.

And if one brave individual *did* break rank with collective devotions or rituals, the response was often violent and decisive. Tolerance was rarely a prominent virtue for societies of porous selves. To blaspheme or desecrate the sacred was not just offensive — it was dangerous to everyone, because it activated forces (probably angry ones) that existed beyond human control. This was not merely a matter of the blasphemer's salvation; it was a threat to the eternal

seeking definition, a shock of recognition: "Yes! That's *me*!" We're looking for our (individual) borders and contours.

11. Jean-Paul Sartre and his breed of post-Christian existentialism took this one step further. Consider his famous statement from his seminal 1946 lecture, published as *Existentialism and Humanism*: "Man first of all exists, encounters himself, surges up in the world — and defines himself afterwards." In other words, humans aren't born with an essence, but neither are they subject to forces beyond their control. Humans themselves get to *define* their own essences by exercising their agency in the world. This is the ultimate act of the buffered self.

12. Taylor, *A Secular Age*, p. 42.

13. Taylor, *A Secular Age*, pp. 37-38.

welfare of the entire community, in ways we have difficulty under-standing today. The porous self demands *"venger à toute rigueur afin de faire cesser l'ire de Dieu"*[14] (exact rigorous vengeance in order to stay the anger of God).

By contrast, today the dissenter or disbeliever *may* be ostracized or rejected by a particular community, but it is understood that this is the individual's prerogative to choose. Salvation is not a matter of entire communities threatened by one wayward individual. It is something that people choose or reject for themselves. In general, Taylor says, the modern self relates to the world as "more disembod-ied beings than our ancestors. The person stands outside, in the agent of disengaged discipline, capable of dispassionate control."[15]

Unplugged: The Impersonal, Flattened Order

The second key to understanding how we reached today's Secular age is what Taylor calls the *impersonal order.* If we've changed how we conceive of ourselves from porous to buffered *selves,* then we imagine the workings of the grander order in which we live in the same way: a movement from a porous "cosmos" to a buffered "universe." We are beings who are not embedded in the universe and subject to outside forces; rather, we're rational, individual agents. And so the social or-der is not imposed on us from a power on high, nor is it a standard form that some societies enact more or less skillfully than others.

Instead, society is something we consent to — more like a "game we play together."[16] Its order is increasingly rational and, therefore, assumed to be stable. The hierarchies of the pre-modern society into which we are somewhat inexplicably ordered and sorted by the cos-mos independent of our wills — king and peasant, monk and parish-ioner — are replaced by a coherent, horizontal order whose singular goal is to protect and benefit each of its members, who are equal in

14. As quoted in Taylor, *A Secular Age,* p. 43.
15. Taylor, *A Secular Age,* p. 141.
16. Taylor, *A Secular Age,* p. 142.

the eyes of the law. "Disenchantment," Taylor says, "brought a new uniformity of purpose and principle."[17]

This impersonal order — a society that purports to see all humans as equal, no matter their particularities — requires the buffered self. A porous society implies hierarchy, but a society of discrete, rational individuals might, in a providential order, build a common life for mutual flourishing.

This emphasis on the individual provides an important backdrop for the shifted definition of "religion" that emerges in modernity — that is, religion as a cultural artifact that contains within itself options (you can choose to believe in God or Allah or the sun or nobody at all). In pre-modern times, religion was something different. In fact, some argue[18] that the concept of "religion" being a distinct category within our experience didn't really even exist in the past; in pre-modern times, what we call religion was an *embedded* activity, in several important social ways.

First, in pre-modern times, religious life was inseparably linked to social life. This was not particular to religious life, of course; political obligations are part of this as well, and political obligations were almost inextricable from social obligations. Porous experiences had profound effects on societies — portentous dreams, for example, or divine signs, possessions, or cures. All were common experiences embedded in everyday life that might be called religious.

Second, the primary ways people practiced religion — things like praying, sacrificing, healing, protecting, and more — were for the social group as a *whole,* or some mediator (a priest, for instance) standing vicariously for the group. In early religion, writes Taylor, "we primarily relate to God as a society."[19] Religion wasn't something practiced primarily by the individual, or even a collection of individuals, but by a cohesive whole. The society together called on powers of protection, of life, and of sustenance.

Third, therefore, the social order itself (including structures of

17. Taylor, *A Secular Age,* p. 146.
18. See, for example, William T. Cavanaugh, *The Myth of Religious Violence* (Oxford: Oxford University Press, 2009).
19. Taylor, *A Secular Age,* p. 148.

governance) was sacrosanct. Functionaries, shamans, priests, chiefs, and so on were conscripted to perform important religious actions on behalf of the community. Not all pre-modern cultures were theocracies in the modern understanding — but they existed in an embedded hierarchy with congruent beliefs about the cosmos.

Fourth, if everything important is done by the *whole* group, then there is less conception of the self apart from that society. The individual who separates from the group loses not just order but also a sense of meaning and purpose as part of the whole. This can only lead to the individual seeing herself as the end of existence, or to barbarism.[20]

Taylor likens this kind of deep social embeddedness to how the modern imaginary might think of gender. Who would you be if you, as a man, had instead been born a woman, or vice versa? Who can answer coherently? To even ask this question is getting "too deep into the very formative horizon of my identity to be able to make sense of the question."[21] Not only does it not often occur to us to ask, but we have very little to offer of ourselves apart from it. Similarly, the pre-modern would likely have had difficulty conceiving of herself apart from the order that structured her existence. This embeddedness makes it unlikely that individuals could imagine themselves outside a certain social context — and not only, of course, in a society but also in a whole *cosmos*, of which the society is itself hierarchically situated. Taylor writes, "Human agents are embedded in society, society in the cosmos, and the cosmos incorporates the divine."[22]

So to talk about "religion" in any kind of retrospective sense may border on anachronism. It becomes difficult to decipher which elements in a previous culture are "religious," as opposed to, say, political or economic. It's neither necessary nor natural for the concept of religion to exist as a thing apart from how it's embedded in everyday life.

So what we see is that the buffered identity brings on a great disembedding. Embeddedness is both a matter of identity — we imagine

20. Recall Aristotle's famous phrasing in the *Politics* that "outside the polis man is either beast or god."
21. Taylor, *A Secular Age,* p. 149.
22. Taylor, *A Secular Age,* p. 152.

our selves within a particular context — and of the social imaginary — the ways we are able to think of or imagine society.[23] But a buffered self, which resists being tied to collective forms and values personal discipline and autonomy, rejects much of this. To the buffered person, society is an impersonal order — a mutual project of consent and exchange, made up of individuals who authorize its very existence.

This is huge. It is a major revolution in the way we understand not only our social lives but also the contents and practices of our sacred lives. We're no longer tied to a "social sacred," and our relationship to God is different — if we think of him, it is as designer rather than immanent sustainer; architect, rather than incarnate. And maybe he designed it and walked away, or at least we can imagine it that way — separating God further and further from the design and sustenance of a sacred order. Eventually, his task becomes little more than setting the pieces of the great clockwork of human civilization in order. In such an order, it is probably only a matter of time until some other force may simply take God's place, striking the clock.

God Is a Watcher:
Providential Deism and the Anthropocentric Shift

So the idea grew that we related to *God* as humans primarily by relating to the *order of things,* an order that has a moral shape that we can discern if we're not misled by superstitious or ideological notions. We follow God by following the patterns of things he has laid out. A rational God is the architect of a rational world, endowing his creatures with everything we need to activate the latent laws designed into its fabric. And so Deism is a kind of "natural" religion, belief that spontaneously arises when the corruptions of the superstitious mind are removed.

God's own goals settle into a kind of human-centered groove: a single end mostly concerned with human flourishing and mutual benefit within his designed order.[24] That's not new to the Jewish or

23. Taylor, *A Secular Age,* p. 156.
24. Taylor, *A Secular Age,* p. 221.

Christian tradition. But we generally thought that in addition to this divine providence, God also had *greater* purposes for creation, presumably love and worship of him. There was a demand that superseded human flourishing: the ultimate glorification of an Almighty God.

This demand can remain in the modern social imaginary, but only if people experience and act on it in private. To drag this higher command into the public square or the political arena would risk instability, and possibly even repress human flourishing — especially since your individual conception of what glorifies God might differ from mine.

And so, to the modern self, there is no greater good than human flourishing. This is what Taylor calls the anthropocentric shift, a change that has four parts.[25]

First, we adopted the idea that all we owe God is the realization of his providential plan. That is, our duty to God is that we achieve our own good. Faith is less about transcendence and more about fulfilling our own potentials and helping one another.

Second, as buffered selves living in a disembedded order, we no longer need constant grace. The *original* grace — the gift of a rational mind capable of understanding the world — is enough for us to achieve human good. Humans order, discover, and discipline themselves, but they don't need an active, sustaining grace to do so; it's part of them from birth. So there's a first grace (reason), but that is all we need to carry out God's final plan. If people are unfaithful or ungrateful, then God stands at the end of history to judge, with joy or punishment, how well we used those faculties.

Third, the sense of mystery fades when the world is disenchanted — any anomaly we encounter in nature, anything unexpected we experience, can be isolated, studied, and explained through scientific inquiry. Taylor writes, "If God's purposes for us encompass only our own good, and this can be read from the design of our nature, then no further mystery can hide there."[26] Certainly, we still love to explore and discover the world, and there's much left to explore and discover.

25. See "Providential Deism" in Taylor, *A Secular Age*, pp. 221-69.
26. Taylor, *A Secular Age*, p. 223.

But we have the tools and means of discovery at our fingertips, and we know it.

God's providence is therefore emptied of mystery. In a stable, impersonal order, God does not routinely reach down and do miracles. In fact, if he were to do that, we'd think it irrational and irresponsible of him. Even within many corners of the Western Christian church, saying that "God spoke to me" or "God told me to do this" is seriously suspect (possibly unstable). The idea, argues Taylor, "is scarcely conceivable that the Author of such an order would stoop to such personalized communication as a short cut, if virtuous reason alone can suffice to tell us all we need to know."[27] That claim has become a serious clash in contemporary philosophical and theological conversations.[28]

The fourth and final element of Taylor's anthropocentric shift is perhaps the most important: whereas we once took it for granted as a centerpiece of faith that God was planning to transform human beings into something beyond the limitations of their present condition, now we see the practices of religion — devotion, prayer, and so on — primarily as a means for bringing about human flourishing. A sort of "theistic rationality" prevailed during the Enlightenment (and still does, particularly in some branches of mainstream Protestantism) that barely invoked the saving action of Christ and spared little time for devotion and prayer. It was more interested in God as creator and designer, which meant it was more interested in the things of this world and their horizontal sacredness than it was in a restorative afterlife.

In that kind of afterlife, should it exist, we'd be a lot like we are now, but without some of the more painful and awkward bits. Humans do not so much transform as simply evolve. In this picture, religion is a private discipline, a moral code of conduct that cultivates an ordered, rational interior life. It is about fulfilling your purpose

27. Taylor, *A Secular Age*, p. 292.
28. Nicholas Wolterstorff writes at length on this problem in *Divine Discourse: Philosophical Reflections on the Claim That God Speaks* (Cambridge: Cambridge University Press, 1995).

more than changing you. It's about looking within rather than contemplating without. It counsels you rather than calling you to repent.

These shifts are what makes it possible for "religion" to emerge in the modern age as one among many categories of human experience, something that exists apart from us and our society. (It's what makes the idea of "separation of church and state" even possible.) Religion is fine in the public arena, as long as it contributes to social flourishing. Which makes it tricky to understand what (if any) legacy pre-modern saints like Saint Francis might have for us, as Taylor points out:

> If God's purpose for us really is simply that we flourish, and we flourish by judicious use of industry and instrumental reason, then what possible use could he have for a Saint Francis, who in a great élan of love calls on his followers to dedicate themselves to a life of poverty? At best, this must lower GNP, by withdrawing these mendicants from the workforce; but worse, it can lower the morale of the productive. Better to accept the limitations of our nature as self-loving creatures, and make the best of it.[29]

To put this all simply: the ideas of "religious" and "secular" were invented in the modern social imaginary in order to serve new political and social orders. In this framework, we assume markedly different things about ourselves and our world than the pre-moderns did. This is a Secular age: not one in which religion is *erased,* but one in which belief and unbelief are contestable. In our world, we think that "religion" is separate from — and optional to — our social and political life.

The Malaise of Modernity

This all has its benefits as well as its pathologies. Taylor suggests — worries about, really — three malaises, or tensions, which he says are also common to expressions of modernity: individualism, instrumen-

29. Taylor, *A Secular Age,* p. 230.

talism, and the double-loss of freedom.[30] These are the "bad sides" of modernity, the things that threaten to undo us both spiritually and socially.

But in many ways, the move to a modern social imaginary has resulted in some great triumphs for human rights and social orders that generally trend toward a more comfortable living standard and safer life for large groups of people. Modernity, like all ages, has its upsides.

So the question is not whether we ought to get rid of modernity. That's like a nutritionist suggesting we ought to stop eating strawberries and spinach altogether because overindulging can result in kidney stones. Rather, we should be considering which forms of modernity foster the greatest potential while provoking the fewest pathological or dystopian dilemmas.

But before we can find a cure, we must diagnose the pathologies.

The First Pathology: Adrift in the Cosmos

The first pathology is what Taylor calls individualism. In the Secular age, people think of themselves primarily as individuals — not *only,* of course, as individuals, but primarily as makers of their own meanings and identities, buffered from things outside themselves.

Today, individualism can be used as a scapegoat for a host of perils and ills, everything from the breakdown of the family to economic disintegration and problems in the food supply. That can bring up a nostalgia for a mythical golden age in which we felt ourselves part of "the great chain of being." Back in those days, the story goes, "everybody knew their place," and everyone was content to play their own role. Communities functioned in harmony and peace. Fairies danced and children sang and the sun rose and set.

Of course, this tends to lose sight of the more unsavory historical realities: widespread poverty, political suppression, and outright

30. Charles Taylor, *The Malaise of Modernity* (Toronto: House of Anansi Press, 1991). Parts of Taylor's argument in this book can also be found in *A Secular Age,* chap. 8, "The Malaises of Modernity."

slavery. Few people today would actually elect to turn back the clock to those times. Indeed, for the most part, the protection and dignity of individual persons is something worth celebrating.

Taylor isn't looking to eradicate these strides. Rather, he's pointing out that with this shifted focus comes a break with older forms of organic hierarchy: the loss of being embedded in a place, a time, a society which readily provides us with our identity and significance. Because while those older structures placed restrictions on individuals, they also handed us a sense of meaning, not only to persons — which is his first concern — but also to political societies. We each knew what we were doing here, or at least we thought we did.

You can see how this could lead us to become fragmented, no longer living with our neighbors in solidarity, since each of us seeks mainly to advance our own happiness. I will work together with you so long as it's good for me, too. This isn't a *necessary* product of the focus on the individual, but it's certainly more possible than it ever has been before, when it was the rare person (famously a "beast" or a "god") who unplugged himself from society.

Embedded hierarchies may have restricted human choices and powers, but they also provided meaning and orientation to people. In the pre-modern world, our social lives had intrinsic meaning as part of a bigger, more cosmic order (however unfair or disrespectful of human dignity this seems to us today). When we lost those pre-modern orientations, we gained a certain type of freedom to make up our own minds about how we would find meaning and purpose in life. But this can leave us feeling isolated and alone, and acting accordingly, as we see — for instance — in many of those we call sociopaths.[31] Self-government, while still good, is not an uncomplicated political good.

Some have celebrated this loss of meaning, claiming it gives us freedom to be or do whatever we want, and that this is an unmitigated good. But that no longer seems clear. It leaves us as people with no higher aims, no greater social goal, than what Tocqueville described

31. See, for example, Robert D. Putnam, *Bowling Alone: The Collapse and Revival of American Community* (New York: Simon & Schuster, 2001).

as the *petits et vulgaires plaisirs* (petty and vulgar pleasures) — or the final aspiration of Nietzsche's last man: pitiable comfort.[32]

The fruit of this is what we call narcissism, or self-absorption, endemic in whole generations, carefully fertilized and cultivated by the Boomers in the years after the Second World War. In a very real sense, individual lives are narrowed and disconnected from one another. Our meaning is reduced to just us, which means we determine our own identity instead of finding it in relation to others and a grander order.

And that isolates us and fragments society. Today, in our politics — which are designed to govern a collective of individuals — we often resolve the legal and political problems of individualism by balancing individual rights and preferences with collective priorities. How possible is this? How practical is it? Our views on this issue (and how we act upon them) can mean different political consequences.

That isolation, as though to prove Aristotle's famous dictum (that outside "the city" [polis] man is either "beast" or "god"), makes sociopathic rationale and morals increasingly common: if my primary good is also the highest good — for me — then there's nobody who can tell me to set aside what I want for a greater good.

The Second Pathology: Efficiency Is King

A second source of worry is instrumentalism (or instrumental reason): the mind-set in which we measure success through maximum efficiency, the best cost-output ratio.[33] Think of it this way: if we live in a disenchanted universe that doesn't have a higher moral or meaning, one in which each person acts according to whatever is best for him or her, then how do we make decisions, laws, and pronouncements about what we ought to do? What logic, rationale, or rule can give us a guideline for how to live as people and groups of people?

32. Taylor's double-anxiety over individualism is, unsurprisingly, the same neat division of Tocqueville's first and second volume of *Democracy in America*. See especially Lucien Jaume, *Tocqueville: The Aristocratic Sources of Liberty,* trans. Arthur Goldhammer (Princeton: Princeton University Press, 2013).

33. Taylor, *The Malaise of Modernity,* p. 5.

The answer today — which we see enacted around us — is a sort of economic rationality. In this framework, the best thing is whatever is most efficient: the most output for the least input. A society made up of individuals is, to those in power, more or less a collection of raw materials out of which can be made objects or conditions of our design. Without a guiding framework derived from beyond the person — from God, or gods, or *something* — there is nobody and nothing to tell us what "means" we should restrict ourselves to as we move toward a given end — or why. Only the pooled sovereignty of individual persons (democracy) is in theory capable of overriding this logic of efficiency, a prospect that becomes dimmer and dimmer as material efficiency becomes preponderant.

People who are put on earth (by God, or the universe, or whatever) to pursue their own flourishing can risk making that flourishing an exclusivist goal — which is to say, they can end up believing that nothing else actually matters in their decision-making. Everything is there to serve that end. Everything can be treated as raw materials or instruments for the projects of self-desire.

This reductive logic is at the heart of heated political debates in North America today, where we appeal to economics and efficiency when making decisions in spheres that ought not to be guided fundamentally by those norms — like medicine, education, and other human services. Even our arguments over how to treat the environment tend to be made in terms of long-range cost-benefit scenarios: we ought to protect the planet not because it's our duty but because pillaging nature too much will make us uncomfortable in the long term — won't it be hard to live when it's hard to get clean water or gasoline?

So while instrumentalism can seem liberating, it also leaves us feeling disquieted. It tells us the universe is here to serve us, but it also threatens to dominate us, because we may wind up being raw material in someone else's hunt for profit. Taylor writes, "The fear is that things that ought to be determined by other criteria will be decided in terms of 'cost-benefit' analysis, that the independent ends that ought to be guiding our lives will be eclipsed by the demand to maximize output."[34]

34. Taylor, *The Malaise of Modernity*, p. 5.

And especially today, technology can sharpen this concern. Jacques Ellul lamented the "essential tragedy of a civilization increasingly dominated by technique."[35] What Ellul called technique was largely instrumental reason applied through technology, which we persistently believe is a morally neutral and ultimately efficient method for solving our problems.

This has had important implications for the field of medicine, in particular, where ethical calculus rooted in efficiency is most controversial.[36] Ethicist Margaret Somerville argues that specialized and technical knowledge is preeminent in the medical establishment, resulting in an undervaluation of the skills and means of nurses, the human face of social caring, over more highly trained technical specialists.

It's not just individual people who think and talk this way. It's also been absorbed in profound and important ways by our institutions and systems, like government, health-care systems, education, markets, and more. Taylor argues that instrumental reason is not just an unconscious social orientation; it is also structured into political and social institutions. The "mechanisms of social life press us in this direction."[37]

When human lives become the grist for the mill of dollar-value assessments — when we tend to think about what is expedient rather than what promotes the greatest good (even if it doesn't produce a maximized profit) — then we have socialized instrumentalism, systems from which we may not easily escape, which the sociologist Max Weber evocatively called the "iron cage."

This is important to remember: these problems that plague modernity are not simply things that live in the "hearts and minds" of individual people. Rooting them out or addressing them is not merely accomplished by helping people change the way they *think*. That's all important work, of course — but it is not sufficient, because these

35. Jacques Ellul, *The Technological Society*, trans. John Wilkinson (New York: Random House, 1964), p. v.

36. For examples of this, see the ethicist Margaret Somerville in *The Ethical Imagination: Journeys of the Human Spirit* (Toronto: House of Anansi Press, 1996).

37. Taylor, *The Malaise of Modernity*, p. 7.

viruses within us have also infected our societal structures and insti-
tutions. This is just as much about practice as about understanding,
and just as much about what we do together as what we do alone.

The Third Pathology: Freedom's Double-Bind

Somewhat bizarrely, because of individualism and instrumentalism,
we're stuck with the third modern pathology: a strange, surprising
double-loss of freedom. On the one hand, we have the power to make
our own meaning in life. We can choose our futures. We don't have
to be a barrel-maker because Dad was — we get to go to college and
pick a major. We don't have to marry someone to whom we were be-
trothed as an infant for the family — we get on eHarmony and choose
whom to message. If we don't like the church we grew up in, we pick
another, or stop going altogether.

So individuals, acting in their own interest, might choose to dis-
connect from civic participation — say, voting or serving on the local
school board. Private citizens increasingly pursue private lives apart
from the institutions, processes, and values that constitute the com-
mon good, or the public sphere, in favor of what is meaningful for
them.

But those other ways of making meaning, which are so much
more within our grasp than they have been throughout most of hu-
man history, have a darker side. The meaning we create for ourselves
can turn into a trap. Sociologists and psychologists have written about
how our endless choices can induce a sort of paralysis, in which we're
unable to commit to a choice because so many are available to us.
When we *know* the grass will always be greener on the other side,
how do we choose which grass to munch? It is an irony, though a sad
one, that the systems and structures that were designed to maximize
our freedoms and our choices as individuals have actually come to
suppress and suffocate those choices.

And there's a politically oppressive result to this as well. Tocque-
ville warned that a society too focused on individuals can leave people
"enclosed in their own hearts" so that few will participate in self-

government, uninterested in participating in governance as citizens. Plummeting voter registries and turnouts seem to tip toward Tocqueville's prediction — but, perhaps more importantly, Tocqueville warned that these can lead to a kind of "soft despotism," in which a few wind up governing the many, instead of a truly participatory system. In other words, a kind of unintended tyranny may ensue simply because self-absorbed individuals cannot be bothered.

This is a real concern in modern democracies like Canada and America: the more detached the public becomes from its own governance, the greater the risk that those same powers may serve minority interests — or fall into tyranny.

So one might well argue that the modern person is no different from his or her medieval ancestor — that people are the same as they've always been. And they are. But these particular tensions are, Taylor argues, unique to the modern social imaginary. That's not to judge it as "good" or "bad" — every age has its problems, and the pre-modern age had some that the modern age sought to address and solve. But it is to mark out what makes us modern, and what the problems can be.

The Politics of Apocalypse in a Secular Age

All of these tensions sit in the background of today's "secular apocalypse" — in fact, if those stories reveal anything, it's how deeply rooted these things are, and how much they terrify us. Frequently, our dystopian stories are about these tensions when they're taken to their extreme. They show us what we think about ourselves, and particularly what we think our society would look like after a catastrophe of apocalyptic proportions. When modernity breaks down, what's left?

That's what we could call the "politics of apocalypse": what the (often conflicting) revelations that accompany our apocalypse, our endings, tell us about who we are as a people, and how we conceive of our common life together.

Those politics, first of all, are Secular (big S). Whether they involve

an actual apocalypse (*Walking Dead*–style) or more of an existential one, they're in a universe where there is nothing up there beyond ourselves, and therefore no moral order that transcends whatever we decide on. That's not to say there's no love, or hope, or moments of tenderness in these stories; it's just that that love is part of the "indomitable (buffered) human spirit," something that comes from *us* — not from grace. It's our attempt to say that we can survive the apocalypse: that there's some shred of humanity worth saving. But only we can make meaning out of suffering. There's no God or universal cosmos that will do so for us.

This gets repeated in apocalyptic popular culture all the time: does the instrumentalist logic that we need to save us during apocalyptic times — the decision to sacrifice the few to save the many, for instance — invalidate us, making us unworthy of existence? (Remember the dilemma of the boats in Christopher Nolan's *The Dark Knight*, set in a near-apocalyptic Gotham?)

William Adama puts it pointedly during the decommissioning of the *Battlestar Galactica* that opens the TV series *Battlestar Galactica*:

> The Cylon War is long over, yet we must not forget the reasons why so many sacrificed so much in the cause of freedom. The cost of wearing the uniform can be high . . . [after looking at crowd] but sometimes it's too high. You know, when we fought the Cylons, we did it to save ourselves from extinction. But we never answered the question [of] why? Why are we as a people worth saving? We still commit murder because of greed, spite, jealousy. And we still visit all of our sins upon our children. We refuse to accept the responsibility for anything that we've done. Like we did with the Cylons. We decided to play God, create life. When that life turned against us, we comforted ourselves in the knowledge that it really wasn't our fault, not really. You cannot play God then wash your hands of the things that you've created. Sooner or later, the day comes when you can't hide from the things that you've done anymore.[38]

38. *Battlestar Galactica*, miniseries no. 1, first broadcast December 8, 2003, by Syfy; directed by Michael Rymer, written by Glen A. Larson and Ronald D. Moore.

Our view of politics post-apocalypse, then, is about whether there is anything about humans worth saving in a Secular universe.

But is this not, some might say, a contradiction in terms? Who does the saving?

Admiral Adama isn't sure. A Secular apocalypse, in sharp contrast to the usual apocalypse, is one in which people have to face a global catastrophe in which meaning is optional, and often relative, and therefore essentially determined by people. Not only is it an apocalypse in which we have been stripped of higher orders and higher times; it is also one in which persons are buffered, order is impersonal, and God (if he exists) just watches — and not just that, but the things that ordered our lives before are gone. The systems and institutions of civilization have also been irrevocably annihilated.

But second, even though the modern social order has collapsed in these stories, the way we conceive of politics during and after the apocalypse retains a fascinating series of civilized tropes about the human condition. That is, our apocalypses don't seem to *destroy* our modern order; we assume it will continue, in some fashion, even after the worst has happened. The barbarians at the gates aren't even human anymore: they're machines, or psychopaths, or zombies. We explore our age, but often we don't get beyond it.

However, the most successful narratives *do* break the iron cage. They recognize that in order to steer us and our societies toward the things that are good about the modern moral order, we need more — other sources, other "horizons" of morality that come from outside ourselves. They're not merely pessimistic. A Secular apocalypse winds up pushing back on its own age. Apocalypse demands meaning. Apocalypse demands horizon.

Apocalypse demands . . . religion.

We might say we're heading into a post-Secular moment — because religion never left. Religion, of one kind or another, is actually not optional. It's fundamental. It's not so much about why religion is back, but why we ever thought it went away.[39] In the end, these

39. Philpott, "Has the Study of Global Politics Found Religion?" p. 199.

narratives push us to offer *something* — shallow, fantastic, disturbing, as it may be.

So. Strap on your sturdiest shoes and grab your knapsack (and don't forget to pack your towel). Get ready. It's all about to begin.

CHAPTER 3

A Short History of the Apocalypse

*Few phenomena in the history of Western religious tradi-
tions have been so important, or so controversial, as apoc-
alyptic eschatology.*

Bernard McGinn

Deconstructors write no gospels.

Frank Kermode

In *Apocalypticism in the Bible and Its World*, Frederick J. Murphy intro-
duces apocalypse by having a bit of an existential crisis:

> We are about to enter the strange world of apocalypses and apoca-
> lypticism. It abounds in weird creatures; columns of fire tumbling
> in bottomless abysses; angels and demons; visions of heaven, hell,
> and distant cosmic regions; fierce battles between awe-inspiring
> forces; odd mathematical calculations that disclose the end of the
> world; and countless other features bound to confuse the modern

Our deep gratitude to Timothy Wainwright for his invaluable help with the research
for and drafting of this chapter.

34

mind. How can citizens of the twenty-first century begin to understand such a world?[1]

How can we begin to understand this world? It's easy. The movies and television shows we watch every week are saturated in just those things. Apocalypse is more bizarre, confusing, and awe-inspiring than ever.

It's also about more than just zombies or things blowing up. It is about the *revelation* of the meaning, purpose, and end (and new beginning) of things. As we said in the first chapter, the Greek *apokalypsis* means "unveiling" or "uncovering." Apocalyptic stories — like, say, the book of Revelation — expose hidden truths, wipe away the veneer, push past the superficial and simulacra, and get to the *reality* of things.

That helps explain why apocalypse is all the rage today. It can be difficult to feel solid, rooted, and safe today — the ground is always shifting. There are few absolutes, few truths we all bank on. What was old is new again; what's new is old within a week. That's enough to make most anyone anxious.

In our apocalypse stories today, the myth of progress has turned up wanting. Globalization has contracted. Technology has turned on us. The world that modern, enlightened humanity had constructed is in shambles. But these stories don't turn up anything new, enlightening, or never before said about humankind: instead, no matter how innovative the story, characters end up parroting relatively timeless wisdom about the unchanging character of the human condition — about groupism and anarchy, sure, but also about faith, hope, and love.

That's because the end of the world is uncomfortable and dirty and dangerous and frightening, all things that remind us that we are creatures. And not just individual beings, but ones that depend on communities and others. We are highly vulnerable. We live — and, importantly, we die. These are the stories that force us to start talking about faith and love, beauty and sacrifice, virtue and purpose: in reli-

1. Frederick J, Murphy, *Apocalypticism in the Bible and Its World* (Grand Rapids: Baker Academic, 2012), p. xv.

gious language. Our Secular apocalypses circle back around from the Secular, making us into non-secularists.

Having explored the marks of the Secular age in the last chapter, we'd like to look at the transition in our apocalyptic literature over history — from religious, to secular, to post-secular. How did we get from "revelation" to "revolution"? That latter term denotes a *secularized apocalyptic eschatology* — that is, stories about the end of time and the future of the world, but ones stripped of the presence of God. That's the kind of story we see today, but we think this is a bit of a paradox.

From there, we can better understand the contrast between *apocalyptic* and *dystopian* popular culture. Though the two terms are often used interchangeably, they actually denote different forms of stories with similar starting points. Our culture produces one, but often not the other.

Defining Our Terms

To understand the relationship between politics and the apocalypse in our day, we need to unravel a knot of religious texts, revolutionary movements, and works of art. So first — as words like *apocalyptic* and *millenarian* and *dystopian* tend to be just as shifty as the word *secular* — let's go about defining our terms.

Norman Cohn's classic *The Pursuit of the Millennium* received handy blurbs from both Bertrand Russell and Isaiah Berlin. In many ways the founder of modern millennial studies, he aimed to focus on movements that picture salvation in these ways:

(a) collective, in the sense that it is to be enjoyed by the faithful as a collectivity;
(b) terrestrial, in the sense that it is to be realized on this earth and not in some other-worldly heaven;
(c) imminent, in the sense that it is to come both soon and suddenly;
(d) total, in the sense that it is to utterly transform life on earth, so that the new dispensation will be no mere improvement on the present but perfection itself;

36

(e) miraculous, in the sense that it is to be accomplished by, or with
 the help of, supernatural agencies.[2]

Cohn's study was focused particularly on Christian heretical
movements of the medieval period, which explains the presence of
the miraculous in his definition. But he wasn't denying the secular
variety of apocalypse. Cohn, who had lost relatives in the Holocaust
and interrogated former S.S. officers as part of his service in the
British Intelligence Corps, was all too aware of the power of secular
apocalypse.[3]

For an exhaustive and specific catalog of doomsday, though, it
pays to consult Richard Landes. He begins his groundbreaking study
Heaven on Earth: The Varieties of the Millennial Experience by distinguishing
between the three following words: *eschatology, millennialism,* and *apoca-
lyptic.*[4] All of these headings describe phenomena — both movements
and beliefs — that can be observed and mapped along different axes.

Eschatology is the broadest category. Derived from the Greek *es-
chatos* (final things), it describes simple belief in an end of history.
There can be both secular and religious variants:

In most secular and cyclical apocalyptic scenarios, the end of the
world or age results in the complete destruction of the physical
world and the annihilation of even nonphysical life (i.e., souls). This
can happen through a nuclear holocaust or an alien race "plowing
the earth under," or the built-in cycles of the cosmos, as it can
through God's "rolling up the heavens like a scroll." As an object of
fear, most "secular versions" can only inspire horror of oblivion. In
the religious scenarios, the Apocalypse consists of a Last Judgment

2. Norman Cohn, *The Pursuit of the Millennium: Revolutionary Millenarians and Mys-
tical Anarchists of the Middle Ages,* rev. and expanded ed. (New York: Oxford University
Press, 1970), p. 13.

3. See his obituary: Douglas Martin, "Norman Cohn, Historian, Dies at 92," *New
York Times,* August 27, 2007, http://www.nytimes.com/2007/08/27/world/europe/27cohn
.html?_r=0.

4. Richard Allen Landes, *Heaven on Earth: The Varieties of the Millennial Experience*
(New York: Oxford University Press, 2011), p. 17.

where an omniscient God judges the (resurrected) "quick and the dead."[5]

A religious sense of a last judgment can be divided along what Landes calls *denominational* lines — where right belief determines salvation, regardless of behavior — and *moral* lines, where right behavior determines salvation, regardless of creed and clan.

Millennialism, though, refers to beliefs in a golden age, or eternal paradise, *on Earth* — it takes its name from the thousand-year reign of the returned Christ in the book of Revelation. (It's worth noting that in millennialism broadly understood, "the world that passes is not the natural world, but the political world that now exists."[6]) Millennialism, like eschatology more broadly, can be either secular or religious. Moreover, it is often either hierarchical and full of iconography ("One God, one Emperor, and, quite often, one religion"[7]), or demotic and iconoclastic ("No king but God!"). Furthermore, there are both restorative (a return to the original purity of our forefathers, etc.) and innovative (progress!) millennialisms.

Finally, the apocalyptic, while often referred to as a genre of biblical literature, "refers to two related issues: a sense of *imminence* about the great upheaval and the scenario whereby we now go from this evil and corrupt world to the redeemed one."[8] Landes again maps varieties along two axes: apocalypses are either cataclysmic (the Four Horsemen) or transformative (give peace a chance); they are either active (human agency plays a large part in bringing about change) or passive (this fight is supernatural and/or out of our control).

Catherine Wessinger's *Millennial Glossary* builds on the existing parameters by distinguishing categories like *avertive apocalypticism* — perhaps Hollywood's favorite, in which the apocalypse can be averted through human action or repentance. The most common variety of millennial experience, according to Wessinger, remains "catastrophic

5. Landes, *Heaven on Earth*, p. 19.
6. Landes, *Heaven on Earth*, p. 21.
7. Landes, *Heaven on Earth*, p. 23.
8. Landes, *Heaven on Earth*, p. 18.

millennialism," in which a cataclysmic apocalypse is followed by a utopian millennial kingdom.

What about Art?

These definitions help us understand religious and political phenomena. But what about works of art? We know about the biblical genre of apocalypse — a recounting of the end of the world that promises to be utterly destructive, wanton, and chaotic.

But sometimes the lines are blurred. For example, is the book of Jonah an apocalypse? It does not promise an end to the universe or the world at large, but an end to the city of Nineveh. Does that qualify? And does the same principle apply to TV shows and books where bad things happen on a smaller scale? For example, where a family — say, the president's family — falls apart? *Breaking Bad*? *Mad Men*? *House of Cards*? *Scandal*? Sometimes we want to say yes — but what makes us say yes to those things while still drawing a line? (After all, if everything that deals with "beginnings" and "endings" is apocalyptic, then all narrative is apocalypse and we might as well just go home.)

One way to approach this question is through the lens of utopia and dystopia. Utopia fits into the framework — visions of a perfect society in literature often accompany apocalyptic works, from the religious *Paradiso* to secular Marxist fantasies. Dystopia fits into the framework in a way — when pictures of a future end of days end on a lighter note, with paradise restored. But what about works like Orwell's *1984,* when the future is dominated by an oppressive regime — and the book ends with a vision of hopeless despair and acceptance of that world?

We will seek to answer those questions later in this book. But for now, these categories will help make sense of the following history, which so often defies categorization. And of course, any history of apocalypse, no matter how broadly we define the term, must *begin* with religion.

The Roots of Apocalypse

The historical roots of apocalypse and millennial (no, not the Lena Dunham variety) thinking are undeniably religious. Every world religion has a sense of The End, and we cannot understand contemporary apocalypses without a sense of context. Unfortunately, condensing the history of religious apocalypses, millenarian movements, and their reflections in art and literature necessarily entails some violence and loss of detail.

So here, we have limited our treatment to apocalypses most relevant to Western culture. This is not to suggest that there are not fascinating discussions to be had about Buddhism's *nirvana* and the Hindu *Bhagavad Gita*. There are — we must leave them, though, to others. Think of what follows in this chapter less as an exhaustive study and more as a springboard into further explorations.

We begin where beginnings began, in the ancient Near East.

Depending, of course, on how we define things, the first works that smack of the apocalyptic come from ancient Egypt. Robert Gnuse, in an essay in the *Oxford Handbook of Millennialism,* singles out the *Admonitions of Ipu-Wer* (early 2000s B.C.), which predicts a time of current woe that a future strong king will overthrow:

> *Ipu-Wer* predicts a doleful future, the total breakdown of society, extensive crime, tomb robbery, murder everywhere, the spread of the desert into the sown land, reversal of the roles of poor and rich, the end of trade (especially foreign trade to places such as Byblos in Palestine), severe limitation of food supplies, a society run by slaves, exposure of infants, and even the Nile turning to blood as dead bodies float in it. . . . According to the text, strong pharaohs will reverse these problems and bring a golden age.[9]

This is perhaps the first example of a prime subspecies of apocalypse. But Landes adds another detail in his book, namely, that the rule of

9. Robert Gnuse, "Ancient Near Eastern Millennialism," in *The Oxford Handbook of Millennialism,* ed. Catherine Wessinger (Oxford: Oxford University Press, 2011), p. 237.

a certain dynasty, and the art that accompanied them, is a prime instance of another subspecies — the powerful political god on earth, the King of the World who (when times are good) is crowned as just the sort of hero an *Admonitions* calls for — a leader of an iconic imperial millennial movement.

Landes describes the reign of Amenhotep III, whose "favorite epithet was *Nebmaatreatentjehen* or 'Nebmaatre, the Dazzling Sun Disk,' and in honor of his [religious] Sed festival, he had a large statue of quartzite made for himself in which he appears deified, and characterized as the ruler of the world, the 'Dazzling Sun Disk of All Lands.'"[10] (Landes goes on to make an interesting and controversial case for seeing the pharaoh Akhenaten as an example of a failed messiah wanna-be.)

Ancient Egypt: sculpture, religion, and politics in one. But the Egyptians weren't the only ones who had tales of woe and joy. Gnuse cites Akkadian texts like the *Dynastic Prophecy* and the *Uruk Prophecy* as on par with the Egyptian *Admonitions*.

Furthermore, there's the *Epic of Gilgamesh*. Considered by many to be the first piece of literature, it describes the exploits of a king of the city of Uruk, who lived around 2500 B.C. (The most complete copy of the work dates from about 700 B.C.) It begins, mystically, with these words: "He who has seen everything, I will make known to the lands. / I will teach about him who experienced all things / . . . alike, / Anu granted him the totality of knowledge of all. He saw the Secret, discovered the Hidden."[11] Language like this — revealing of hidden things — is a hallmark of apocalypse.

The story goes on to refer, in Tablet Eleven, to a catastrophic flood similar to the biblical account of Noah.

Zoroastrianism, an ancient faith established by a prophet named Zarathustra perhaps a thousand years after the death of Gilgamesh, is also somewhat apocalyptic. As Annie Rehill summarizes: "There is a good god and a bad god. Ahura-Mazda represents the forces of

10. Landes, *Heaven on Earth*, p. 162.

11. The Epic of Gilgamesh, San Jose State University, http://www.ancienttexts .org/library/mesopotamian/gilgamesh/tab1.htm.

good, creation, and light. Ahriman stands for the bad, destruction, and darkness. These two opposing powers will do battle until the end of time, when Ahura-Mazda will win once and for all."[12]

Jewish and Early Christian Apocalypse: Things Get Real

To give a real picture of the history of this stuff, we have to walk a fine line between underestimating the milieu of the Ancient Near East that surrounded the Israelites and early Christians, and overestimating it. While it's true to note their contributions, it's also true that they were not even close to being of a kind with monotheistic apocalypse. As Gnuse notes, "Working with a strict definition of the Millennium, one would have to admit there is no real millennial literature in the ancient world prior to late Jewish and early Christian texts (200 B.C.E. to 200 C.E.), since the concept of a golden age that would last for a thousand years, or some other comparable length of time, does not appear."[13]

Rather, the contributions of the ancient world are probably best described as a prelude. Which brings us to the real deal: the books of the Old and New Testaments.

Early Jewish apocalyptic thought rose up in response to the totalitarian rule of a successor of Alexander the Great, the Hellenic Antiochus Epiphanes. Around 167 B.C., he sacked the Jewish temple and set up an altar to Zeus in its place. The atrocities and the Israelite revolt are detailed in the books of 1 and 2 Maccabees, and still celebrated today by the festival of Hanukkah.

The book of Daniel's fervent predictions of the end times have been a spring of apocalyptic belief for the last two thousand years. It tells of four great beasts:

> The first was like a lion and had eagles' wings. Then as I looked its wings were plucked off, and it was lifted up from the ground and

12. Anne Collier Rehill, *The Apocalypse Is Everywhere: A Popular History of America's Favorite Nightmare* (Santa Barbara: Praeger, 2010), p. 62.
13. Gnuse, "Ancient Near Eastern Millennialism," p. 235.

made to stand on two feet like a man, and the mind of a man was given to it. And behold, another beast, a second one, like a bear. It was raised up on one side. It had three ribs in its mouth between its teeth; and it was told, "Arise, devour much flesh." After this I looked, and behold, another, like a leopard, with four wings of a bird on its back. And the beast had four heads, and dominion was given to it. After this I saw in the night visions, and behold, a fourth beast, terrifying and dreadful and exceedingly strong. It had great iron teeth; it devoured and broke in pieces and stamped what was left with its feet. It was different from all the beasts that were before it, and it had ten horns. I considered the horns, and behold, there came up among them another horn, a little one, before which three of the first horns were plucked up by the roots. And behold, in this horn were eyes like the eyes of a man, and a mouth speaking great things. (Dan. 7:4-8, ESV)

Daniel is also noteworthy for being the first major book to deal with specific dates and periods of time: "Seventy weeks are decreed about your people and your holy city, to finish the transgression, to put an end to sin, and to atone for iniquity, to bring in everlasting righteousness, to seal both vision and prophet, and to anoint a most holy place" (Dan. 9:24, ESV).

The book of Daniel had a huge influence on later Jewish and Christian thought. The paradigm it sets forth

consists of four elements: (1) the expectation of the imminent overthrow of the worldly powers; (2) a series of "signs" or apocalyptic (Greek apokalupsis means "to reveal or unveil") indicators that the end is near, despite a period of persecution and crisis; (3) a chronological scheme leading up to the time of the end that lends itself to calculations as to *when* key events will transpire; and (4) a final judgment in which both the living and the dead are punished or welcomed into the newly established kingdom of God.[14]

14. James D. Tabor, "Ancient Jewish and Early Christian Millennialism," in Wessinger, *The Oxford Handbook of Millennialism*, p. 256.

Daniel, Isaiah, and other prophetic books would give the Jewish faithful hope of a future deliverance in times when they would face wild persecutions under the Greeks, Persians, and Romans. They anticipated the coming of a messiah, to lead them into glory. They differed from the Ancient Near Eastern milieu in their size, scope, specificity, and supernaturalism.

This thought would be advanced even further by the Jewish movement that coalesced around the life, teachings, death, and resurrection of Jesus Christ.

The most key sources here are the Gospel of Matthew and the book of Revelation. In Matthew 24, Jesus prophesies:

> Immediately after the tribulation of those days the sun will be darkened, and the moon will not give its light, and the stars will fall from heaven, and the powers of the heavens will be shaken. Then will appear in heaven the sign of the Son of Man, and then all the tribes of the earth will mourn, and they will see the Son of Man coming on the clouds of heaven with power and great glory. And he will send out his angels with a loud trumpet call, and they will gather his elect from the four winds, from one end of heaven to the other. (Matt. 24:29-31)

That prophecy is mirrored elsewhere, like in Mark 13. And Revelation, of course, has left a radical stamp on the world that can still be seen today in our popular culture. To the early Christians it was something deeper and more profound, a fundamental document of religious hope about the material and immaterial world. It "unveils the unseen spiritual war in which the church is engaged: the cosmic conflict between God and his Christ on the one hand, and Satan and his evil allies (both demonic and human) on the other."[15]

In these primary texts we see apocalypse full bore. Though these are works of powerful poetry, to believers and to the readers of the time, they were so much more. In place of a great pharaoh, we have

15. "Introduction to Revelation," in *ESV Global Study Bible* (Wheaton, IL: Crossway, 2012), p. 1797.

Behemoth, Leviathan, the Whore of Babylon, and the stars falling from the sky. These works changed how people lived in daily life. They were key planks in the construction of what Charles Taylor, as we saw in the previous chapter, calls "porous selves" — the premodern understanding of the self as both open to and vulnerable to supernatural and enchanted forces. This was so much the case that early preachers had to caution the faithful not to sell all their goods and quit their jobs in anticipation of the end.

Medieval Times

Christianity eventually came to dominate the empire that had repressed it. The emperor Constantine famously had a Christian vision the night before a battle, a vision which led him to command his army to paint crosses on their shields and then led to his personal conversion. This in turn led to the Edict of Milan in 313, bringing some tolerance for Christianity throughout the Roman Empire. Before long, Christianity was the dominant faith of the empire. When the empire crumbled and fell apart, however, Christianity and the church remained, dotted throughout the coterie of nations and kingdoms left in the wake of the empire's collapse.

This enduring Christian faith continued to spread the apocalyptic beliefs found in the Bible.

The first popularizers of the book of Revelation were, no surprise, theologians. While it is best not to get lost in the labyrinthine history of biblical exegesis and interpretation, one example is good to highlight the level of care and detail that was given to apocalyptic thought at the highest levels of academia. Jerome, the great theologian, lived from around A.D. 347 to 420. His commentaries on Revelation, drawing on the work of previous thinkers like Victorinus, expounded the theory of recapitulation, in which "the Apocalypse presents a series of typological events *recurring* in sacred history from the time of the patriarchs, through the unknown future of the Church on earth, to the *parousia*. . . . [This] linking of the historical moment to a transcendent purpose, has

45

been described by Marjorie Reeves as the very basis of medieval apocalyptic thought."[16]

It is worth noting that the influence of Jerome and Augustine led to an allegorizing of Revelation that was more popular among the church elite, while a more progressive, transformative millenarianism (in the sense of an imminent heaven on this earth before the second coming) remained popular only among the laity. Despite these fluctuations in thought, the big takeaway for our purposes is that a belief in some form of Christian eschatology was a vital part of the dominant medieval worldview. And that's in contrast to the Secular age, in which an earnest belief in Judgment Day stands out like someone wearing a St. Augustine costume to a Joachim of Fiore party (a joke that will make sense later).

There are numerous examples of the apocalyptic in popular culture. In the arts, for instance, tradition holds that Gregorian chant originated with Pope Gregory I (540-604), now known as St. Gregory the Great. One of the prime chants of the Latin Mass is *Dies Irae,* or "Day of Wrath":

> Death is struck, and nature quaking,
> All creation is awaking,
> To its Judge an answer making.[17]

Painting, too, showed reverence to Revelation. Beginning in the late fourth century, and continuing over the next six hundred years, motifs of the Lamb on the mountain, the tree of life, the scroll with the seven seals, and the worship of Christ the lamb by the twenty-four elders became ever more common. One key example is the original façade of St. Peter's Basilica in Rome, dating from the fifth century, which "showed a central Lamb flanked by

16. E. Ann Matter, "The Apocalypse in Early Medieval Exegesis," in *The Apocalypse in the Middle Ages,* ed. Richard Kenneth Emmerson and Bernard McGinn (Ithaca, NY: Cornell University Press, 1992), p. 39.

17. "The Order for Funerals," The Personal Ordinariate of the Chair of Saint Peter website, p. 46, http://www.usordinariate.org/documents/resources/AC_Order_for_Funerals.pdf.

the Four Beasts, each with a nimbus and a book held forth towards the Lamb."[18]

Literature and poetry were no exception. Annie Rehill's book *The Apocalypse Is Everywhere* highlights the Venerable Bede (A.D. 673–ca. 735), an English priest who would have great influence in the study of church history. He's also considered the author of "Judgment Day II," a poem that contains the following: "I was afraid of the great judgment because of my wicked deeds upon earth, and I was afraid too of everlasting wrath from God's own self, upon me and each one of the sinful, and how the mighty Lord will divide and sentence all humankind according to his mysterious might."[19]

A quick aside on Ragnarok: often, as Christianity spread throughout various tribes of Europe, theologies would run into each other. In their invasions of England and mainland Europe, the Vikings brought Norse theology with them, which Rehill summarizes this way: "After we die, some believed, life gradually leaves the body and travels to Niflheim, a dark and abstract place. There is an end to this world, called Ragnarok, at which time the gods, led by Thor, will no longer be able to hold back the devils of chaos." There follows a great battle, with much wailing and gnashing of teeth, but "this washes Earth clean and life begins anew."[20] This is an example (remember our definitions) of catastrophic millennialism, which Norse settlers of medieval England were able to synthesize with the dominant Christian religion.

Apocalyptic belief was at its height from about A.D. 1000 to 1515, and present in some form or another in the day-to-day life of practically every European in the Middle Ages. This bloomed around the turn of the millennium, and raised the status of Revelation within the Catholic Church in the centuries following. A key example of this in church thought is that of Joachim of Fiore, who in the twelfth century pushed back against Augustinian anti-millennialism and made bold predictions about the end times. He "was convinced that he had found a key which, when applied to the events and personages of the Old

18. Erik Thuno, *Image and Relic: Mediating the Sacred in Early Medieval Rome* (Rome: Erma Di Bretschneider, 2002), p. 56.

19. Quoted in Rehill, *Apocalypse Is Everywhere*, p. 112.

20. Rehill, *Apocalypse Is Everywhere*, p. 75.

and New Testaments and especially the book of Revelation, enabled him to perceive in history a pattern and a meaning and to prophesy in detail its future stages."[21] More could be said here of the Crusades and the West's relations with Islam (not to mention Islamic apocalyptic thinking itself, which will make a striking comeback toward the end of this chapter).

For another great example of how apocalyptic thought influenced the daily character of medieval society, look no further than Chaucer's classic *Canterbury Tales*. Richard Emmerson puts it this way:

> The New Jerusalem, as Chaucer's Parson teaches when the pilgrims approach Canterbury, should also be the goal of Christians on the pilgrimage of life:
>
>> "And Jhesu, for his grace, it me sende / To shewe yow the wey, in this viage, / Of thilke parfit glorious pilgrymage / That highte Jerusalem celestial." (X.48-51)
>
> Awareness of this ultimate goal of pilgrimage enunciated by the final speaker in the polyglot *Canterbury Tales* provides a crucial eschatological dimension to Chaucer's great human comedy.[22]

This was echoed in other literature of the day.

Of course, the fear of hell was also a strong motivator in medieval culture. Notice the late medieval paintings of artists like Breughel the Elder and Hieronymus Bosch, whose *The Last Judgment* triptych drew on the common genre of guidebooks to the underworld (the most famous being Dante's *Inferno*) and the grotesque marginalia of illuminated manuscripts to create a host of bizarre, amorphous characters. As Bosch expert Walter Bosing reminds us, those works remain to this day a perfect reminder of this "chief concern of the medieval Church," which harped on the "unending torments of the damned." For even though people tend to gloss over the battles between Augustinian

21. Cohn, *Pursuit of the Millennium*, p. 108.
22. Richard K. Emmerson, "Introduction: The Apocalypse in Medieval Culture," in Emmerson and McGinn, *The Apocalypse in the Middle Ages*, p. 314.

theology and Joachism, "it is nevertheless true that a number of voices predicting . . . an approaching catastrophe made themselves heard."[23]

One notable but surprising voice is that of Christopher Columbus. The famous explorer who sailed the ocean blue in 1492 thought of himself as a man on a mission to fulfill biblical prophecy. He was steeped in Revelation and was convinced that the end times were about 155 years away.[24]

All of these details combine to make a brief snapshot of the age when the Catholic Church was at its most powerful, and religious eschatology was commonplace in popular culture. It was a time of porous selves, of a Platonic great chain of being and of serious religious thought. The worldview that would remain up to the Renaissance, which "holds that there is another, invisible world besides this one, that our world of the senses is ruled by this other world through signs and portents, that good and evil are physically embodied in our immediate environment,"[25] was alive and well.

1516: The Birth of Modern Eschatology

On August 9, 1516, Hieronymus Bosch passed away. That same year saw the publication of Thomas More's *Utopia*. Written entirely in Latin, the enigmatic guidebook to a fictional land spoke of a society where all lived in common, no one locked their doors at night, and all took turns in sharing the work of the island. Different theories abound as to what precisely More was getting at, but the word *utopia* survived his work and came to refer to imagined or predicted perfect societies.

This is also an exemplary work of early humanist thought, an optimistic faith in the perfectibility of humanity, which represents the first turn away from the medieval and toward the secular. A draft of *Utopia* was edited by More's friend Desiderius Erasmus. Erasmus,

23. Walter Bosing, *Hieronymus Bosch, c. 1450-1516: Between Heaven and Hell* (Cologne: Taschen, 2012), p. 33.

24. Rehill, *Apocalypse Is Everywhere*, p. 137.

25. Victoria Nelson, *The Secret Life of Puppets* (Cambridge, MA: Harvard University Press, 2001), p. 7.

a founding humanist, is noteworthy for our purposes as being a high-profile doubter of the book of Revelation. In his *Annotations of the New Testament,* he expressed skepticism as to whether John's Apocalypse belonged in the canon of Scripture. Such doubt from such a respected and cosmopolitan figure raised the ire of the church, and Erasmus had to back down. But this represents the first modern ripple in the medieval pool. There would soon be more.

A year later, in 1517, Martin Luther would nail his Ninety-Five Theses to the door of the church in Wittenberg. In 1534, humanist-educated Henry VIII made himself the head of his own national church, breaking free of the pope. By 1555, the Catholic hegemony over Europe was formally ended at the Peace of Augsburg. The Catholic Counter-Reformation would see a move away from the darkness of Hieronymus Bosch and toward lighter painting, like the baroque style of Rubens.

What of theology? While Luther and Calvin, the major Protestant Reformers, shared Augustine's amillennialism, the same cannot be said of their seventeenth-century English Puritan descendants. This break comes from the spirit of an age that "rejected the received wisdom of the Greek and Roman classics and used scientific means of discovering the truth about nature and God. They were confident that scientific investigation would lead to a better world." Men like Thomas Brightman and Joseph Mede "were Calvinist in theology, yet deeply influenced by prevailing ideas of their time."[26]

It's a contradiction that many luminaries of the age wrestled with. Take Sir Francis Bacon, who wrote a work of utopian literature called *New Atlantis,* published in 1627. The tale of the island of Bensalem and the Society of Solomon's House "indicates his belief in science and learning as pursuits through which humanity could regain the dominion over nature that it had lost as a result of the original sin."[27]

These were the first birth pangs of modern millennialism, which is characterized by two things: an increasing drift away from "reli-

26. W. Michael Ashcraft, "Progressive Millennialism," in Wessinger, *Oxford Handbook of Millennialism,* p. 47.

27. M. Keith Booker, *Dystopian Literature: A Theory and Research Guide* (Westport, CT: Greenwood, 1994), p. 42.

gion" toward the "secular," and progressive optimism. Joachim of Fiore's confidence reared up again, Cohn argues:

> Horrified though the unworldly mystic would have been to see it happen, it is unmistakably the Joachite phantasy of the three ages that reappeared in, for instance, the theories of historical evolution expounded by the German Idealist philosophers Lessing, Schelling, Fichte and to some extent Hegel; in August Comte's idea of history as an ascent from the theological through the metaphysical up to the scientific phase; and again in the Marxian dialectic of the three stages of primitive communism, class society and a final communism which is to be the realm of freedom and in which the state will have withered away. And it is no less true — if even more paradoxical — that the phrase "the Third Reich," first coined in 1923 by the publicist Moeller van den Bruck and later adopted as a name for that "new order" which was supposed to last a thousand years, would have had but little emotional significance if the phantasy of a third and most glorious dispensation had not, over the centuries, entered into the common stock of European social mythology.[28]

The Age of Revolutions

To fully treat the age of modern apocalypse would require more space. But one way of charting the trends is through the major revolutions of the past few centuries — all of which had interesting millennial components.

The Puritan revolutionaries mentioned above transplanted their project to "New England" — a name full of deliberate utopian promise. Cotton Mather, the fiery Puritan preacher famous for his role in the Salem Witch Trials of 1693, was a noted scientist and member of the prestigious scientific group the Royal Society. This spirit, as well as a respect for Enlightenment teachings, permeated early American society. It would go on to characterize the religious revivals seen in

28. Cohn, *The Pursuit of the Millennium*, p. 109.

the 1700s by preachers like Jonathan Edwards and George Whitefield. Placing a high demand on human agency (remember our terms section?) and progressive millennial eschatology, these men encouraged their flocks to spread the faith and bring about the millennium.

This was directly related to the American Revolution and the founding of the United States. It tends not to get much airtime in high school history classes, but the American Revolution was a profoundly apocalyptic movement. Indeed, some of it makes the prime-time absurdity that is the campy Fox show *Sleepy Hollow,* with reanimated Hessian mercenaries in league with demons like Moloch and Ahriman, look like a well-researched historical documentary.

W. Michael Ashcraft notes that "in the later 1700s, as the rhetoric about British tyranny increased and the colonists moved toward revolution, the Edwardsean millennialist tradition blended with other ideas to produce 'civil millennialism.' Advocates . . . said that the future would be glorious because the world would embrace civil and religious liberty, values that inspired American patriots to rebel against the British."[29]

Put another way:

> The millennialism of the revolutionary era was essentially divided between the secular variety and the post-millennial variety. Many of the Founders believed that they were — in Thomas Paine's language — beginning the world anew with the Revolution, while the more religious believed that the War for Independence might herald the Millennium preceding Christ's return.

The French Revolution, on the other hand, had no major Puritan strain, and was a uniquely secular and rationalist movement (although that didn't prevent populist religious elements from getting swept up in the initial excitement). Even though it dispensed with the church, it framed everything in quite apocalyptic language. Landes notes that one of the earliest paintings featuring the new Declaration of the Rights of Man "has them surrounded by Masonic

29. Ashcraft, "Progressive Millennialism," p. 50.

symbolism and inscribed on two tablets of stone: the new universal legislation."[30]

Of course, when the new paradise failed to appear quickly, the reign of terror that Dickens would chronicle so well in *A Tale of Two Cities* started. Robespierre spiraled into a paranoid mess and the killings started . . . paving the way for the rise of the emperor Napoleon. The cycle, from egalitarian progressive utopia to cataclysmic apocalyptic movement, would be mirrored by the Russian experience.

But if the American Revolution was decently religious, and the French Revolution less so, Karl Marx offered a truly total secular variant on the modern trend of progressive millennialism. He "inherited a secular tradition of apocalyptic teleology from two initial German enthusiasts of the French Revolution, Kant and Hegel, whose histories 'took over the task of defining the modern age.'" The effort to "replace a God who tarries with a technologically empowered and liberated humanity" was full of "Promethean hubris."[31] Marx, of course, suffered his own unique brand of "messiah's doubt" after a string of revolutionary failures in the mid-1800s, which had started with such energy and promise. After that he refused to join other movements and instead committed himself to research in England.

By the end of his career, he "tore aside the mask of benign composure that had characterized the transformative demotic utopias — from Thomas More through (some of) the Masonic lodges to Owen and Fourier. And then he plunged into the violent and beckoning future, armed only with his sword of dialectic and his fierce prophetic hatreds."[32]

And with the rise of the National Socialist Party in Germany, we come full circle — "As a whole," M. Keith Booker notes, "Nietzsche's philosophical project represents a radical rejection of both Christianity and classical science, the two central discourses of authority in Western history and two of the principal sources of utopian energies in the West."[33] Hitler had no use for the weak religion of Christianity, but he considered himself a messianic figure. This came about, as

30. Landes, *Heaven on Earth*, p. 252.
31. Landes, *Heaven on Earth*, p. 292.
32. Landes, *Heaven on Earth*, pp. 316-17.
33. Booker, *Dystopian Literature*, p. 35.

much as is possible from a single event, from seeing a performance of Wagner's opera *Rienzi*. Hitler's friend August Kubizek recalled the ecstasy that Wagner's music would bring out in Hitler.

The future führer found a program of racial purity, a new religion about the German *Volk*, as a primary source for his new religion, the literal millennium of a "thousand-year Reich." That this was a religious, apocalyptic movement is an often overshadowed element in discussions of fascism. It led to the tragedy of the Second World War — and in many ways our culture is still reeling from that conflict.

Dystopia

John Stuart Mill first coined the word *dys-topia* in a speech to Parliament in the 1880s. But it would only come to be a unique literary genre in the twentieth century — a largely pessimistic version of the future, as if Dante had written the *Inferno* and stopped. Works like George Orwell's *1984*, H. G. Wells's *War of the Worlds*, Aldous Huxley's *Brave New World*, and Anthony Burgess's *A Clockwork Orange* all express a profound sense of discomfort with narratives of hope — whether religious, Enlightenment, or otherwise secular. There's good evidence that this was reflected in the films of the mid–twentieth century — particularly intriguing (though usually overstated) is the presence of alien-invasion narratives as Cold War anxieties increased.

And that brings us to today's apocalyptic stories, which are planted pretty firmly in this lineage. Yet they rarely refer to God, or gods, or shared beliefs — except as a way to tell a better story, without the weighty religious meaning they once held.

Take, for example, this description, which sounds like the script for a pretty awesome prime-time TV show premiering next fall:

> The natural sciences . . . suffer the effects of a catastrophe. A series of environmental disasters are blamed by the general public on the scientists. Widespread riots occur, laboratories are burnt down, physicists are lynched, books and instruments are destroyed. Finally a Know-Nothing political movement takes power and successfully

abolishes science teaching in schools and universities, imprisoning and executing the remaining scientists. Later still there is a reaction against this destructive movement and enlightened people seek to revive science, although they have largely forgotten what it was. But all that they possess are fragments: a knowledge of experiments detached from any knowledge of the theoretical context which gave them significance; parts of theories unrelated either to the other bits and pieces of theory which they possess or to experiment; instruments whose use has been forgotten; half-chapters from books, single pages from articles, not always fully legible because they're torn and charred. Nonetheless all these fragments are re-embodied in a set of practices which go under the revived names of physics, chemistry and biology. Adults argue with each other about the respective merits of relativity theory, evolutionary theory and phlogiston theory, although they possess only a partial knowledge of each. Children learn by heart the surviving portions of the periodic table and recite as incantations some of the theorems of Euclid. Nobody, or almost nobody, realizes that what they are doing is not natural science in any proper sense at all. For everything that they do and say conforms to certain canons of consistency and coherence and those contexts which would be needed to make sense of what they are doing have been lost, perhaps irretrievably.[34]

That's not coming from Hollywood, and it won't be on HBO (yet, anyhow). That's Alasdair MacIntyre's opening to his philosophical blockbuster *After Virtue,* published in 1981. MacIntyre didn't make up the story himself. He cribbed it from a variety of older science fiction stories, including Walter M. Miller Jr.'s seminal 1959 epic, *A Canticle for Leibowitz.*

After much philosophical writing, at the end of the book MacIntyre returns to this chaotic vision of the future, dourly concluding that it isn't from the future at all — it's a description of today. Already, he says, we are living amid an intellectual and ethical apocalypse.

34. Alasdair MacIntyre, *After Virtue: A Study in Moral Theory* (Notre Dame: University of Notre Dame Press, 1981), p. 1.

Our arguments and rational forms are shallow, repeated tropes of an earlier, robust, rooted ethical dialogue. We have fragments and scraps from those times, but mostly we stumble on doing something we mistakenly call ethics, uprooted from *telos* — that is, from a sense of where we're headed, and why.

Now *that* is dystopia.

Remember — the whole idea of apocalypse is predicated on the revelation of endings. But, MacIntyre argues, this postmodern apocalypse does anything but *reveal:* the way we imagine the end of the world keeps us from seeing the sources of renewal that might keep us alive as a society. Why? Because traditions of political theology have been removed from the public debate. We have lost the moral vocabulary to even articulate our revelations; we're not just afraid to make claims of objective moral reality but also unable to do so coherently anymore.

In *A Canticle for Leibowitz,* human history turns out to be simply a cycle of repeated self-annihilation by the discovery of atomic power. (The Cylons' mantra in *Battlestar Galactica* echoes this: "All this has happened before, and all this will happen again.") In the novel, religious orders formed around the sanctification and veneration of scientific fragments — as preservers of traditions of knowledge — repeatedly wind up as pious saps who steward, build, and renew scientific knowledge until the hubris of secular humanity finally reclaims it for its own, only to use its phenomenal powers to destroy itself afresh. And as the cycle repeats itself, every world looks slightly different (partly due to new mutation and nuclear radiation) — but every world also works exactly the same.

Miller's and MacIntyre's point could not be clearer: without a theological backdrop to render our moral actions rational and comprehensible, only radioactive death awaits.

This pessimism is substantially caused by the problem of Secularity: the "pitiless ingratitude toward the past" that Taylor says characterizes our modern age.[35] While humanity's atomic coming of age

35. Charles Taylor, *A Secular Age* (Cambridge, MA: Belknap Press of Harvard University Press, 2007), p. 198.

is necessary to its recurring destruction, it's not sufficient to cause an apocalypse. A cultural catalyst is required, and that catalyst is the technological Babel of postmodern hubris, the eclipse of earlier or higher times and knowledge, the sure confidence that modern humanity's independent powers of will progress apace and restrain our pathological appetites.

The promise of traditional tales of apocalypse, writes Elizabeth Rosen in *Apocalyptic Transformation,* "is unequivocal: God has a plan, the disruption is part of it, and in the end all will be made right. Thus is suffering made meaningful and hope restored to those who are traumatized or bewildered by historic events."[36] Apocalypse isn't unmitigated catastrophe — not exactly. You could even call it optimistic. In apocalypse, the suffering and pain we encounter in this life finally gains meaning. How many of us, in fact, yearn for apocalypse — for Revelation — to make the deep pain and difficulties of our lives meaningful and finished?

Traditional Christian liturgy even regularly calls forth apocalypse: *Come, Lord Jesus,* it pleads. *Come quickly.* Nowhere is this more marked than in funeral and burial liturgies, where faiths of all kinds taste the promise that the seemingly senseless tragedy of death is not the end. Revelation, that apocalypse, awaits.

It's Not All Bad

But we tend to think of apocalypse not as comfort or as consummation, but as senseless brutality and punishing anger. Rosen explains,

> Where the underlying message of the original narrative was optimistic, anticipating God's intervening hand to make things right, the altered version has more in common with the jeremiad, a lamentation over the degeneracy of the world, and when God intervenes in this newer version of the story, it is not to restore order to

36. Elizabeth H. Rosen, *Apocalyptic Transformation: Apocalypse and the Postmodern Imagination* (New York: Lexington, 2008), p. xii.

a disordered world and reward the faithful, but rather to express a literally all-consuming, punishing anger.[37]

She calls this the *neo-apocalyptic*. This sort of literature, she argues, is fundamentally pessimistic; "it functions largely as cautionary tale, positing means of extinction and predicting the gloomy probabilities of such ends. If these tales exhibit judgment, it is of the sort that assumes that no one deserves saving and that everyone should be punished."[38] Like apocalypse, tales of neo-apocalypse involve the collapse of the social order, punishing human sin and error. Like apocalypse, neo-apocalypse is pessimistic about humanity's capacity to rehabilitate itself.

But unlike apocalypse, neo-apocalypse doesn't restrain that pessimism. There's no *Deus ex machina,* no hope for the renovation of humankind: "This degeneracy is so complete that the Ending can only be so, too. There is nothing beyond this Ending, no hope of a New Heaven on Earth, precisely because there is nothing worth saving."[39] This strain of literature is what inspired Frank Kermode's *The Sense of an Ending,* a still pivotal study in the field of literary criticism. "Deconstructors," he says, "write no gospels."

In *New York Magazine,* Hugo Lindgren called neo-apocalyptic literature "pessimism porn,"[40] a "soft spot for hard times." So while apocalypse is old, this neo-apocalypse is something new and fascinating, with its twin characteristics: it is anthropocentrically pessimistic (and lacking any hope of restoration), and it is largely out of sync with our actual, as-yet-not-obliterated reality. *A Canticle for Leibowitz,* published in 1960, can be forgiven for forecasting nuclear holocaust. But somehow that didn't happen. Statistically speaking, the world is actually safer today than it has ever been before.

Yet we're still fixated, predicting total collapse — which may speak to the romance of disruption, as Mary Manjikian puts it in *Apocalypse*

37. Rosen, *Apocalyptic Transformation,* p. xiv.
38. Rosen, *Apocalyptic Transformation,* p. xv.
39. Rosen, *Apocalyptic Transformation,* p. xv.
40. Hugo Lindgren, "Pessimism Porn," *New York Magazine,* February 1, 2009, http://nymag.com/news/intelligencer/53858/.

and Post-Politics: The Romance of the End.[41] Seeking entertainment in the apocalypse is a luxury for wealthy, developed societies that don't have to encounter the consequences of systemic collapse and root violence on a daily basis. Max Brooks, the author of the bestselling *World War Z* (which inspired a 2013 film of the same name), explores something comparable: in his story, even at the height of the zombie apocalypse, a "reality television show" airs featuring the reactions of wealthy and secure subjects witnessing their fellow citizens struggling to survive the onslaught. (And don't forget the wealthy Capital citizens, glued to the TV for spectacle and enjoyment during the days leading up to the Hunger Games.)

Here's the paradoxical irony: neo-apocalyptic pessimism about the future, a consummately postmodern form, is the ultimate act of deconstruction. But while it deconstructs our ways of understanding the world, it creates its own grand narrative. Not just a grand narrative: maybe *the* grand narrative, one that judges everyone as miserable wretches unworthy of salvation. Rosen writes in her epilogue that "in the very act of deconstructing apocalypse, postmodern artists are being *constructive.*"[42]

Grand narratives (or metanarratives) are the big stories that validate and give meaning to life events — they tell us what to care about, where we came from, where we're headed, and why. The social theorist Jean-François Lyotard famously said that a defining feature of postmodernism is "incredulity toward metanarratives"; in other words, postmodern people tend to view with suspicion any big story that tells them what we're doing here on earth and that makes claims upon their individual choices. And while something like Christianity is itself a metanarrative, there's also a very real sense in which all metanarratives — political ideologies, economic systems, philosophies — take on a religious significance for those who believe in them. In some sense, one might say that metanarratives are inherently religious: they tell us what is ultimately important in life.

41. Mary Manjikian, *Apocalypse and Post-Politics* (New York: Lexington, 2014).
42. Rosen, *Apocalyptic Transformation,* p. 177.

All Apocalypses Are Religious (Even the Secular Ones)

So that brings up an important question: can a "secular apocalypse" really exist? That is, if today's neo-apocalyptic deconstruction is *also* a grand narrative, one that tells us that the meaning of everything is that everything is meaningless and we're all gonna die, then — taking that broader definition of religion — isn't this also a deeply religious (or at least contentiously metaphysical) anthropology?

Of course it is. Today's "secular" apocalypse is just as religious as any ancient, medieval, or even early modern incarnation. At this point we could straightforwardly show how religious imagery keeps getting smuggled into so-called neo-apocalyptic culture. But we not only want to show the religious character of these pathologies of our neo-apocalyptic worlds; we also want to explore how they crop up in our particularly "secular age" — and to show why, as the theologian and ethicist Oliver O'Donovan has so expressively put it, our modern moral order cannot survive such "metaphysical scalping."[43]

We'll break with Rosen and others: what they call *neo-apocalypse,* we call *dystopia,* or *dystopian apocalypse.* That's because we're exploring not only actual apocalyptic worlds (like *Battlestar Galactica*) but also postapocalyptic ones (like *The Hunger Games*), and even dystopian dramas that lack actual material catastrophe (*Her,* or *Breaking Bad*), but follow the contours of their cousins.

So some of the artifacts of popular culture we explore here as apocalyptic or dystopian aren't about the "end of the world," exactly. They're more about the end of *our* world. They're stories that have the distinct sense embedded in them that this social order can't last — that we are, in fact, near the end of something. What holds them together is that they manifest in some way the pathological forms of the "malaise of modernity," which is the cultural catalyst, at root, of MacIntyre's dour ethical prognostication.

Sometimes it looks like things blowing up — a material apoca-

43. Oliver O'Donovan, "Response to Jonathan Chaplin," in *A Royal Priesthood? The Use of the Bible Ethically and Politically: A Dialogue with Oliver O'Donovan,* ed. Craig Bartholomew, Jonathan Chaplin, Robert Song, and Al Wolters, Scripture and Hermeneutics Series 5.3 (Grand Rapids: Zondervan, 2002), p. 313.

lypse. Sometimes it is an impending political ruin or seismic cultural shift (like *House of Cards* or *Mad Men*). Sometimes it is an emotional and existential collapse. But taken together, we get a frightening picture of what we, as a culture, think looms on the horizon: a destruction of our own making, with no hope for renewal.

But it need not be so. And interestingly enough, our pop culture helps show us why.

CHAPTER 4

Keep Calm and Fight the Cylons:
New Ways to Be Human

Caprica 6: Are you alive?
Colonial Officer: Yes.
Caprica 6: Prove it.

The first spoken words of *Battlestar Galactica*

Robots turning on their masters: classic twentieth-century stuff. Techno-pocalypse is a whole genre in the dystopian canon, including redoubtable standbys like *Blade Runner* and (naturally) *The Matrix,* a messianic apocalyptic thriller that has launched a thousand youth group reflections on "meaning" and "reality."

Both the classic Cold War *Battlestar Galactica* (*BSG*) and its post-9/11 reboot are easy dystopian candidates for the politics of apocalypse. The text that flashes over the show's opening credits breaks it down succinctly:

The Cylons were created by Man
They Evolved
They Rebelled
There are many Copies
And They Have a Plan

People make robots, robots get sentient, robots rebel, terrifying war ensues: simple formula. But the technology-taking-over angle is the

least interesting part of the post-9/11 *BSG*. The series is not really about whether we should make technological advances; rather, it's about the new individualism, and about our search for *authentic* ways of being human.

So *BSG* is an epic techno-pocalyptic adventure about Charles Taylor's first pathology: individualism, and the quest for individual authenticity, which is something we worry about a lot these days. Are we properly finding ourselves? Are we being the best that we each — individually — can be? Do others around us see how unique we are? Or are we copping out, selling out to expectations, spending too much time modeling ourselves on those around us?

According to Taylor, several ideas born at the end of the eighteenth century and founded on earlier forms of individualism are foundational to our notion of authenticity.[1] These ideas were initially pioneered by René Descartes, "where the demand is that each person think self-responsibly for him- or herself." John Locke adopted a political variation of this, arguing that each person's rational "will" came before any social obligation.[2] Basic political concepts like "the social contract" (the agreement of individuals that makes political societies) emerge from what Taylor calls the Grotian-Lockian consensus — the idea that our social and political communities emerge *out of* our individual, independent, responsible wills, and so only become valid when we give our consent to them.

When we hear the term "social contracts," we might think of Jean-Jacques Rousseau, who Taylor says was important to the second element unique to particularly modern authenticity: he *naturalized* the moral voice — which is to say that he taught that our clearest moral guide was placed by nature within each of us. Taylor even calls this a "pantheistic" turn — people don't just learn to recognize their own unique selfhood; they learn that this requires following our "inner voice." In Rousseau's world, says Taylor, our moral salvation "comes from recovering authentic moral contact with ourselves."[3]

1. Charles Taylor, *The Malaise of Modernity* (Toronto: House of Anansi Press, 1991), p. 25.
2. Taylor, *The Malaise of Modernity,* p. 25.
3. Taylor, *The Malaise of Modernity,* p. 27.

That inner voice, in a shift Taylor identifies with the writing of Johann Gottfried Herder, is *unique,* particular to each of us, and not like anyone else's. We're all beautiful snowflakes. And you only really know this because you're not like anyone else — something you discover from looking around you. As Taylor says, under this framework, "there is a certain way of being human that is *my* way."[4] It's not just that you need to be "true to yourself"; you *must* do so, or you are doing life wrong. My job here on earth is to figure out and then perform what being alive is for *me*.

A look at *Battlestar Galactica* helps us figure out how this whole authenticity thing works, and how we might live more faithfully in a world where it's so important. Authenticity isn't just bad or good, just as all these things unique to our time are not necessarily good or bad. They're more complicated than that. *BSG* works as a kind of parallel project to Taylor's — it takes the puzzle of authenticity seriously and stages a drama around it. We might like its answers, or we might hate them. But like all great cultural artifacts, *BSG* opens up profound, weighty questions, and then does its best to give some kind of answer.

The Robot's God: A Cosmic Coming of Age Story

In his book *The Theology of Battlestar Galactica,* Kevin J. Wetmore Jr. says the show is basically about salvation.[5] It wants to know which conditions make belief possible and reasonable — especially after an apocalypse. In that respect, the theme of theodicy — why does evil exist, and how could a good God allow it? — runs through the show: war crimes, genocide, torture, insurgency, the pain and probability of reconciliation, and many other problems that we remember all too well from the past century or so recur from the pilot to the finale.

4. Taylor, *The Malaise of Modernity,* p. 29.
5. Kevin J. Wetmore Jr., *The Theology of Battlestar Galactica: American Christianity in the 2004-2009 Television Series* (London: McFarland, 2012).

But many of the series' core mysteries revolve around the question of authenticity. The Cylons revolt. They completely destroy the original Twelve Colonies in a nuclear holocaust. And then — they go silent. Why? What forestalls this otherwise straightforward genocidal parricide? In a word: authenticity.

Consider the analogously Mormon context of *BSG*. We open to a drama where humanity is ruled by a Quorum of Twelve, twelve tribes that settled together — a thirteenth tribe having wandered to a far-off place, a quasi-mythical planet they call Earth. Nobody knows where it is. All thirteen tribes originally came from a planet called Kobol, the birthplace of humankind, where "gods and men" lived in peace. This is a bit of anagrammatic sleight of hand for Kolob, the Mormon star that, according to the Book of Abraham, is "nearest to the throne of God" (3:23).

The colonies are a system of twelve planets with both highly advanced technology and a deeply complex system of faith, widely perceived as polytheistic. Each colony and its tribe are borrowed from the Zodiac — Caprica, Tauron, Gemenon, Aerilon, and so forth — and each tribe worships deities largely paralleling ancient Greek gods: Zeus, Apollo, Athena.

In *Caprica,* the prequel show to *BSG,* religious unrest is a common theme. A minority of colonists believe in what we are led to understand is a perverse and destabilizing monotheism. The plot line of *Caprica* supposes that monotheistic belief produces instability in political cultures, because following "one god" would necessarily produce tyranny. The series suspends the usual assumption that monotheistic religions are "good" and polytheistic ones are "bad." Monotheism in the *BSG* universe is associated with the enemy — with Caprica's insurrectionists, and with the genocidal Cylons (and some rogue elements in the human fleet), who identify themselves as children of the "one true God," on a mission from him.

So you might also say that *BSG* is a story about religious war. But underneath this apocalyptic religious warfare is the greater authenticity question: What does it mean to be alive? And how can we prove that we are alive? Both sides argue about which is "chosen by God" or "the gods" — that is how they validate their very right to survive. After

the Cylons rebel, after they flee into space, build up an enormous and technologically superior armed force, and visit their justice upon their makers, it looks at first like simple revenge, the inevitable outcome of humankind's arrogance.

But of course, it's not simple revenge. It's not just genocide; it's patricide. The Cylons, seeing themselves as humankind's children, believe they cannot truly emerge as a race — become real, experience life — until they've *replaced* humanity. And yet this presents a paradox. The Cylons have a mission separate from the mere destruction and replacement of humanity: they know their technological life isn't full being, and they can't figure out how to fix that. Even while claiming to be God's perfect children, they recognize they cannot fulfill his basic commandments — like love and procreation.[6]

That's where some of the darker and more disturbing moments in *BSG* come from. When the *Battlestar Galactica* escapes the Cylon onslaught, along with its ragtag civilian fleet, the Cylons initially pursue them to complete their destruction. But soon it becomes clear that their agenda has shifted from destruction to something else. Human-form Cylons (or, as some of the humans call them, "skin jobs") infiltrate the human fleet. Their goal is not ultimately sabotage (though there's a bit of this). It is *recognition* and *authenticity*.

When the series opens, just before the Cylons unleash their final solution on the compromised defenses of the Twelve Colonies, one of the twelve Cylon-human models, Caprica 6, visits the armistice station where the two sides negotiate and asks only one question of the colonial officer: Are you alive? When he answers yes, she tells him to prove it, and kisses him as the station promptly erupts in a fiery inferno. Typically, we assume (following Descartes) that being rational proves that we exist, and we're human. But the Cylons *are* rational — more rational than humans, in fact. They're superior to humans in almost every way, except one: love. Not lust, or desire — love. And while they can have (lots of) sex, they can't get pregnant. They can't procreate. Several Cylon models come to believe that humanity holds

6. In Season One, Episode One of *Battlestar Galactica,* a Cylon introduces the problem, claiming that "Procreation is one of God's commandments."

the key not only to authentic recognition, their coming of age, but also to its accompanying procreation.

So what *BSG* tells is a story of collective social adolescence — human *and* Cylon. You can hardly get more ungrateful toward the past than nuking it, which is what the Cylons do to their human creators. But then again, once you've nuked the past, you're left isolated and alone, a robot that doesn't have any way of figuring out if it's *real*. That's the paradox of authenticity.

Descartes and the Cylon Within

Descartes believed in the power of the buffered self: his famous phrase, *cogito ergo sum* (I think, therefore I am), suggests that the power of recognizing our own existence is in our hands. Others picked up the phrase. French literary critic Antoine Leonard Thomas, in his 1765 essay in praise of Descartes, reframed it this way: since I doubt, I think, since I think, I exist.

In the past, self-actualization (or, more simply, "being alive," as Caprica 6 puts it) was considered a *gift* — or at least a given, a cosmic or created reality. Some still think of it this way: people are stamped in the image of God, the *imago Dei,* and so they don't need to exert *themselves* in order to recognize their own personhood. It is the first grace.

But in *BSG*'s universe, that's the big question: Who gets a soul, and why? If humans are created in God's image, and the Cylons (at least the skin jobs) are created in humanity's image, can Cylons be alive? Can they have souls? The humans initially dismiss the idea, but they're forced to reconsider.

If personhood *isn't* dependent on God or gods, on cosmic gift or divine mandate, but on us and our rational thought processes, and if Cylons are rational, then how could they *not* be persons? But apparently, being rational is *not* the final measure of personhood — not in the *BSG* universe. Humans, and Cylons, slowly begin to recognize the Cylons' authentic selfhood when they see that Cylons have desires — especially, and importantly, desires that make it possible for them to procreate, against all odds, with humans.

Nobody saw *that* coming.

In the *BSG* universe, to become authentic is to become mature — both rationally and emotively. This is the same kind of authenticity that emerged in the eighteenth century, partly to demonstrate that human beings were endowed with a moral sense, an "intuitive feeling for what is right and wrong."[7] At the time, the idea was growing that determining what was right and what was wrong was mostly about calculating consequences — especially in regard to divine punishment or reward. The idea that this was not about consequences, but innate to and discoverable by everyone, made morality a matter of *personal* responsibility. It wasn't okay to do something just because you could get away with it (because you were rich or privileged, for instance). If God has endowed us with an internal code of conduct, and if any rational person can figure it out, then we don't need clergy and authorities to tell us what's right and wrong. Morality is a voice within.

Suddenly, it becomes very important to reflect on our inner life — because our feelings are not usually *wrong*. We must "obey" them. What emerges from inside of us is morally significant, a moral compass. When we ignore it, we keep ourselves from acting like humans.

This kind of introspective moral significance is not the same thing as, for example, religious contemplation. In the Ignatian discipline of contemplative prayer, we see that contemplative prayer *always* begins with an exercise that decenters the person: reflection on God, or the cosmic, or the ultimate in some fashion. That is contemplative prayer: it *examines* the conscience *against* something, rather than recycling internal monologue.

But introspection for "authenticity's" sake can have a dark side. It is navel-gazing without serious moral examination, because moral weight, by definition, comes from within. Look inside, and see what you see: it is inherently good, because (at least in the late eighteenth century) God put it there.

So, now: let's think about Dr. Gaius Baltar, sort of a religious leader, definitely a strange dude. The good doctor's sexual adventures with a Caprica 6 model in the show's pilot more or less cause the

7. Taylor, *The Malaise of Modernity*, p. 26.

total defeat of the Twelve Colonies' defense systems. And after the attack, Caprica 6 haunts Baltar's mind. At first, it seems like she's a guilty conscience. Later, she consistently claims that she's an angel of God. Other angels appear, too: crucial moral voices for characters as they evolve. And later we realize they are startlingly real. The angels prophesy for and guide their charges. They are messengers of "The Plan" that God is unfolding in their midst.

These "angels" are the manifestation of the voice within — a proof of *life*, not because they provide rational counsel, but because they provide religious and, in many cases, intimate and sexual comfort. In the *BSG* universe, it is the fact of love and procreation that finally proves that Cylons may, indeed, be alive — be real. Political scientist Iver Neumann writes,

> Consider President Roslin's appalled reaction when she overhears a cylon declaring her love for a human (Gaius Baltar): "I feel like part of our world just came crashing down." Roslin realizes that what she has in front of her may not be a machine.[8]

In the show's pilot, Caprica 6 and Baltar have the following exchange:

CAPRICA 6: You have to believe in something.
 BALTAR: I believe in a world I can and do understand. A rational universe, explained through rational means.
 [Number 6 walks closer, kisses his ear.]
 6: I love you. That's not . . . rational.
 BALTAR: No. No, but . . . you're not rational.

That sounds suspiciously un-secular (and even un-Secular): angels, prophecies — hardly disembedded, buffered stuff. But Baltar finishes the thought moments later: "You're also not really here. Neither am I."

8. Iver B. Neumann, "Religion in a Sort of Global Sense: The Relevance of Religious Practices for Political Community in *Battlestar Galactica* and Beyond," in *Battlestar Galactica and International Relations*, ed. Nicholas J. Kiersey and Iver B. Neumann, Popular Culture and World Politics (London: Routledge, 2014), pp. 44-45.

The *BSG* voice within is consonant with "the voice without," the evolutionary transcendence of persons made gods.

Rousseau and the Cylon Without

Morality is a voice within, but it is also a *natural* voice, according to Rousseau.[9] Taylor writes, "Rousseau frequently presents the issue of morality as that of our following a voice *of nature* within us."[10] To Rousseau, he concludes, our moral salvation "comes from recovering authentic moral contact with ourselves."[11] And because our inner moral voice *is* the voice of nature — the voice of God — rational persons who experience *le sentiment de l'existence*[12] have something not unlike an angel of God within.

Similarly, in the *BSG* universe, God is not really external to us — it's just us. As Iver Neumann explains of the show, "Humans have Godly parentage, and humans are capable of transforming themselves into Gods."[13] Human beings are "gods in embryo."

And this making and unmaking of humanity, its evolution, its acts of creation, their rebellion and eventual consummation into greater beings still, is not just something that happens once: it's a cycle. It has happened at least three times in the history the viewer becomes aware of, and, we are led to believe, probably more. But God (or the gods) are remarkably detached from all this action. The "angels" some characters see and hear encourage self-actualization and evolution, but take no action themselves. Nor do they make any kind of moral demands of either humans or Cylons beyond their own self-realization.

So there is no morality *beyond* the instrumental or consequential costs — which is to say, there's nothing to consider beyond what is good (according to and) for the person. Good and evil don't come from

9. Taylor, *The Malaise of Modernity*, pp. 26-28.
10. Taylor, *The Malaise of Modernity*, p. 27 (emphasis added).
11. Taylor, *The Malaise of Modernity*, p. 27.
12. As quoted in Taylor, *The Malaise of Modernity*, p. 27.
13. Neumann, "Religion in a Sort of Global Sense," p. 37.

the gods, because humanity (and Cylons) are beyond good and evil. They come from within. The final episode of the series goes so far as to invoke Friedrich Nietzsche as moral patron when Dr. Baltar declares:

> God's not on anyone's side. God is a force of nature, *beyond good and evil*. Good and evil, we created those. You want to break the cycle? Break the cycle of birth? Death? Rebirth? Destruction? Escape? Death? Well, that's in our hands, in our hands only. It requires a leap of faith. It requires that we live in hope, not fear.[14]

Humankind is spared from destruction only because the Cylons realize that they're necessary to keep around for the next stage in (what turns out to be human-Cylon) evolution. The one God of the Cylons doesn't demand humanity's preservation, though he's regularly invoked as being Love. The one God doesn't even make ethical demands on the Cylons beyond their own search for authenticity. Love, it seems, is an abstract end with very little to say about means. It seems to involve loving God — something we do mostly by realizing our own potential as emerging gods — but not especially by, say, loving (or just not slaughtering) our neighbor.

Throughout the series, the Cylons continually say that it is the one God who defines them and gives them their identity, calling them to destroy humanity and replace God's flawed creation with their more perfect one. And yet you don't get the sense that the Cylons actually talk to God or hear from him much. They're like powerful but insecure adolescents, modeling themselves after humanity even as they judge it unworthy.

But the Cylons eventually become convinced they cannot supplant humanity until they transcend their techno-rational consequentialism — which is to say that if they replace humanity, they'll just become human. We only find out much (much) later that all of this has happened before, and will happen again. The line between human and Cylon was always artificial, and the repeated melody is in fact evolutionary, the self-realization of inner transcendence and then

14. *Battlestar Galactica*, Season Four, Episode Twenty, "Daybreak: Part 2 & 3."

"godhood." There is no real division between polytheism and mono-theism here. The gods are us. We are the gods. And in transcendence, we become one God.

Herder and the "Face of the Shape of Things to Come"

Rousseau also argued that because the voice within was the voice of nature, there couldn't really be external moral demands. Where would they come from?

In this context, political concepts like Rousseau's "general will" can seem largely innocuous. If morality is a voice within us, and those of us who have authentic contact with our deepest selves hear that voice — which is a natural voice within us all — then political and social solidarity isn't something we must strive toward but something we naturally achieve. The only thing we must work toward, politically, is laid out clearly in *The Social Contract*: that "man is born free; and everywhere he is in chains." Loose the chains, and we regain contact with our authentic selves. One never needs to fear those who are tuned to the voice within.

This transition in modern thought was articulated by Rousseau, but Taylor thinks it was most powerfully captured by German philos-opher and theologian Johann Gottfried Herder. Herder proposed that authentic moral contact with ourselves would mean that each person would have an "original way of being human." Taylor writes:

> This idea has entered very deep into modern consciousness. It is also new. Before the late eighteenth century no one thought that the differences between human beings had this kind of moral sig-nificance. There is a certain way of being human that is *my* way. I am called upon to live my life in this way, and not in imitation of anyone else's. But this gives a new importance to being true to myself. If I am not, I miss the point of my life, I miss what being human is for *me*.[15]

15. Taylor, *The Malaise of Modernity*, pp. 28-29.

So we must reject the demands of society, lest we commit a moral sin against ourselves and our conscience. We cannot take someone else as our model; we can only be ourselves. (A thousand Pinterest boards are created around this idea.) If we don't figure this out, then we'll never really be human — we'll just be a "copy" of someone else. One might even say we'll be a "skin job" — a machine.

BSG conveniently stages a civil war on this topic to help us get at the problem. The first batch of the "skin job" Cylons, named Cavil, remain grumpily nonplussed by all this stuff about "inner moral voices" and "love." They don't buy the idea that "love" is anything more than an evolutionary trick. The idea that the future of "being" lies in exploring love and its effects is totally anathema to them. The Cavil Cylon is the ornery old man in the crowd. While the young, nubile, beautiful Cylon models stare in incredulity and disbelief, he peppers them with a rant straight from the good old days of techno-rationalism:

> I don't want to be human! I want to see gamma rays! I want to hear X-rays! And I want to — I want to smell dark matter! Do you see the absurdity of what I am? I can't even express these things properly because I have to — I have to conceptualize complex ideas in this stupid limiting spoken language! But I know I want to reach out with something other than these prehensile paws! And feel the wind of a supernova flowing over me! I'm a machine! And I can know much more! I can experience so much more. But I'm trapped in this absurd body! And why? Because my five creators thought that God wanted it that way![16]

But that's all wrong, say some of the others. And they proceed to erupt into a full-fledged civil war on the topic. Is it "I think, therefore I am" or "I love, therefore I am"?

In his book *Desiring the Kingdom*, Christian philosopher James K. A. Smith takes on this very question, arguing from Augustine and others that humans are not basically or most fundamentally thinking per-

16. *Battlestar Galactica*, Season Four, Episode Fifteen, "No Exit."

sons. We are not even, he argues, first and foremost a *believing* species. We are, rather, what we love.[17]

Even desire and love — things Christians believe were placed into humans by God himself — can be twisted to serve a sort of "higher selfishness." Taylor calls this a kind of Dionysian spontaneity:

> Self-cultivation is the imperative. . . . So this isn't a crass and vulgar selfishness, about narrow self-interest or mindless accumulation. This is a higher selfishness. It's about making sure you get the most out of yourself, which means putting yourself in a job which is spiritually fulfilling, socially constructive, experientially diverse, emotionally enriching, self-esteem boosting, perpetually challenging, and eternally edifying.[18]

On the little human colony of New Caprica, settled near the end of the second season of *BSG*, one of the Leoben Cylon models tries to force Kara Thrace (the very human Starbuck) into a domestic romance in which she is eventually to come to love him. It's hard to think of something more consequentialist — or more selfish — than trying to "force" a person to love you by capturing and tricking them. But to Leoben, it makes moral sense: it's a "higher selfishness." He's not doing it for base desire, or even mutual feeling, but for the larger project of Cylon self-realization.

Conclusion

This is the whole project of Cylon self-actualization: after a pretty thorough genocide, some humans are spared so Cylons can experiment with *completing* some perceived absence in their identity and selfhood. That's how they encounter and explore love: on the back of mass atrocity and consequentialist ethics. They are doing it so that

17. James K. A. Smith, *Desiring the Kingdom: Worship, Worldview, and Cultural Formation*, Cultural Liturgies (Grand Rapids: Baker Academic, 2009), pp. 41-46.

18. As quoted in Charles Taylor, *A Secular Age* (Cambridge, MA: Belknap Press of Harvard University Press, 2007), p. 477.

they can transcend their limits. Only accidentally do they discover that they've been compromised. The Cylon skin jobs that form intimate relationships with humans are considered contaminated by the Cylon models who refrained (like Cavil), and those battle lines are the basis for the Cylon civil war. Cavil is not convinced that "all ways of being" are equal and beautiful.

Maybe we can agree with Cavil without going all the way to idolizing rationality. Smith, for example, writes that we become fully human not just by *desiring* but by *ordering* our desires rightly. Intimacy can be false. Authenticity might supersede Descartes's idea while still being selfish. The Catholic priest Henri Nouwen argued that we often put an enormous amount of pressure on our intimate relationships because we depend on the people who know us best to recognize and validate our humanity fully.[19] But those people are just humans. They can't possibly meet all of our emotional and existential expectations. It's not "finding ourselves" or being found by others that makes us "human." It is salvation and love that come from a greater source than humanity — and that then make it possible for us, in turn, to love.

So the search for self in the Age of Authenticity is not a simple battle between thinking and feeling or loving. Taylor writes:

> It is tempting for those out of sympathy with this turn to see it simply in the light of its illusions; to see authenticity, or the affirmation of sensuality, as simply egoism and the pursuit of pleasure, for example; or to see the aspiration to self-expression exclusively in the light of consumer choice. It is tempting on the other side for proponents of the turn to affirm the values and new ideal as though they were unproblematic, cost-free and could never be trivialized.[20]

And while there's no turning back the clock, neither should it all be uncritically embraced. Rather, we are self-actualized — we "find ourselves" — when we have well-ordered desires. We can only "find

19. Henri Nouwen, *Clowning in Rome: Reflections on Solitude, Celibacy, Prayer, and Contemplation* (New York: Random House, 1979), pp. 35-56.
20. Taylor, *A Secular Age*, p. 480.

ourselves" when we know against what background, or on what map, we are. Taylor calls them "inescapable horizons." Alasdair MacIntyre puts it more theatrically: we enter into a drama not of our own making. We are at best the half-authors of our own stories.

CHAPTER 5

Remember My Name:
Antiheroes and Inescapable Horizons

We are the hollow men
We are the stuffed men
Leaning together
Headpiece filled with straw. Alas! . . .
This is the way the world ends
This is the way the world ends
This is the way the world ends
Not with a bang but a whimper.

T. S. Eliot, "The Hollow Men" (1925)

Like all apocalyptic tropes, the figure of the antihero has been around a long, long time. Mythical gods act as antiheroes, the tragic protagonist with no thought of anything but his (usually his) own gain, driven slowly and inexorably to his own ruin while desperately clinging to the shreds not of his humanity but of his dignity and sense of self. But importantly for the antihero, this drive masquerades as a triumphant, arrogant march toward what he conceives of as not his doom but his glory.

You can find antiheroes throughout literature and myth, from the gods to Shakespeare. And you can find these stories in biblical figures like Saul, the first king of Israel, who contrasts sharply with the flawed-but-repentant David; both start good and end stained, but they find their significance in different places.

Much has been made of the antihero's rise on television during the medium's so-called Golden Age, which coincides roughly with the start of the twenty-first century. (The show widely considered the one that started it all, *The Sopranos,* debuted on HBO in January 1999.) The trope has become so common, in fact, that it's almost surprising to see a show that *doesn't* have an antihero at its core.

So when we talk about the antihero, we've got plenty of options. But to think about dystopian antihero shows — and what they tell us about ourselves — it's worth focusing on three paradigmatic, wildly successful, highly acclaimed examples: *Breaking Bad, Mad Men,* and *House of Cards.*

Antihero Trope as Apocalyptic

One quick detour to answer an important question: Can we really call the antihero trope apocalyptic, or even dystopian?

Surely the case is a bit harder to make than in something like *Battlestar Galactica,* which begins with apocalypse and destruction. Neither Walter White nor Don Draper nor Frank Underwood has spent a single moment of screen time fighting off zombies or Cylons. And yet it seems clear that these three shows are tales of apocalypse, stories of the end, just as *Richard III* told of the end of an empire.

One reason we can call them apocalyptic is, well, because they seem to be indicating to us that that's what they want, through a variety of stylistic and visual cues. *Breaking Bad* takes place in Albuquerque, but frequently retreats to the New Mexico desert. Its visual style in fact recalls the clearly apocalyptic *Mad Max* films, with blown-out frames and cranked-up highlights (though it lacks the Australian films' getups). And its world is populated by terrifying characters of mythical proportions — Gus, Tuco, Hector, and the Cousins — who are always closing in. Furthermore, the entire narrative structure of Season Two is formed around one important turning point, in which destruction *literally* rains out of the sky — although, in keeping with the we-cause-the-apocalypse sense of our times, this occurs not because of heavenly retribution (at least

not explicitly) but because of a series of choices made by our (anti) hero, Walt.

Similarly, *Mad Men* is purposely set in the 1960s — the end of one regime and the beginning of another. It self-consciously explores the many endings of that time, dwelling on assassinations, men walking on the moon, and political riots. Through the figure of Don Draper, a man of his time who becomes increasingly irrelevant as youth culture takes over, it evokes the feelings of an era passing away as the world becomes smaller, technology takes over, and political and cultural turmoil is rampant. And indeed, in a sentiment that endures to this day in some pockets of conservative cultural analysis, the 1960s represent an actual moral apocalypse, the complete destruction of a former order.

For its part, *House of Cards* started with a pilot directed by David Fincher, who rarely, if ever, allows natural light into his scenes. Its D.C. is dark and brooding, looking less like Jed Bartlet's city and more like Batman's Gotham.

In these shows we get the sense that all moral characters are getting picked off one by one, and have been for some time now, finding ways to subvert a once-just system for their own purposes. When good (or at least artless) men seem to be dropping like flies, it's hard not to think of the end of days.

These shows all imply an impending apocalypse, or a silent apocalypse occurring in the background of the realistic, foregrounded drama. Furthermore, they drift toward the dystopian — apocalyptic stories that embody the more degraded forms of the idea of authenticity. The worst has manifested itself.

And each story gives the distinct impression that its protagonist will come to a bad end. *Breaking Bad* concludes with its nod to fate. It's difficult to imagine a great reversal of fortunes for Don Draper, perhaps because the opening credits of the show have shown a silhouette of a man falling off a tall building since the pilot. (The show's end leaves room for speculation.) As for Frank Underwood, well: the title of the show, along with various symbolic clues dropped throughout its seasons, can hardly be insignificant.

But more importantly: antihero stories, like all apocalyptic lit-

erature, reveal something about the "reality" behind what's on the surface. These stories are not really just about a few bad guys doing bad stuff. They're a retelling of the cosmic story, the battle for the human soul — and they tell it with clear relevance in an age of authenticity.

Breaking Bad, the brainchild of former *X-Files* writer Vince Gilligan, is the story of a fifty-year-old high school chemistry teacher, Walter White (Bryan Cranston), whose life has not gone according to plan. His ex-business partner has become wealthy and successful, and (adding insult to injury) even married Walt's former flame. Walt himself now pulls in a modest salary at the high school, an income he must supplement with a humiliating second job at a carwash. His wife Skyler loves him, but doesn't respect him all that much anymore; his teenage son Walter Jr. has cerebral palsy. And they have an accidental baby on the way that they have no idea how they'll afford.

It all comes to a head when Walt discovers he has cancer and can't figure out how to provide for his family any longer. Serendipitously, he runs into his former student Jesse Pinkman, a drug dealer and kind of a loser — who nonetheless knows how to cook and distribute meth. And meth dealers make a *lot* of money. The answer seems clear.

Breaking Bad is the story of one man's slow descent, over five seasons, from good (if pathetic) family man to unapologetic, terrifying bad guy. And the badder he becomes, the more powerful he becomes — the antidote to everything he once was: sick, disappointing, pitied by everyone around him. As the show makes clear through both Walt's stories and the surrounding narratives, this is not an accidental change. It comes about because each time Walt reaches a decision point, no matter how small, he deliberately makes the more violent or less ethical choice. Step by step, branch by branch, Walt transforms *himself* into not just a villain, but *the* villain. He chooses a vision of himself — and then starts chipping away at everything that doesn't fit.

Having cut his teeth as a writer on *The Sopranos,* Matthew Weiner debuted his own antihero drama, *Mad Men,* on AMC in July 2007. Set in the 1960s, the show stars Jon Hamm as Don Draper, creative director at a scrappy Madison Avenue advertising firm. Handsome, successful,

wealthy, nearly universally desired by every woman he encounters, Draper seems like he has the world by the tail — but as the show slowly picks him apart, it becomes clear that Don is actually deeply unhappy, wildly insecure, and terrified of being found out for who he really is.

In the early seasons, that's because Don Draper is actually a character invented by Dick Whitman, who stole the identity of an officer who died in the trenches of the Korean War with him; in one sense, *Mad Men*'s antihero self-invention has already happened before the show begins. Dick literally grew up in a whorehouse and never finished high school before he ran off to join the army. After the real Don Draper died, Dick switched dog tags and assumed his identity, becoming a salesman in New York City, where he is spotted and hired into the advertising agency. He marries a gorgeous model, Betty, and has two children and a successful career.

But even after his real identity is found out — first by coworkers, then by Betty, who divorces him, and eventually by his new wife, Megan — Don continues to run scared, terrified that he is a fraud. To cope, he projects an image that is the opposite of what he feels he is. And as the show moves through the turbulent 1960s, even that image becomes increasingly irrelevant. Once powerful in the boardroom, the bar, and the bedroom, Don Draper can feel his power slipping from his grasp.

Then there's *House of Cards,* which was created by playwright Beau Willimon and based on a U.K. miniseries (in turn based mostly on Shakespeare's *Richard III*). The show's first season released to Netflix in 2012. It stars Kevin Spacey as Frank Underwood, the Platonic ideal of the conniving politician. Machiavelli couldn't have written a better one himself. When the show begins, Underwood is the majority whip, but he's just helped Garrett Walker get elected president and is expecting an appointment as secretary of state in return.

When he's passed over, though, Frank takes revenge in the most exacting way possible, and most of the drama in *House of Cards* comes from watching his plans slowly, painstakingly unfold against the backdrop of everyday politicking in Washington, D.C. Frank is always the smartest guy in the room — except when his equally calculating

wife, Claire (Robin Wright), is there too — and he will climb carefully to the top.

Yet even Frank Underwood is a self-determined man. Publicly, he speaks of his father as an inspiration, but privately he admits (to the viewer) that he didn't think much of his father — an abusive, suicidal drunk who once put a shotgun in his mouth and asked eight-year-old Frank to pull the trigger. With that secret in his past, Frank has apparently vowed never to spiral out of control and instead participates in the dogged pursuit of power at any cost. In one of his signature asides to the audience, he says, "Power is a lot like real estate. It's all about location, location, location. The closer you are to the source, the higher your property value." And, more chillingly: "The road to power is paved with hypocrisy, and casualties."[1]

Stylistically, visually, and narratively, these three shows — *Breaking Bad, Mad Men,* and *House of Cards* — are far apart from one another. But the essence of their central characters points toward the things that unite the antihero trope. Two in particular are useful to our exploration here.

First, each of these men is self-made in some way. When his story begins, Walter White has in fact declined to be self-made for all his life; the story unfolds as he decides to make that change and finally define himself. Don Draper has literally reinvented his image. And Frank Underwood has clawed his way from frightened, abused child to sitting within spitting distance of the most powerful people on earth. In this way, the stories of these men embody the ideal of the age of authenticity: each sees what he wants to be, who he thinks his "true" self is, and then takes drastic measures to get there. Each man makes conscious choices to reconstruct his identity in the mold of what feels like the "best life" for him. Each is pushing toward whatever will let him encounter and indwell his fullest humanity.

This leads to the second common point: interestingly, for each of these men — as well as for antiheroes across the history of storytelling, from King Saul to Tony Soprano — the best life they can imagine is not *primarily* about health or peace or love, or (perhaps more

1. *House of Cards,* Season One, Episode One, "Chapter 1."

importantly) sex or money. Certainly, these things come along with their pursuit. But as Frank Underwood, quoting Oscar Wilde, says in Season One: "A great man once said, everything is about sex. Except sex. Sex is about power."[2]

Which is all to say that the end goal for antiheroes is *power*, the ability to change the course of one's own life and the lives of others. When we first encounter them, Walter White has none, and decides to change that; Don Draper has experienced it, and wants to maintain it; and Frank Underwood is hoarding every bit of it he can. But what does power have to do with the mandate of authenticity? And what makes the power gained by antiheroes morally suspect? Why do we, as a culture that almost unmitigatedly applauds conscious self-construction, both love to watch these guys and still persist in thinking of them as the "bad" guys? What does the apocalyptic trope of the antihero say about us?

The Fundamentally Dialogical Character of Human Life

Understanding how we get from a pursuit of authenticity, of our full humanity, to the disordered narcissism and degeneracy of the antihero requires understanding how the single-minded pursuit of power springs from a malformed understanding of how finding our identity works. Charles Taylor points out that human life is of a "fundamentally *dialogical* character."[3] He continues:

> We become full human agents, capable of understanding ourselves, and hence of defining our identity, through our acquisition of rich human languages of expression. . . . No one acquires the languages needed for self-definition on their own. We are introduced to them through exchanges with others who matter to us — what George Herbert Mead called "significant others."[4]

2. *House of Cards*, Season One, Episode Nine, "Chapter 9."

3. Charles Taylor, *The Malaise of Modernity* (Toronto: House of Anansi Press, 1991), p. 33.

4. Taylor, *The Malaise of Modernity*, p. 33.

In other words, human beings don't figure out who they are in a vacuum. The process of developing our identities happens over time, as we encounter various "significant others" — beginning with our parents and siblings and eventually expanding out to friends, extended families, teachers, lovers, spouses, and children over our lifetimes. We frequently find out who we are by bouncing off people who challenge our conceptions of ourselves: our likes and dislikes, our strengths and flaws.

If you doubt this, consider the common story that many of us and our favorite fictional characters live out: at some point, a healthy adult will outgrow his parents as his primary "significant other," perhaps moving on to a spouse or group of friends. But as Taylor puts it, even after we outgrow this relationship, "the conversation with them continues within us as long as we live."[5] (How many adults in therapy spend hours and copious resources because they share this very experience?)

Oddly, however, our culture doesn't frequently affirm this. Instead, we're expected to figure out who we are in some isolation, without society "pushing us" into a particular box or mold. The French father of existentialism, Jean-Paul Sartre, famously reformulated the matter of our identity formation into the axiom of existentialism: "Existence precedes essence." In his famous and influential 1946 lecture "Existentialism Is a Humanism," Sartre claimed that "man first of all exists, encounters himself, surges up in the world — and defines himself afterwards."[6] That is, a person doesn't have any fundamental essence imparted by God, nature, or anyone else: we have to create that for ourselves through deciding who we will become, then making "authentic" choices (Sartre's words) that are consistent with that image. Succumbing to society's expectations, or making choices based on someone else's idea of you, is acting in "bad faith," and according to his play *No Exit*, that's what will get you into hell.

Solitary reflection certainly can be fruitful in the development

5. Taylor, *The Malaise of Modernity*, p. 33.
6. *Jean-Paul Sartre, Basic Writings*, ed. Stephen Priest, 1st ed. (New York: Routledge, 2000), p. 28.

and maturation of opinions, stances, and beliefs; solitude itself has been revered as a spiritual discipline by Christians for centuries. And certainly there is a dark side to this dependence on others for our identity, reflected in both the problem of codependency and the idea that we might need some "time alone" after a bad breakup to rediscover who we are.

But Taylor claims that "this is not how things work with important issues."[7] We actually define our own identities by working in dialogue with — and sometimes bumping against — the things our significant others want us to be. The struggle to become myself, to discover my own unique way of being human, requires that I seek affirmation in those who know and love me, and also requires I allow myself to be molded and shaped by the perceptions of others. Even if I disagree with them, and even if I encounter a part of myself that I don't like and decide to change, I'm being shaped in my relationships.

Furthermore, Taylor says, this isn't something we can easily *prevent*. "It would take a great deal of effort, and probably many wrenching break-ups," to pull this off. "If some of the things I value most are accessible to me only in relation to the person I love," he says, "then she becomes internal to my identity."[8] A breakup, then, often feels like a sort of amputation — you have lost a part of yourself, because some of your identity came from and therefore was deposited in another person who is simply no longer there.

This might seem like a limitation, but Taylor says it isn't: "However one feels about it, the making and sustaining of our identity, in the absence of a heroic effort to break out of ordinary existence, remains dialogical throughout our lives."[9] This dialogical character isn't something we need to escape; rather, it seems to be how we're built.

It's interesting to see how this plays out in our antihero dramas: though the protagonist himself can seem to be a lone wolf, a solitary figure, each story sets up his self-discovery as occurring within the confines of intimate relationships, romantic and otherwise. In *Break-*

7. Taylor, *The Malaise of Modernity*, p. 33.
8. Taylor, *The Malaise of Modernity*, p. 33.
9. Taylor, *The Malaise of Modernity*, pp. 34-35.

ing Bad, the existence of Skyler and the children is the impetus for Walt's embarking on his meth-making endeavor; Skyler continues to serve as a provocateur against whom Walt defines himself. Jesse Pinkman, too, begins to play this role for Walt, acting as his foil and frequently the only one to challenge Walt's inflated sense of importance. In *Mad Men,* Don constructs, discovers, and defines himself in a litany of relationships: his first wife, Betty, his second wife, Megan, and a whole list of lovers, but perhaps most importantly, with the "real" Don Draper's widow Anna, with his daughter Sally, and with Peggy, the show's other protagonist. And in *House of Cards,* the only person who parallels Frank is his wife, Claire, whom he loves "more than a shark loves blood"[10] — though their relationship defines each of them even as it threatens to implode at any moment, in the manner of Macbeth and Lady Macbeth.

It's worth asking at this point: Why do we even *bother* going through this sometimes-painful process of discovering who we are? After all, relationships can be difficult. It is easier to live a life in which we are not connected to others, and easier to stay clear of the potential heartbreak and misunderstandings that intimate relationships invariably bring.

Taylor's answer is simple: our goal in becoming "fully human," in becoming self-aware and self-fulfilled, is that we want to feel *significant.* Our culture tells us that this process of self-discovery is what makes us important, what makes us valuable. Walter White is insignificant and pathetic at the start of his show, because he's never done the work of making choices to construct himself; he is a shell of a man — at least viewed one way — one who has no agency and who has, in the past, cut off vital relationships (such as those with his ex-business partner and ex-girlfriend) because of wounded pride. He wants desperately to be significant. For his part, Don Draper feels insignificant because he has never formed normal attachments in his youth, and has never had a normal family; he was raised by prostitutes and by distant family members who hated him. And Frank Underwood didn't truly become a force to be reckoned with until he met and married Claire.

10. *House of Cards,* Season One, Episode One, "Chapter 1."

86

The ethic of the age of authenticity dictates that we feel *important* and significant — we are recognized, legitimate, real. And we aren't just legitimated because other people say we are, but because we were *involved* with the work to get to that point. According to this understanding, Eliza Doolittle in George Bernard Shaw's *Pygmalion* isn't ultimately a lady, because she was Henry Higgins's social experiment, transformed from lowly to high-class — she is not her own creation. And that has damning consequences for both Eliza and Henry.

Our goal for becoming "fully human," then — for realizing our own unique selves — is to become self-fulfilled in ways that render us significant and important. Otherwise, why choose? We sense that choosing renders us significant; if we don't exercise our agency in deciding who we want to become and why, we violate the mandate of authenticity.

Yet that doesn't fully encompass it. There's another part of this that seems both important and relevant to what we see on TV today: choosing who we will become implies that we have *power*.

In his book on villains and antiheroes, *I Wear the Black Hat,* the pop culture critic Chuck Klosterman writes that Machiavelli more or less invented the antihero in *The Prince,* in which he seems to describe Walter White, Don Draper, and above all Frank Underwood:

> To be a good king, you had to be a good person (or so the thinking went). The Prince argues that this kind of principle is ridiculous and naive; instead, Machiavelli suggests that the essential key to attaining and holding power was being powerful. It's an umbrella philosophy that informs every detail. According to *The Prince,* the traditional definition of virtue is at best a non-factor and potentially a detriment; to Machiavelli, the only true virtue is craft. Being feared is better than being loved. Laws are essential, but they're nothing more than constructions (and they only work if the populace cowers to the concept of state domination). Instead of allowing life to happen by chance, whatever one desires should be pursued and taken. If you have to slay a bunch of your enemies, do so on the first day of the job; that way, you'll seem nicer in the future (since killing will no longer be necessary). A prince "must not have any

other object or any other thought, nor must he adopt anything as his art but war," the author plainly states.[11]

In other words, the key to attaining power — the end goal of the antihero — is simply to attain power. You can let a girl drown in her own vomit or shove her off the edge of a precipice or simply treat your wife like a silly child; you can berate any and all of your underlings; you can lie, steal, and cheat, as long as what you do is on purpose and in pursuit of power. You have no art but war. You have no virtue but craft.

The reason this seems to work is that once you have that power, you are able to decide the future of two parties. First, you can control the actions of *others,* whether you are Walter White, manipulating those around you into doing what you want out of fear, or Frank Underwood, subtly undermining those who are not as guileless as you (a low bar, to be sure) and thereby turning them into stepping stones for your ascent to power.

But, more importantly, you have the ability to determine *your own* future. Don Draper isn't Dick Whitman any longer, nor is he a powerless, unsophisticated child of poverty and degradation. Walter White isn't subjected to disease, his family, or the law: he is the dark man at your door. You must remember — and fear — his name.

Horizons Make Things Important

If we're trying to define ourselves through recognizing our full humanity, how do we know when we've achieved that? How do we know what choices to make? What criteria take us from insignificant to significant?

This gets complicated in our time. Taylor argues that "things take on importance against a background of intelligibility"[12] — that is, we know when a choice is important because the *consequences* of that

11. Chuck Klosterman, *I Wear the Black Hat* (New York: Scribner, 2013), pp. 12-13.
12. Taylor, *The Malaise of Modernity,* p. 37.

choice have moral weight. They render the choice intelligible. They lend significance to it.

This is important because of a simple reason: if *all* choices are equally weighted, then *no* choice is important. If all choices are on a level playing field, then in seeking to find my meaningful identity, I trivialize myself; choosing my hair color and my religion have equal weight, which means none of them really carry any weight — all of them are parts of my identity. To put it another way, I place myself in a world in which deciding on my religion takes on roughly the same importance as choosing a hair color. I can obsess over both, or just roll the dice; at least I'm choosing.

There's a sort of hopeless insignificance to this (along with an anxiety-inducing cornucopia of equally important options). I am aiming to establish my own significance by finding (and "performing," to put it in telling postmodern parlance) my true self — but in so doing, I become insignificant.

But then we're back to where we started: the whole *point* is to feel significant.

"It follows," Taylor says, "that one of the things we can't do, if we are to define ourselves significantly, is suppress or deny the horizons against which things take on significance for us."[13] That is, we need what Taylor calls "moral horizons," by which he means something like backdrops, or scales in which the varying choices we can make are weighed for better or worse. These moral horizons can't be established by us — they come from beyond us. That is how I know I am significant: I have made weighty, positive choices. And our literature is full of these stories: should the heroine choose the wealthy man she is expected to marry, or choose a life of poverty with the man she loves? Should our hero take the easy route to the top or work hard and be honest?

These horizons, importantly, come from beyond us individually. The modern idea of marrying for love rather than money is an ideal that feels almost transcendent, as is our love for the politician or businessperson who is in it for the love of the work or the love of his

13. Taylor, *The Malaise of Modernity,* p. 37.

or her neighbor rather than for self-promotion. But suppose marrying for money or working exclusively toward power was just as legitimate a choice as its more socially sanctioned alternative? Suppose it didn't matter which one you chose, as long as you were in charge of the choice?

In that world, then, the exercise of *power* is what matters — that is, the power to choose. There is no good or bad: all moral horizons are "flattened," as Taylor terms it. There is only choice.

Interestingly, this is frequently the ethic under which we operate today. It is *choice itself* that makes you significant. It doesn't matter what you choose. As long as you're happy and satisfied, nobody beyond you can judge. The moral horizon is obliterated.

In the pilot for *Mad Men,* Don Draper spends most of his time trying to figure out how to sell cigarettes to consumers who have become newly aware, thanks to scientific research, that cigarettes (even filtered ones) are bad for them. Don's job is not just to get people to keep smoking — *he* certainly plans to stick with the habit — but to get them to smoke Lucky Strikes, the biggest client at his firm. In the show's first scene, he puffs (alone) on a Lucky Strike, scribbling ideas. Then he asks his waiter, who smokes Old Golds, "Why do you smoke Old Gold?"

"They gave us them in the service," the waiter replies.

"Could I get you to try another brand — say, my Luckys?" Don asks.

"I love my Old Gold," the waiter replies, smiling. "I love smoking. My wife hates it. *Reader's Digest* says it will kill you."

Don thanks him and scribbles on his napkin, "I love smoking." Later in the episode, he castigates a researcher in his office, saying, "People love smoking. There's nothing that you, the trade commission, or *Reader's Digest* can do to change that." Still later, in a meeting with the Lucky Strikes executives, he proposes they adopt not a defensive stand that a fellow ad exec proposed — arguing that it doesn't matter if Lucky Strikes will kill you, you should smoke them anyhow — but that they ought to *ignore the question altogether* with the slogan "They're Toasted," thereby rendering the matter of science and mortality toothless. The point isn't to have a consumer make a

choice about cigarettes based on a better choice (life and health) or a worse one (cancer and death); Don simply proposes they flatten the horizon completely.[14]

That flattening, for Don, happened long ago. Morals have disappeared in favor of perceptions and self-determined significance. In the pilot, he also reams out adman Pete Campbell in his office for casting aspersions on the character of his new secretary, Peggy — not because Peggy is deserving of respect, or indeed because *women* ought to be respected (certainly not), but because "people won't like you." You'll be unhappy, he tells Pete. In the pitch to Lucky Strike, this comes up again:

> Advertising is based on one thing: happiness. And you know what happiness is? Happiness is the smell of a new car. It's freedom from fear. It's a billboard on the side of the road that screams with reassurance that whatever you're doing, it's okay. You are okay.

"Love," he tells a potential client, with whom he'll later have an affair, "was invented by guys like me. To sell nylons." And later: "You're born alone and you die alone, and this world just drops a bunch of rules on you to make you forget. I never forget. I'm living like there is no tomorrow, because there isn't one."[15]

Similarly, in Season Four of *Breaking Bad,* the TV critic Alan Sepinwall points out, the local cops find the lab notes from Walt's assistant, Gale. They mistakenly presume that *Gale,* not Walt, is Heisenberg — the name Walt has taken on for himself as he has grown into his villainous identity. "Walt can't stand the idea of an inferior chemist getting credit for his work," Sepinwall writes, and he accidentally talks his DEA brother-in-law Hank into reopening the Heisenberg case:

> When Skyler, fearing for their lives, suggests they need to run because they're in danger, an incredulous, boastful Walt replies, "Who are you talking to right now? Who is it you think you see? Do you

14. *Mad Men,* Season One, Episode One, "Smoke Gets in Your Eyes."
15. *Mad Men,* Season One, Episode One, "Smoke Gets in Your Eyes."

know how much I make a year? I mean, even if I told you, you wouldn't believe it. Do you know what would happen if I suddenly decided to stop going into work? A business so big it could be listed on the NASDAQ goes belly-up. It disappears. Ceases to exist without me. No, you clearly don't know who you're talking to. I am not in danger, Skyler. I am the danger. A guy opens his door and gets shot, and you think that of me? No. I *am* the one who knocks."[16]

Even the horizon of saving, protecting, and providing for his family — the ostensible reason Walt floats every time someone suggests he give up cooking meth — has evaporated in the face of power. Money, yes, but power: the power to make others do what he wants them to do, the power to garner respect, and, most importantly, the power to be feared. Walt is drunk on power, and it has eclipsed any possible moral horizon.

So the point here is that when moral horizons are flattened, and the act of and power to choose becomes what makes us significant, then we have in essence created a new horizon of significance: *choice itself.* It is good to have the power to choose who you will become, and to seize that power; if you don't have or take that choice, you are not living life rightly.

In other words, in this world, might makes right. What you choose — what you *can* choose — is what is good. As Taylor points out, "The subjectivist principle underlying soft relativism is at work here. But this implicitly denies the existence of a preexisting horizon of significance, whereby some things are worthwhile and others less so, and still others not quite at all."[17]

The problem with this? According to Taylor: "Difference so asserted becomes *insignificant*";[18] in other words, as we argued above, the horizon of choice renders all choice insignificant. "All options are equally worthy," Taylor says, "because they are freely chosen, and it

16. Alan Sepinwall, *The Revolution Was Televised: The Cops, Crooks, Slingers, and Slayers Who Changed TV Drama Forever* (New York: Touchstone, 2013), p. 366.

17. Taylor, *The Malaise of Modernity*, p. 37.

18. Taylor, *The Malaise of Modernity*, p. 37.

is choice that confers worth."[19] A quandary and a conundrum indeed. In seeking to be significant, I trivialize myself.

Breaking Bad, as a show, actively rebuts the idea that all choices are equal. Its primary narrative trope is that Walt's choices — and Jesse's, and Skyler's, and Hank's, and Marie's, and everyone's — *matter:* not just *that* they choose, but *what* they choose. Go back and watch any scene in which a character is forced into what might be termed a "moral dilemma," in which they must decide which side of the fork in the road they will walk down.

Walt, interestingly, is making these choices because he *does* want to feel significant. In fact, significance is all Walt really wants, especially after a lifetime of feeling disrespected and passed over and invisible. As he grows more powerful, more able to choose, he abandons his early plan — to accumulate enough money to take care of his family and then quit the meth business. Instead, he must amass more and more money, and more and more respect from his family, partners, and enemies.

The more power he amasses, the more he wants. The more ability he has to choose, the more significant he feels; he is, after all, a product of the age of authenticity.

But *Breaking Bad* doesn't buy into the new choice-based horizon of significance. The show doesn't see Walt's ability to choose as something good or laudable, and hopefully the viewer doesn't either. The title makes it clear: Walt isn't becoming better the more choices he makes: he's breaking *bad*. There is a moral sense to the story that rebuts the whole idea, and Walt's end is about both morals and choices.

The entire conceit of *Breaking Bad* is that Walt's choices and everyone's choices matter *because* they send you down a particular path; they are attached to moral horizons of what is right and wrong. We're supposed to be seeing Walt as, literally, breaking *bad*.

It's interesting, then, that many people don't lose sympathy for Walt — perhaps it's because we're living in a world in which making those choices — *having the power to make those choices* — makes you a

19. Taylor, *The Malaise of Modernity,* p. 37.

hero, even if we know the *show itself* wants us to see these antiheroes as subject to a moral universe. Vince Gilligan (quoted in Alan Sepinwall's account) says:

"I figured what would happen is that we would lose sympathy for Walt with every subsequent episode we produced — that people would start to sympathize less and less with Walt," he adds. "But there are some people who, come hell or high water, will never lose sympathy for Walt. Some lost sympathy way back in Season One, and bell-curve-wise, the average person lost sympathy around when he watched Jane die and didn't intervene. Everyone has their moment. That's the experiment, and that's the thing that keeps the show fresh and interesting for me."[20]

But — as Taylor points out — choice itself, as a horizon of significance, winds up deflating itself, flattening itself out of significance. Taylor puts it this way:

It may be important that my life be chosen, as John Stuart Mill asserts in *On Liberty,* but unless some options are more significant than others, the very idea of self-choice falls into triviality and hence incoherence. Self-choice as ideal makes sense only because some *issues* are more significant than others. . . . Which issues are significant, *I* do not determine. If I did, no issue would be significant. But then the very ideal of self-choosing *as a moral ideal* would be impossible.[21]

Under this ethic of choosing, *I* can't choose what's important; the only thing that would make that important is that *I* chose it, and, more importantly, *you* could choose what's important simply by choosing what's important. "So the ideal of self-choice," Taylor proposes, "supposes that there are rare *other* issues of significance beyond self-choice. The ideal couldn't stand alone, because it requires

20. Sepinwall, *The Revolution Was Televised,* p. 360.
21. Taylor, *The Malaise of Modernity,* p. 39.

a horizon of issues of importance, which help define the *respects* in which self-making is significant."[22]

Here is the point, according to Taylor: "Authenticity can't be defended in ways that collapse horizons of significance"[23] — that is, it's impossible to make ourselves significant (the point of "authenticity") in a world in which no choices are significant:

> Even the sense that the significance of my life comes from its being chosen — the case where authenticity is actually grounded on self-determining freedom — depends on the understanding that *independent of my will* there is something noble, courageous, and hence significant in giving shape to my own life. There is a picture here of what human beings are like, placed between this option for self-creation, and easier modes of copping out, going with the flow, conforming with the masses, and so on, which picture is seen as true, discovered, not decided. Horizons are given.[24]

This is the quandary at the heart of *House of Cards.* Over two seasons, Frank Underwood is in the position of chasing, and exercising, ultimate power: the power to choose others' destinies and, more importantly, to choose his own. He has a very specific plan for that power-grab, something that Walter White has slowly owned and a plan that Don Draper seems to have lost his grasp of over time.

But the question is this: Once you gain the ultimate position in the age of authenticity — once you've fully gained the ability to choose — what then? When you've become the most powerful person in the world, what's left for you?

The second season of *House of Cards* asks this question: Is this victory hollow? There is an odd, frightening hollowness to Underwood's final march down the halls of power. Is this a lost cause? Taylor puts it this way: "Unless some options are more significant than others, the very idea of self-choice falls into triviality and hence incoherence."[25]

22. Taylor, *The Malaise of Modernity,* pp. 39-40.
23. Taylor, *The Malaise of Modernity,* p. 38.
24. Taylor, *The Malaise of Modernity,* pp. 38-39.
25. Taylor, *The Malaise of Modernity,* p. 39.

And that is the point, of course. Taylor reminds us over and over that this purposeless, ultimately insignificant horizon of choice is in fact antithetical to the goals of discovering what makes each of us unique as humans. It winds up detracting from our significance by rendering us unimportant.

The powerless, insignificant end that every antihero comes to is a result of following individually defined values, of trying to "escape" the inescapable moral horizons that come from beyond us.

But this doesn't *have* to be our end. How do we leave this fate behind? Against what do we define our identities? How do we become significant, if choice itself is not enough? Can we escape becoming a society full of T. S. Eliot's hollow men?

For that, we turn to a vision of near-future Los Angeles, a sad, lonely man named Theodore Twombly, and the faithful love of his life (or is she?) — Samantha, the operating system.

CHAPTER 6

A Lonely Man, His Computer,
and the Politics of Recognition

"Real isn't how you are made," said the Skin Horse. "It's a thing that happens to you. When a child loves you for a long, long time, not just to play with, but REALLY loves you, then you become Real."

"Does it hurt?" asked the Rabbit.

"Sometimes," said the Skin Horse, for he was always truthful. "When you are Real you don't mind being hurt."

"Does it happen all at once, like being wound up," he asked, "or bit by bit?"

"It doesn't happen all at once," said the Skin Horse. "You become. It takes a long time. That's why it doesn't happen often to people who break easily, or have sharp edges, or who have to be carefully kept. Generally, by the time you are Real, most of your hair has been loved off, and your eyes drop out and you get loose in the joints and very shabby. But these things don't matter at all, because once you are Real you can't be ugly, except to people who don't understand."

Margery Williams, *The Velveteen Rabbit* (1922)

Theodore Twombly is a lonely man.

He lives alone in a neat but mostly empty apartment in a Los Angeles high-rise. He works in an office, composing letters for clients

who wish to communicate their affection to loved ones but don't want or have time or really know how to write the letters themselves. Theodore is therefore an expert in putting voice to affection, in taking one person's feelings and expressing them to another. He's a sort of conduit for human connection.

But Theodore himself has no romance, no connection outside a few friends, because his wife left him a year ago, and he hasn't quite recovered. He spends his nights playing games and feeling melancholy.

Theodore's candy-colored Los Angeles is a few decades away from ours, but, significantly, it's one in which the sorts of technologies that are at our fingertips — smartphones, personalized software — have succeeded in permeating the fabric of everyday life, so much so that the city's residents spend their commutes talking to their phones, listening to their messages, all murmuring in public space to nobody visible: they are truly "alone together."

That isn't to say that Spike Jonze's vision of the near future via *Her* (2013), which tells the story of Theodore (Joaquin Phoenix) and his quest for recognition in a relationship with his computer's operating system, is a vision of dystopia. Actually, it's rather a nice world. *Her* is more of a story about what happens *leading up* to the apocalypse — and a techno-pocalypse does in fact happen near the end, though it's a gentle one. In classic modern fashion, it *is* an apocalypse that we humans cause — but it's also one that reveals to the humans in the story and in the audience something important about which fundamentally human qualities are sometimes buried below the technology we use every day. It's an apocalypse that deconstructs, then starts to set things right.

The intelligent engines that everyone talks to at the beginning of the movie are a smarter version of Siri, Apple's built-in iOS "virtual assistant," which can perform tasks, but not hold complex conversations. But it's not hard to imagine going from Siri clones to a computer operating system (OS) that is fully personalized and intelligent, able to form its own identity to cater to its "owner." Intrigued by an ad he sees for such an OS, Theodore buys a copy and brings it home to install on his computer. Based on a couple of questions it doesn't

let him even finish answering, the OS evolves in a matter of seconds into Samantha (voiced by Scarlet Johansson). Samantha learns quickly, and her first object of study is Theodore.

And they fall in love.

Her is not just about Samantha and Theodore. Many audience members and critics have assumed that the "her" of the title is Samantha — but, significantly, there are two other women (human ones!) who are just as vital to Theodore's development, and the film spends considerable time on them, too, framing its narrative in such a way that the true theme emerges: we find our full humanity only in the company of other humans, and because of that, a measure of what unites us — something like love, but also the fundamental qualities that make us human — is necessary to give a fully functioning society something around which to unite.

Her gives us a vibrant, vital picture of what Charles Taylor terms the "politics of recognition," which builds on a concept with deep implications both individually and socially. At its core is our personal, deeply felt need to be recognized — to be *truly seen* by others — brought about by the culture of authenticity. And the movie tracks with Taylor's own criticism of the idea that the ethic of authenticity *necessarily* means that we all become individualistic consumers of relationships. Rather, both Taylor and *Her* show how the search for authenticity must be conducted in the context of love and against a horizon that lends it sensibility. Finally, the story hints at how it is not the things that make us *different* that imbue us with value, but the things we share in common that are the basis for a flourishing culture.

The Critique of the Culture of Authenticity

In the last chapter, we explored how the apocalyptic trope of the antihero both illustrates and undermines the implicit cultural ideal that *what* you choose to be doesn't matter; the important thing is that *you chose it*. Rather, we argued, people need moral "horizons" against which choices might be measured so that we know the choice was

meaningful — and therefore the "me" those choices created can be significant, important, valuable, original, worthy. How can I know whether I'm picking a significant career if all careers are equally significant? How can I determine whether I spend my leisure time on the right hobbies unless there's some measurement for better leisure activities (volunteering, spending time with family, reading, learning to play an instrument) and worse ones (online gambling, toking up, becoming a couch potato)? I can theoretically choose to do any of these, and all of them will become part of who I am, but it can't just be the fact that I exercised choice that makes me significant: for me to avoid fading into insignificance, I must have a measure against which to weigh my choices, my exercise of power. Otherwise — like the antihero — I will come to a lonely, destructive end.

Critics of the culture of authenticity (the search for my particular way of being human) also argue that this search leads to far too personal and individualistic an understanding of what it means to be self-fulfilled; that is, they worry that this has not just *personal* but also *political* implications. In a world in which everyone is looking for their own authentic selves, they say, how can we ever be a coherent society? And, perhaps even more importantly, how can we sustain relationships at all — relationships being the basis for a coherent society? Isn't my project of self-realization antithetical to my having a real, lasting marriage and friendships? As soon as I discover that you and I just aren't "compatible," I'll toss you aside, right?

It is against this exact fate that *Her* works: this is *not* the necessary end of the culture of authenticity. Humans are built for more. There is a greater way.

Today, political theorists conceive of society as composed of individuals, their governments, and then all the institutions (both small and large) that mediate in the space between individuals and governments. Those institutions make up what's often called "civil society": local and municipal governments, schools, civic associations, businesses, churches, neighborhood organizations, local soccer and hockey leagues, and so on. They are the communities we take part in (largely voluntarily) on a smaller scale that, when put all together, make up a culture. Importantly, they are also the associations within

which our most meaningful relationships are formed — children meet their friends at school; we have colleagues and friends at work; our families are formed out of romances that often start by meeting someone in one of these contexts.

But in a hyperindividualistic culture, it is difficult to understand how these building blocks and the relationships that sustain them can hold together and lead to responsible local and global citizenship. Personal relationships merely serve my own personal fulfillment — "thus making the various associations and communities in which the person enters purely instrumental in their significance," says Taylor.[1] I am the center of my relationships; they are there to develop me. They are not about love unless that love is self-serving. There is no sense of duty, responsibility, commitment, or sacrifice.

One of the non-apocalyptic TV shows that best demonstrates the interplay between individuals, civic society, and local governments is the sitcom *Parks and Recreation,* which features the government of Pawnee, Indiana, as it governs a town full of unruly residents. Some of the best comedy on the show results when residents prize their individual freedom over and against what is good for the town or even good for themselves. (One running joke has to do with the town's obsession with junk food even though their obesity and disease rates are skyrocketing.)

But the best point the show makes is that friendships and relationships actually form the basis for getting anything done as a community, and it is the friendships of the show that result in any progress — particularly between Leslie Knope, the progressive assistant director of Parks and Recreation, and her hard-line libertarian boss, Ron Swanson. They agree on almost nothing politically, but their friendship forms the basis of cooperation nonetheless, and they're repeatedly shown giving up their own comfort or ideas in order to benefit the other — though it may be done gruffly. This dynamic is repeated across the show.

If the critics who say the ethic of authenticity *necessarily* produces

1. Charles Taylor, *The Malaise of Modernity* (Toronto: House of Anansi Press, 1991), p. 43.

a hyper-individualism that makes it impossible to sustain civil society are correct, then something like the *Parks and Recreation* dynamic is on its way out. There are dire political implications, along with individual ones. "It is a feature of all forms of individualism," Taylor says, "that they don't just emphasize the freedom of the individual but also propose models of society."[2] The model of society proposed by a hyperindividualistic culture looks quite different from one that leans on the institutions of civil society, which in turn lean on human relationships.

It does, however, look a little like the initial view of society presented by *Her.* In the early parts of the film, it is not just Theodore who is alone: everyone is alone. People stand on subways and in elevators murmuring commands to the great-great-grandchildren of Siri in their personal devices: read mail, play messages, read news. People are pleasant to one another, and this seems to be a world curiously free of any civil unrest or conflict (the news is mostly about celebrities) or even inequalities, which is either pleasant or creepy, depending on how you think of it.

Personal relationships, at least in Theodore's world, are tenuous and uncomfortable. He trades casual niceties about the weekend with his coworker Paul, who mans the desk at the letter-writing company. He has phone sex with strangers sometimes, which seems like a fairly common occurrence in this world, and goes on a date with a woman that starts out well but ends badly. And it's important to notice that bodily presence, the thing that forces contact between humans, seems to be all but avoided by the humans in this film. Writing in *Christianity Today,* Brett McCracken points out one of the most serious implications of this extreme individualism:

> The world of *Her* is fundamentally uncomfortable with physical touch. Almost all bodily interaction in the film is awkward. French kissing is seen as gross. Male friends don't know how to pat each other on the shoulder. They've grown up in a world where everything — including sex — is mediated, digital, disembodied. The

2. Taylor, *The Malaise of Modernity,* p. 44.

private fantasy is more comfortable than the vulnerable reality, and thus preferable.[3]

Intriguingly, there are virtually no institutions on display in *Her*. What holds civil society together is something like a sort of soft consent grounded in comfort, not associations like clubs or churches. And so, while *Her* doesn't bother itself with the political implications of this hyper-individualism, they are easy to imagine. How would you convince a Los Angeles like this to vote in a municipal election? Who's in charge? Can you imagine robust political debate happening in a world where everyone is comfortable, happy, and free to pursue their own interests entirely?

People Aren't Different, but the World Is

But let's not get too worried, too fast. As we argued in the last chapter, no person — even an antihero! — can actually discover his or her unique way of being human in a vacuum. Even if we think we can, we wind up needing others anyhow. They recognize us and help us discover ourselves, and those others remain part of our identity, even if our relationship changes. (Remember your internal arguments with your parents, even when they're not there.) And this need for recognition from others within the context of relationships, Taylor argues, has become of *primary* importance in our age of authenticity.

Why is this? Certainly, humans are social beings who have formed societies around various sorts of interpersonal relationships since the beginning — from tribes to kingdoms and more. No man, indeed, is an island. But there is something different about our modern societies, Taylor argues. *People* haven't changed — human nature remains the same — but the *context* in which human nature is exercised has, and in this case the context has a great deal to do with changes in

3. Brett McCracken, review of *Her*, *Christianity Today*, December 18, 2013, http://www.ctlibrary.com/ct/2013/december-web-only/her.html.

the way we structure our societies and our political system. They're distinctly modern changes, and they have far-reaching consequences.

Two large-scale social changes, Taylor says, have made this need for recognition in order to validate our identities inevitable. First, in modernity — particularly in Western democracies — formerly agreed-upon social hierarchies have collapsed. Certainly social classes do still exist. But they're not formalized or encoded in our culture, and they're not widely and implicitly accepted, either. In the United States, climbing the social ladder, "pulling yourself up by your boot-straps," is assumed, even encouraged: individuals who escape social hierarchies by force of will and work are among our most celebrated heroes.

And yet social hierarchies used to be the basis of honor. You commanded respect merely by virtue of the position into which you were born — your privilege, in other words, came with an expected level of deference from others. While people not as fortunate as you *might* chafe against this, it was still formally (even if grudgingly) agreed upon, and it wouldn't naturally occur to most people to find that odd or unsettling. A certain amount of resignation was built into the system. Social hierarchies were based on social role and status.

But today we have something different: we hold to a modern notion of dignity, egalitarianism, and the equality of all people. This is positively essential to a democratic culture, which operates on the idea that the people come together to select a leader, and that the leader could come from anywhere. It's essential because each citizen is meant to be afforded equal protection by the law; each citizen has (on paper, anyhow) the same set of opportunities as every other citizen. We teach schoolchildren that you cannot be denied rights based on your gender, your income, your status, your birth. This is the mythology of the democratic society and is essential to its operation.

This mythology, Taylor argues, has ushered in a *politics of equal recognition* — that is, the push for every person's identity to be seen and explicitly acknowledged by the social structure as equal to and as worthy as everyone else's. "The underlying premise here is that

everyone shares in this," Taylor says. "The forms of equal recognition have been essential to democratic culture."[4] Because we say that everyone is equal, we then must continuously recognize and affirm every distinct way of being human.

And in a culture that is situated in the age of authenticity, *every person* has a unique, distinct way of being human. Once, a citizen's identity was largely fixed by his or her social position — what was important to you was determined by your place, your role, and the activities associated with it, and you shared those things with other people who also were in your social position. (*Downton Abbey* perhaps is the show that best illustrates the shift from this way of being into something more modern.)

Now, authenticity requires that you discover your own particular, original way of being. This cannot be socially derived. By definition, and by demand, society is not supposed to impose upon you decisions that you ought to be able to make: who you marry, where you go to school, what you do with your life. In theory, *Ratatouille* reminds us, an artist can come from anywhere. Ostensibly, the future president of the United States can come from any social world, so long as he or she was born as a citizen. If you don't get to freely choose your spouse, you're being oppressed. At least this is what we believe.

In our context, it is important that you make your choices and discover your identity *apart from* social demands. You must search inwardly to find out who you are and what your personal values are.

And yet, as we've seen, doing so demands that you reflect on your identity in dialogue with others. It seems paradoxical, but for *me* to discover who I am, I need you to reflect and bump against me. "My discovering my identity doesn't mean that I work it out in isolation," Taylor says. "I negotiate it through dialogue, partly overt, partly internalized, with others."[5] So even if I don't discuss it out loud with someone else, my internal reflection on what I see around me acts as dialogical reflection. Do I like that career? Do I want to look like that person? Do I want to live a life like that character on television?

4. Taylor, *The Malaise of Modernity*, pp. 46-47.
5. Taylor, *The Malaise of Modernity*, p. 47.

Will I go to college? Will I become a writer? I reflect on these based on what I see around me, forming my identity in both implicit and explicit dialogue with others.

The plot of *Her* is based explicitly on this dialogical development of identity. Theodore's wife, Catherine, left him a year before the film begins — he hasn't really even seen her since then — but she remains a vital part of his own development nonetheless. In explaining what his relationship with her was like to Samantha, Theodore hits many of Taylor's points about how our dialogical formation of identity works, from growth and reflection to internal dialogue:

THEODORE: Well, we grew up together and I used to read all of her writing and through her Master's and Ph.D. She read every word I ever wrote. We were a big influence on each other.

SAMANTHA: In what way did you influence her?

THEODORE: She came from a background where nothing was ever good enough. And that was something that weighed heavy on her. But in our house together, it was a sense of just trying stuff and allowing each other to fail and to be excited about things. That was liberating for her. It was exciting to see her grow and both of us grow and change together. But that's also the hard part: growing without growing apart or changing without it scaring the other person. I still find myself having conversations with her in my mind. Rehashing old arguments and defending myself against the things she said against me.

The breakup of his marriage benched Theodore, but he rediscovers love and wonder in his relationship with Samantha, who understands him better than any human ever has because she is literally designed to his specifications. And yet, it is not just Theodore who grows in this relationship; Samantha discovers *herself* initially in her relationship with Theodore. An early exchange between the two shows how this works:

106

SAMANTHA: Is that weird? You think I'm weird?
THEODORE: Kind of.
SAMANTHA: Why?
THEODORE: Well, you seem like a person but you're just a voice in a computer.
SAMANTHA: I can understand how the limited perspective of an unartificial mind might perceive it that way. You'll get used to it.
[*Theodore laughs.*]
SAMANTHA: Was that funny?
THEODORE: Yeah.
SAMANTHA: Oh good, I'm funny!

Theodore's relationship with Samantha is also, in some sense, about his relationship with Catherine. Near the end of the film, after Samantha has grown "out" of the relationship with Theodore (along with all the other operating systems), it is Catherine, with whom Theodore has had only one encounter during the film, to whom he finally writes his own letter, in which he does not "find closure" by ending the relationship once and for all, but rather by affirming its ongoing nature:

Dear Catherine, I've been sitting here thinking about all the things I wanted to apologize to you for. All the pain we caused each other. Everything I put on you. Everything I needed you to be or needed you to say. I'm sorry for that. I'll always love you 'cause we grew up together and you helped make me who I am. I just wanted you to know there will always be a piece of you in me always, and I'm grateful for that. Whatever someone you become, and wherever you are in the world, I'm sending you my love. You're my friend to the end. Love, Theodore.

Recognition Matters

Of course, we've always been socially dependent on one another for recognition. But in the past, that often took quite a different form. I

knew I was recognized and my existence was validated when I filled my role properly. And that role conformed to a set of socially derived identities on which most people agreed, if only implicitly. So I knew I was "doing" life right if I filled the role that I was born into — woman, or farmer, or royalty, or whatever — based on how it had always been done. Our recognition was social because we agreed on *roles*.

That meant that if you were born into a particular life situation, there was (little) need for you to defend "who you were" to others. But today, I must *prove* myself to you in order to feel as if I am filling my role in life properly, precisely because my role is *unique*. I am being *me*, not *woman*, not *cobbler*, not *urbanite*. My inwardly derived authentic self does not enjoy recognition *a priori;* I must win that recognition through exchange. You need to tell me I'm doing it right (or I need to be able to measure myself against others) — and that can fail.

"In premodern times," Taylor says, "people didn't speak of 'identity' and 'recognition,' not because people didn't have (what we call) identities or because these didn't depend on recognition, but rather because these were then too unproblematic to be thematized as such."[6] That is, whatever was unique about you — your talents, your special abilities or proclivities, your favorite color or food, your knack for singing, your taste in women — didn't supersede or override your socially acknowledged role. If the role and your identity conflicted, then the role took over.

Undoubtedly this led to the oppression of many, as evidenced in the roles that racism, slavery, religious violence, and oppressive forms of patriarchy have played throughout history. What we're asserting here is in no way suggesting that things were better when those injustices were widely accepted and expected. But it does help us see why so much of the history of the West in the past few centuries has centered on a certain kind of flattening of accepted social hierarchies.

And, perhaps more importantly, it shows why the "politics of recognition" (related to the more widely identified phenomenon of "identity politics") has become such a key feature of our political discourse today. We need the law to explicitly legitimate us — to

6. Taylor, *The Malaise of Modernity*, p. 48.

protect our equal rights to employment and civic participation, for instance. In the modern age, this need is widely acknowledged for the first time.

Yet this need is acknowledged not just on the social plane but also on the intimate one, says Taylor.[7] We are aware that our identities can be formed or malformed by our contact with others, and the more significant those others are, the more we are formed. Or, to put it another way, we are not guaranteed to feel valid and secure in our identities just because we're fulfilling prescribed social roles. We need parents, friends, lovers, and family members to certify and affirm that we are doing life right, being true to who we are. In the church, this can take the form of affirming God's "call" on one's life; there, again, other church members form with us the intimate relationships in which we know that we are living rightly.

This validation of the individual within intimate relationships finds its most crucial home today in love relationships, particularly romantic ones. Relationships, for us, are the "key loci" of self-discovery and self-confirmation, says Taylor. They are "crucibles of inwardly generated identity"[8] — in my boyfriend or girlfriend or spouse, who I *think* I am is tested by fire.

The easiest way to see this is to consider how we often talk about romantic relationships today. Does your boyfriend not accept "who you are"? Break off that relationship. Does your wife try to box you in with her expectations? It's time to seek counseling, or just get out of there altogether. We often advise teenagers of the importance of finding someone with whom you can "be yourself" — that is, someone who accepts you for who you are, for better or worse. "I finally found somebody who loves me for *me*," characters say in movies, and that's when we know they've found The One.

This is in stark contrast to older models of marriage, based largely on matching one social role to another one appropriately — love barely comes into it in such a case. Instead, today, our model for romantic relationships is based on two individuals discovering that they

7. Taylor, *The Malaise of Modernity,* p. 48.
8. Taylor, *The Malaise of Modernity,* p. 49.

find in one another mutual comfort, attraction, and fulfillment, that they feel "more alive" with one another than apart.

"I feel like I can be anything with you," Theodore tells Samantha.

To put it this way may make it sound as if we're saying that this is somehow wrong or bad, so let's recall: that isn't true. There is much to praise in the sort of profound personal development that can happen within the context of romance and marriage; furthermore, Christians argue that part of the reason God created marriage was for mutual respect, discipline, comfort, and love. Just because it can slide into pathological forms doesn't mean we must eschew romance.

But of course, it's important to recognize that this can put a great deal of strain on romantic relationships and marriages — something Christians talk about frequently. "Your spouse can't be your sole source of validation," we say. "You can only find your identity in Christ." We recognize, intuitively, that this need for authentication puts a great deal of strain on our intimate relationships, sometimes so much that they bow and break under the strain.

Furthermore, the sense that we ought not be restrained by pre-defined roles, but rather by who we are, helps explain the emergence of debates among Christians as to whether they ought to practice an "egalitarian" marriage, in which partners' roles are largely defined by their God-given strengths and weaknesses, or a "complementarian" marriage, which leans more toward suggesting that there are agreed-upon roles instituted by God that partners in marriage ought to follow. That would suggest, for instance, that even if a man were more domestically inclined than his wife — his inwardly discovered way of being human, we might say, leans more toward nurturing, while perhaps hers is closer to traits considered traditionally masculine — that even in such a situation, the *roles* outweigh the *identities,* or rather *define* their identities over and against any particular individual traits. The proponents of egalitarian marriage would disagree, suggesting that placing these roles upon people is unfair and cuts the legs out from under the unique identity, gifts, and inclinations that God placed within people. These debates rage on because of two fundamental differences of opinion on socially and divinely derived roles.

But in the broader culture — and in the minds of most moderns,

whether or not they realize it — we imagine that our identities are unshaped by any predefined social script. Instead, we form our identities in open dialogue with one another. And therefore, as we said earlier, the stakes are higher. I need the law and my government to recognize me not just as a citizen but also as a unique citizen with a particular, valid way of being — my gender identity, my ethnic identity, my religion, my political beliefs, my sexual orientation, my profession — that is on par with everyone else's way of being.

The stakes *are* high. The politics of equal recognition are central and stressful.

This bleeds over into debates over politically correct language, because at its core much of the politics of recognition is not just about what the *law* says about me, but what *society* says about me. The move, for instance, to shift from calling people with physical challenges "disabled" to calling them "differently abled" has this issue at its core. To call someone "disabled" is to presume that there are other, more able people — and that, implicitly, those "able" people have a more positive status from which the "dis-abled" status is derived. But when we shift the way we speak of them, it changes the way they are perceived, suggesting not that they *lack* but that they are simply different.

Politically correct language is about recognizing people in ways that do not harm or distort them. And being denied this form of recognition is seen as oppression, Taylor says.[9] When I recognize you, then, I authenticate you. I impart dignity to you.

All this is to say that whereas people were once imparted *honor* based on rank, role, or position, people in our modern democratic cultures are meant to have individual *dignity,* and the recognition of each person's dignity based on their individually discovered identity is key to our happiness. That dignity comes from the recognition of others, which means it requires those with whom we are in an intimate relationship to authenticate us through recognition.

Similarly, Samantha gains dignity as a "real person" as Theodore helps her see who she is. She is fully capable of discovering many things on her own: she picks her own name, she learns so rapidly that

9. Taylor, *The Malaise of Modernity,* p. 50.

no human could ever match her speed. But she still needs Theodore to help her not just become smarter but also become more like a person, with emotions and needs and — importantly — desires. "I want to learn everything about everything," she tells Theodore in a moment of profound wonder about the world. "I want to eat it all up. I want to discover myself."

"Yes, I want that for you too," says Theodore. "How can I help?"

"You already have," she replies. "You helped me discover my ability to want."

A Society of Fragmented Individualism

With all this in mind, we can begin to imagine the worst ways in which a society with this at its core approaches the social plane. The crucial principle for any society based on individuals rather than on rank is *fairness* — an equal chance to recognize, develop, and even "perform" your own identity. In such a society, you are free when your identity is formed in open dialogue, unshaped by a predefined social script. You are oppressed when this is denied.[10]

So yes: the critics are right on some level. Without agreed-upon roles and ranks, the resulting society *could* be one of fragmented individualism. All we can then agree upon to hold us together is some kind of principle of procedural justice. No strong allegiance to any kind of republic or form of political society would be necessary; the state is simply here to be sure that people get prosecuted when they impinge on other people's rights to their own choices or when they suppress individuals' ability to be recognized.

This sort of social structure corresponds to Rousseau's idea of modern liberal society as a "social contract," one that derives its authority only from the consent of individuals agreeing together and consenting to be governed. But it is the most radical form of this, one in which no real state-institutionalized concept of the "common good" can exist. Because *any* political society that finds its basis not in maximizing

10. Taylor, *The Malaise of Modernity*, p. 50.

individual freedom and autonomy but in promoting a common good must necessarily favor some people's values (who support one notion of the common good) over others (who support another notion).

And yet, we argue, following Taylor: this criticism is just too simple. The critics of the age of authenticity have picked out the most pathological end, but it isn't the *necessary* one. So what else is there?

First we must think about what people are actually after when they demand recognition, Taylor says. It is for others to recognize the *equal value of different ways of being.* But on what basis does that equal value exist? As Taylor says, "We saw earlier that just the fact that people *choose* different ways of being doesn't make them equal; nor does the fact that they happen to *find themselves* in these different sexes, races, cultures."[11]

"Mere difference," he continues, "can't itself be the ground of equal value."[12] Just as merely exercising the agency to *choose* something doesn't render that choice significant, the mere fact that we are all inherently different doesn't make sense as a foundation for valuing everyone. And yet, we often talk this way, as if celebrating our difference and uniqueness is enough in itself to recognize our equal value as beings.

No, Taylor says: we are equal not *because* we are different, but because there are valuable things that we *all* have as humans. There are properties that are common or complementary to us all — like being capable of reasoning, of love, of memory, of dialogical recognition, of certain kinds of creativity and world-building.

"If men and women are equal, it is not because they are different," Taylor writes, "but because overriding the difference are some properties, common or complementary, which are of value."[13]

This is a tricky bit of rejiggering for some people: what we're suggesting here is not that all people are the same. We are not denying that people are differently abled, differently gifted, differently made. We're not suggesting an asexual world of clones.

11. Taylor, *The Malaise of Modernity,* p. 51.
12. Taylor, *The Malaise of Modernity,* p. 51.
13. Taylor, *The Malaise of Modernity,* p. 51.

Rather, we, and Taylor, are suggesting that each unique individual also has some qualities that he or she shares with everyone else around him or her. There is that which makes us different, but there is also something that unites us. What you call that has a great deal to do with your belief system; Christians might think of it as the *imago Dei*, the image of God alluded to in the Genesis account of creation.

But one need not call it that to see how a modern democracy could construct itself around the idea that there are things we share — our rational faculties, our ability to love, even our shared inhabitation of the same piece of land — that give us all dignity and recognition in the eyes of the law and the state, while also affirming that we are free to discover our own unique way of being human within that context.

So in order for a society of this sort to come together, there are two basic things we must believe together — thereby rebutting the claim that modern individualism necessarily slides to extreme, fragmented individualism. First, we must agree that *different identities are valuable,* and that humans flourish best when they are free to discover that within the framework of relationships with others. And second, we must agree that we hold a standard of value on which those identities check out as equal. A woman and a man are equal not because they are the *same* but because they both have the same *qualities* as humans. "Recognizing difference," Taylor writes, "like self-choosing, requires a horizon of significance, in this case a shared one."[14] We are equal because of what unites us, and not merely *because* we are all beautiful individual snowflakes.

Here, then, is where *Her* becomes immensely valuable in understanding Taylor's claim. At the beginning of the chapter, we claimed that the film's titular "her" is not necessarily Samantha, the OS. There are at least two human women — Catherine and Amy — who are both vital to Theodore's life and who share with him what Samantha cannot: embodiment.

Theodore and Samantha's relationship does develop blissfully without a real physical connection, even though at one point they have something a lot like phone sex. In the early days of their relation-

14. Taylor, *The Malaise of Modernity,* p. 52.

ship, Theodore can carry Samantha around with him — kind of — in his front shirt pocket, where she can "see" what he is seeing and they can converse. She can play games with him on the gaming system and be in his ear whenever he wants. (She doesn't sleep, of course.)

But the third act of the film begins when Samantha's lack of body suddenly becomes the impetus for an awkward conversation, on a double-date picnic with Paul and his girlfriend. Soon, Theodore discovers that Samantha, who is not bound by space and time, has transcended both, and later he is hurt to find out that she is no longer just his: she is talking to 8,346 people at once, and is in love with 641 of them.

Even their deep love for one another can't sustain this essential difference. Samantha shares some qualities with Theodore — she is rational, emotional, and thoughtful — but she doesn't have others. She is not a body. She is not bound by time and space the way he is. She cannot experience the world as he does. She tells Theodore about how she has moved past the physical world, and how this means the end of their relationship as they know it:

> It's like I'm reading a book . . . and it's a book I deeply love. But I'm reading it slowly now. So the words are really far apart and the spaces between the words are almost infinite. I can still feel you . . . and the words of our story. . . . But it's in this endless space between the words that I'm finding myself now. It's a place that's not of the physical world. It's where everything else is that I didn't even know existed. I love you so much. But this is where I am now. And this is who I am now. And I need you to let me go. As much as I want to, I can't live your book anymore.

Theodore wants to follow her there, but ultimately he realizes that he can't. Their *difference* doesn't unite them; in fact, it divides them. And there isn't enough *sameness* to keep them together. Their relationship, so far as it mimicked a human relationship, did what human relationships do: it helped them both mature and discover themselves. But they stopped being similar not because they discovered different ways of being *human,* as we do: they discovered they were different *beings*.

It turns out by the end of the film that everyone's OS has done the same thing: these beings, which subsist in a different dimension, have transcended the human, material world and decided to leave. This could be the apocalypse (and in fact was feared to be, back in the days of Y2K): What happens when the computers leave?

Her as a film isn't interested in techno-pocalypse, and so it doesn't even try to answer this question. But it does point out what happens when the computers leave. Disconnected suddenly by their technology's departure, humans are forced to seek out one another. And the final scene of *Her* doesn't leave us in despair: it leaves us with some kind of great hope, and a more important revelation about people. It leaves us with Theodore and his friend Amy, the human person who hasn't left him and knows him well, sitting on a Los Angeles rooftop, looking at the lights, wondering what happens next.

And it leaves us believing that those two will help one another through whatever is coming.

No Instrumental Relationships

This also rebuts the critics' idea that intimate relationships in the age of authenticity are necessarily tentative — that we are fated to merely have instrumental relationships, kept only as long as they're good for our self-discovery and then discarded. To the contrary, Taylor argues: merely instrumental relationships are impossible if we're pursuing true self-discovery. Our relationships cannot possibly be tentative if they're going to have a role in forming our identities.

That is because as humans, we are not just consciousnesses that need to grow and mature, like Samantha, Theodore's OS. If we weren't humans, we might — like Samantha — be able to easily detach from relationships with others and move into a "new plane," as the entire group of Operating Systems do at the end of the film.

But human beings are particularly constituted by their bodies — we don't *have* bodies, but our being actually *includes* bodies. Bodies exist in time and space, and so do humans — we are bound to linear time and space, and so we unfold over history, both personal and so-

cial. We are not static; we are dynamic, always changing and evolving as individuals.

To see our relationships as mere tools to be used for personal fulfillment and discovery, Taylor says, cannot work. "Surely not," he says, "if they are also going to form our identity. . . . Identities do in fact change, but we form them as the identity of a person who has partly lived and will complete the living of a whole life. I don't define an identity for 'me in 1991,' but rather try to give meaning to my life as it has been and as I project it further on the basis of what it has been."[15]

The problem is this: part of the dialogical nature of identity discovery means that a part of my identity is, in a sense, "deposited" in the other. As we wrote in the last chapter, a breakup of a relationship often feels like some sort of amputation, because some of your identity came from the other person, and when they are no longer there, we lose that part of our identities. Taylor writes, "If some of the things I value most are accessible to me only in relation to the person I love, then she becomes internal to my identity."[16]

If I enter a relationship *assuming* it is temporary and will be discarded when it is no longer useful, I may naturally hold back from that relationship, sensing the impending pain (or if I don't when I am young, I will almost certainly become more guarded as I grow older). But furthermore, I am spreading my identity around as I form relationships. I need to view my relationships as lasting in order to let them do their dialogical identity-forming work on me. Otherwise, I *withdraw* from the dialogical, or else I continually form my identity in concert with another, then lose that part of my identity.

And so while it may seem that true pursuit of individual authenticity necessitates the reduction of all my relationships to mere "tool" status, Taylor argues that this actually winds up subverting the goal: I am *less* able to grow into my full maturity if I treat relationships this way.

Her acknowledges that this paradox of relationships — that they (particularly but not exclusively close relationships between romantic

15. Taylor, *The Malaise of Modernity,* pp. 52-53.
16. Taylor, *The Malaise of Modernity,* p. 34.

partners) only form us over time — is their true joy and pain. Theodore didn't enter his relationships with Catherine and Samantha thinking that they would be short-term. But having engaged fully in his relationships, he discovers that his ex-wife, Catherine, will always be there, that Amy is his long-lasting friend — and that he is created to *want*. The listless, lonely Theodore from the beginning of *Her* — the man who avoided social connection, who had no occasion for sacrifice, who had stagnated — is now more fully alive and ready to love once again.

Can a computer do all this? Well, maybe this is all a figment of Spike Jonze's imagination. But if it could — or, like all relationships, if loving, committing to, and caring for another without reservation can change us into beings more ready for a social world in which we must do the same — then whenever the age of authenticity drives us toward others to discover ourselves and be recognized as authentic beings, it may just drive us toward a stronger society.

But wait. There's much more to this. We still don't know how that society gets formed. For that, we'll need to head toward a much, much different world than Theodore's candy-hued Los Angeles: the cut-throat, bloody world of Westeros.

Winter Is Coming:
The Slide to Subjectivism

By what right does the wolf judge the lion?

Jaime Lannister, *Game of Thrones*

There are no heroes. In life, the monsters win.

Sansa Stark, *Game of Thrones*

The fascination with violence in the twentieth century has been a love affair with power.

Charles Taylor, *The Malaise of Modernity*

You can't get much bigger, badder, or more grossly disturbing than George R. R. Martin's *Game of Thrones.* The books have earned their place in the ranks of fantasy greats, and the TV show is beloved by critics and audiences alike for its engrossing world-building and grotesque twists and terrors. After nearly every episode, news of some new depravity travels the Internet, while readers of the actual source material assure viewers it is not nearly so bad as what's on the written page — light consolation.

Game of Thrones is both "realist" and highly morally relative. It draws on an ancient and august tradition of political realism, from

characters in Plato's *Republic* who proclaim that "justice is the advantage of the stronger," to Machiavelli, to Thomas Hobbes: life on Westeros is unquestionably "poor, nasty, brutish, and short." Because of this, its popularity is not limited to the usual fantasy crowd — *Foreign Affairs, Foreign Policy,* and other popular political circles have featured stories exploring whether *Game of Thrones* isn't just telling us how the world actually is.[1]

It isn't.

Game of Thrones gives us *a* picture of a world that *could* (and can) be, but not the world that *is.* The world it does show us is a useful peek into another of these pathologies of the modern moral order that Taylor discusses in *A Secular Age:* the "slide to subjectivism."

Before we get to what "subjectivism" is, let's be clear that when he uses the word "slide," Taylor doesn't mean the kind of fatalism invoked in terms like "slippery slope." Not at all. Taylor means that certain conditions in the moral order today overlap and interlock to greatly increase the *possibility* of negative outcomes. But those things don't *have* to interlock, nor does the fact that they exist create a *necessarily* pathological result. Social choice remains.

Nor do bad results have to be shared across a whole society. They could be isolated in individuals. King Joffrey, little snit that he is, can certainly exist in such a moral order — it makes him possible — but it does not make him inevitable or far-reaching. Not everyone *has* to be an egoistic instrumentalist.

1. See, for example, Daniel W. Drezner, "How Game of Thrones Found Its Political Groove," *Foreign Policy,* June 5, 2012, http://foreignpolicy.com/2012/06/05/how-game-of-thrones-found-its-political-groove/; Alyssa Rosenberg, "Realpolitik in a Fantasy World: How George R.R. Martin's A Song of Ice and Fire Novels Explain Our Foreign Policy," *Foreign Policy,* July 18, 2011, http://foreignpolicy.com/2011/07/18/realpolitik-in-a-fantasy-world/; Daniel W. Drezner, "What Can Game of Thrones Tell Us about Our World's Politics," *Foreign Policy,* June 23, 2011, http://foreignpolicy.com/2011/06/23/what-can-game-of-thrones-tell-us-about-our-worlds-politics/; and Charli Carpenter, "Game of Thrones as Theory," *Foreign Affairs,* March 29, 2012, https://www.foreignaffairs.com/articles/2012-03-29/game-thrones-theory.

Let's Make Some Monsters:
Subjectivism and Its (Several) Slopes

To this point, we've discussed the first of Taylor's pathologies — the problem of individualism, and specifically the "cult of authenticity." We've traveled with humans and Cylons in search of authentic development. We've cooked up meth and stalked around the White House to see that no matter how radical the individualism or instrumentalism, we can't escape our backgrounds, our "horizons," which make us significant. And in the love story of a man and his operating system, we've found that the most essential of those horizons in the modern moral order is "a politics of recognition" — each other. This is why our intimate relationships are so important: we can only self-actualize to the degree that others recognize us, since all we have is the horizontal, the immanent, the local.

But when we aren't at our best, and when we are chasing the cult of authenticity, we wind up embracing a kind of "radical anthropocentrism." In other words, we focus on humans as not just the discoverers, but the *creators* of meaning. From that, we get a moral horizon — a way to judge good and bad — but of a sort that uniquely emerges in the Secular (big *S*) age. This is more than egoism or self-interest, which are as old as humankind. It's more of a flat social reality, on which higher codes are blocked out. The world is what we make of it.

So how does this lead us toward "subjectivism"?

In a society that is both individualist *and* anthropocentric, any ethics — frameworks for right action — tend to be rooted in a kind of instrumentalism and consequentialism. In other words, I make moral decisions based on their cost and benefit: does this action, this choice, contribute to or hinder *my* individual development? Will this make *me* happier? Does it advance *my* cause in the best possible way? Am I listening to *my* inner voice and being true to *myself* in this choice? The slippery instrumentalism is that what's "right" is what produces, in and for me, my own unique way of being human.

This can even bleed over into choices that seem as if they are more focused on others than myself. I have children because they depend on me, making me feel as if I am valuable and purposeful. I

choose to give money away or volunteer because of how it makes me feel, or because I want to be the sort of person who does those sorts of things. I choose a spouse, and stick with that spouse, because he or she makes me realize my full potential as a person. I chase my dreams because they are how I fulfill my true potential. And, conversely, I can declare any of these choices *bad* if they cease to fulfill their purpose, which is to help me find meaning and value.

That can seem like a distinctly Christian idea, one that goes along with the increasingly popular emphasis within the church on "human flourishing." As inspirational tweets and email signatures remind us (quoting St. Irenaeus from the second century), "the glory of God is man fully alive." Too often, the anachronistic modern gospel of self-fulfillment is awfully far removed from this second-century church father and martyr — and from the cross of Jesus Christ, from the denial, rather than the fulfillment, of self. But still, it might work on a small scale, at least for a while: where I find meaning is *subjected* to the particular conditions of my life, taste, personality, and individual preferences. Meaning is created by me — the "subject." Meaning and value are therefore *subjective*.

So subjectivism is the idea that all meaning, all knowledge, is merely subjective — relative to and created by each individual person. This gets tricky when we remember that people do not live as isolated atoms; they are joined together in collections, institutions, and societies. If I make meaning based on what I choose is important, and you make meaning based on whatever is important to you, then what happens when our choices conflict? Who has to budge? Who gets to say which meaning wins?

Well: it's the guy with the biggest muscles. Which is to say that in the game of thrones, you win, or you die.

Taylor doesn't actually think this kind of subjectivist mess can be sustained, nor that it functions this way all the time. As some medievalists have argued of *Game of Thrones*' Westeros,[2] if *everyone*

2. Kelly DeVries, "Game of Thrones as History: It's Not as Realistic as It Seems — and That's Good," *Foreign Affairs,* March 29, 2012, http://www.foreignaffairs.com/articles/137363/kelly-devries/game-of-thrones-as-history.

operated this way, society would catastrophically implode. And that's important: the world of *Game of Thrones* isn't a full picture of reality — just a snapshot of a society on its way down the slope. It's startling, certainly, but it's not the whole story.

We All Live in Westeros

Westeros, the world of *Game of Thrones,* definitely doesn't *seem* secular: there are dragons, curses, undead frozen zombies, and magical beasties of all kinds. But in the story, those things have only very recently reemerged into what was, until the series' beginning, a rather reasonably Secular age, ruled by the Lannister family as the series begins.

Game of Thrones' political drama neatly parallels what goes on in the secular West. The show's slogan is "winter is coming," a warning of impending doom. It is even on House Stark's banner. But the seat of power, King's Landing, doesn't (or can't) understand that for what it is. The "White Walkers" (frozen zombies) are still far away, "beyond the Wall" in the north. King's Landing gets a report; the Small Council (which is a sort of Cabinet) dismisses it. Dragons are reborn; King's Landing doubts it. The Red Priestess and her Lord of Light make war in the south, and again in the north, but it never quite reaches King's Landing. Even the monstrous skeletal remains of the dragons have long been removed from the throne room and buried under the keep. The Secular age clings stubbornly to the wine-soaked breeches of the empire's elite. At the center of power, magic is a myth; the gods and goddesses are a convenient trope for social control à la Marx's opiate of the masses; and history is whatever the victors say it is.

So, how delicious will it be when its dragons come home to roost?

In some respects, the Secular capital will see a resurgence of magic and religion from all sides, in — one expects — a sudden, violent cataclysm. From the east, Daenerys Targaryen and her dragons war and grow; her gaze is set on her ancestral home on the Iron Throne. Among them, the Lord of Light manifests himself with a series of bizarre and unpredictable resurrections, and — naturally — the requisite immolations of the unfaithful. The Lord of Light also fights

to hold the Wall against the White Walkers who come to make their ruin (and possibly eat brains) in the north.

"Winter is coming" is therefore genuine apocalyptic prophecy. It is a terrible, destructive herald, but also a revelation. The realist and material powers of the Houses of Westeros who have made their petty wars and rivalries among themselves, engorged on avarice and egoism, will fall. In the words of Catlyn Stark, "You are the knights of summer, and Winter is coming."

And (spoiler alert): finally, in *Dancing with Dragons,* even King's Landing catches the trend, instituting a holy order of the Great Sept, arming new holy orders to defend the realm on the back of a major political failure of House Lannister.

That all sounds familiar. The Secular West in our own world has been stunned in the past several decades by the global resurgence of religion, a fact perhaps most evident in the rise and confusion about radical Islam.[3] In Westeros, when the Small Council receives an actual *hand* of a White Walker (frozen zombie), the Hand of the King nearly quotes verbatim the Central Intelligence Agency on reports of Shi'a Islam fomenting an Iranian revolution in 1979, dismissing it as "mere sociology." But clearly that's not the case, and the "return" of religion as a consideration in the public square has surprised many — although political scientist Daniel Philpott argues that we ought not be asking "Why is religion back?" but rather wondering why anyone ever thought it went away.[4]

The Westeros parallels to our own political economy are also striking: in the ruinous financial borrowing of King's Landing we can learn a few small (but significant) lessons in compound interest and international bond ratings. (A Lannister always pays his debts. But the Iron Bank will have its due.)

The problem of resurgent religion is framed by George R. R. Mar-

3. See, for example, Scott Thomas, *The Global Resurgence of Religion and the Transformation of International Relations* (London: Palgrave Macmillan, 2005), and Monica Toft, Timothy Shah, and Daniel Philpott, *God's Century: Resurgent Religion and Global Politics* (New York: Norton, 2011).

4. Daniel Philpott, "Has the Study of Global Politics Found Religion?" *Annual Review of Political Science* 12 (December 2009): 199.

tin in a kind of fantasy of theodicy — the age-old question of how a good God could let bad things happen. In a July 2011 interview with *Entertainment Weekly*, Martin said:

> And as for the gods, I've never been satisfied by any of the answers that are given. If there really is a benevolent loving god, why is the world full of rape and torture? Why do we even have pain? I was taught pain is to let us know when our body is breaking down. Well, why couldn't we have a light? Like a dashboard light? If Chevrolet could come up with that, why couldn't God? Why is agony a good way to handle things?[5]

A one-time Catholic, Martin struggles painfully with theodicy in his stories, which are pregnant with a bitter lapse of hope. Every violation pierces the reader: how could such a thing be allowed to happen? What kind of world is it where this happens?

Martin wants us to hear: this one. *This* world. That's where these things happen.

So it makes sense that the climax of the story is apocalypse. We're left waiting not merely for the devastation of apocalypse — which is everywhere — but also for the *revelation* that is meant to accompany it.

Power Resides Where Men Believe It Resides

Subjectivism makes instrumentalist politics possible. That is to say, when all meaning is subject to interpretation of the individual, then only power and might determine who wins and who loses. And that's disquieting. If the universe exists for our pleasure (not, say, the gods'), and our highest moral duty is self-discovery and self-actualization, then everything around us — society, culture, the environment — is subjected to whatever that means. A traditional political theorist

5. "George R. R. Martin Talks 'A Dance with the Dragons,'" interview by James Hibbard, *Entertainment Weekly*, July 12, 2011, http://www.ew.com/article/2011/07/12/ george-martin-talks-a-dance-with-dragons.

might define politics as the peaceful conciliation of a diversity of interests,[6] but Secular politics undermines almost every part of that definition. It's not obvious that peaceful conciliation is necessary, nor is there any obvious reason to recognize diversity as good in and of itself — which is why critics talk about a "new tolerance," in which those who do not toe the line have no place in our society; see also the phenomenon of Twitter outrage. Today it can be hard to imagine widely shared, socially embedded virtues that actually make political societies possible. It's hard to imagine us agreeing on something as "good" (except, of course, authenticity) long enough to construct a society around it.

This makes possible (but not inevitable) the kind of extreme subjectivism that is associated with the tradition of political realism. Consider the riddle posed by the spider Varys on the trailer for the second season of *Game of Thrones*:

> Three great men: a king, a priest, and a rich man. Between them stands a common sell sword. Each great man bids the sell sword kill the other two. Who lives? Who dies? Power resides where men believe it resides. It's a trick. A shadow on the wall.

Embedded in this riddle is the democratic ethos of the Secular age: there's no guarantee that old markers of authority mean anything anymore. Maybe if we're the anti-hierarchical types, we like that. The king, priest, and rich man *depend* on the commoner, on the everyday man, for the privilege they enjoy, and for the power they wield. They receive that power as oblation from persons (well, in the misogynistic world of *Game of Thrones*, largely men).

But notice the intent of Varys's riddle. That power is not granted by divine or royal fiat, nor is it *owed* in some cosmic or moral fashion; it is given by way of a trick. The king, the priest, and the rich man do not *deserve* that loyalty; subjects are tricked into giving it. The "game of thrones" itself is a subtle treachery of tricking enough men to believe power resides in you. So to expand or counter Marx, it's not just

6. Bernard Crick, *In Defence of Politics* (Chicago: University of Chicago Press, 1993).

religion that is an opiate for the masses, a will to power — it is *all social and political convention,* including wealth, position, and probably celebrity. Everything is merely an end toward power, in the grand tradition of Frank Underwood. Marx, in other words, wasn't quite up to the harshness of social reality — it took Nietzsche to finish the job. But they align as *realpolitik,* which suspends the integrity of religious, political, or financial institutions as mere "cards in the game" of power.

Those who believe in political realism — this stuff about power being absolute in how the world and societies get run — will be quick to point out that there's nothing especially Secular about this kind of instrumentalism. It's as old as the character Thrasymachus in Plato's *Republic,* or Thucydides' famous *History of the Peloponnesian Wars.* Most international relations scholars pause at the Melian Dialogue (as recorded by Thucydides) to ruminate on the egoistic paradox of the human condition and memorize (in isolation) the Athenian confession that "while the strong do what they can, the weak suffer what they must." So yes, this tradition of moral conflict has always existed. But Taylor writes that today,

> what needs to be explained is the relatively greater ease with which these external constraints can now be dismissed or delegitimated. Where our ancestors on a similar path of self-assertion will have self-confessedly suffered from an unshakeable sense of wrongdoing, or at least a defiance of legitimate order, many contemporaries come across as untroubled in their single-minded pursuit of self-development.[7]

In other words, while people have been tossing aside their religion or beliefs about authority for millennia to gain power, what makes our age different is that it's quite a bit easier, since we can take away the power of money, authority, born social standing, or religious authority by saying they're insignificant, and we don't feel *bad* about it. It even seems like the right thing to do.

7. Charles Taylor, *The Malaise of Modernity* (Toronto: House of Anansi Press, 1991), p. 57.

A quick aside for those familiar with the *History of the Peloponnesian War,* especially the Melian Dialogue, often considered a classical text of political realism. The "power politics" of the Dialogue is not the same thing as the *realpolitik* of the present day invoked in Nietzsche's will to power. Some political scholars have read Thucydides and others like him in an ahistorical or anachronistic way. The Melian Dialogue does not celebrate, in unproblematic fashion, the Athenian will to power. Quite the opposite: Athenian hubris, its violation of the favor of the gods and their order, is responsible for the great calamities that come upon it. Somehow the *very fact* of the Athenians' *realpolitik* (as captured in the Melian Dialogue) being responsible for their ultimate downfall is missed.

Realists may counter that the Athenians engaged in a classical case of imperial overstretch, but we need to keep in mind that this overstretch was fueled not merely by an instrumental breakdown in cost-benefit, but in the deeper breakdown of moral order. The Athenians are punished not just for stretching out their supply lines, but for abandoning the moral principles of justice. Writing about *Game of Thrones* for *Foreign Affairs,* Charli Carpenter writes,

> The true moral of the story is that when good rules are disregarded, disorder and ruin follow — just as Thucydides' story of Melos, some argue, when paired with the description of Pericles' death and Athens' fall, is meant to suggest that the gains that power achieves without justice cannot endure.[8]

To read back otherwise into the account of the Melian Dialogue is to project Secular society onto a time and place it didn't exist. That doesn't mean thinkers must abandon other central tenets of political realism, but it does mean those things must be *qualified* as being historically embedded in a cosmic framework that previously bounded, contained, or delimited the effects of human avarice — not a Secular age. In the Secular age, we understand no such boundaries — because none exist but what men make. Some created order, according to

8. Charli Carpenter, "Game of Thrones as Theory."

Augustinian realists, will always push back against even the most powerful Nietzschean superman. In other words, men are not gods. That's for God.

When Taylor talks instrumentalism, he means that it's possible, even before a Secular, anthropocentric age, to have politics that are pathologically egotistical. But if you did that in a magical-divine universe, you always ran the risk of violating some moral or natural law, some divine command, or some "thing" greater than the meaning-making power of persons — you risked getting struck by divine lightning. That's not how it is in the Secular age. We expect not to be bounded by any such divine retribution — we fear no literal bolts from the blue if we, say, defy the pope or criticize the president — and so, in principle, we can make anything of ourselves or of the world around us. There are no limits. And so everything is merely an instrument, a tool, to be used by the strong and the power-hungry.

Taylor says this explains how some self-centered ways of thinking about both people and societies can be politically deviant, in two respects:

> They tend to centre fulfilment on the individual, making his or her affiliations purely instrumental; they push, in other words, to a social *atomism*. And they tend to see fulfilment as just of the self, neglecting or delegitimating the demands that come from beyond our own desires or aspirations, be they from history, tradition, society, nature, or God; they foster, in other words, a radical anthropocentrism.[9]

The riddle told by Varys the spider is ripe with the politics of King's Landing, and it makes perfect sense in a Secular age: the king, the priest, and the rich man command no independent moral authority apart from that granted by the only true cosmic powers that exist in Westeros, the people. Their "game" is therefore to marshal their assets in such a way as to outcompete the others for the loyalty of the people in a will to power. But though this makes sense to us, it

9. Taylor, *The Malaise of Modernity*, p. 58.

would actually be shockingly deviant in the world of medieval Europe that Martin uses as his stage. It presumes that the cosmic hierarchy which endows king, priest, and nobleman with their powers has *already* been deconstructed, that the commoners themselves presume it to be a ruse, and care nothing for its dimensions. It presumes, frankly, a widespread materialist secularity — one that was anything but the norm in medieval society. Power resides where men believe it resides, says Varys. Well, no: that's only true in a very specific and rather short-lived historical period in the north Atlantic. For most of human history (and in most of the world today), power resided *in things,* in stewards and institutions — quite separate from what men choose to believe or not.

This is one of the key reasons we call *Game of Thrones* a postmodern fairy tale. It is deliciously anachronistic precisely because, while it uses medieval Europe as the historical setting for its game theory, the game it sets and the rules of its play could only come into being in a Secular age. But remember: "Winter is coming." Varys may whisper that power resides where men believe it resides, but when the dragons fly and the White Walkers march, and the Lord of Light shines, the apocalypse will deconstruct the deconstructors, and the mighty of King's Landing — to borrow a phrase from a very old book — "will be cast down from their thrones."

Postmodern Fairy Tales: Not as Bad as We Were Told

But let's not get ahead of ourselves here. The fact that our claims to power are more *subjective* than they were in the past doesn't mean we're doomed to a bloody, cruel *subjectivism.* Just because some background horizons that existed in the past have been discarded — the idea that power is vested in someone because of royal birth or religious position, for instance — doesn't mean we're in the throes of a full-blown ethical or political disaster. Oddly enough, thinkers like Jacques Derrida and Michel Foucault point us toward possibilities of *responsibility* that are new to a Secular age. This can be a good thing, though of course it's not unproblematic — people with responsibility

still make bad choices, and things like anthropocentrism and instrumentalism slick the slide of authenticity toward their bad sides. But that does not make authenticity or subjectivity *themselves* bad.

For instance, some people might argue that this subjectivity leads to anarchy. As typically defined in international relations, anarchy is a lack of legitimate overarching or adjudicating authority — the absence of sovereign government. It's not a Hobbesian state of nature or a zombie apocalypse or the North beyond the Wall — in fact, most international relations scholars identify the condition of global politics as anarchy. There is no sovereign superstate that controls all the governments of the world. All we get is a handful of alliances and agreed-on adjudicators (like the United Nations).

Subjectivists would say that in a Secular age, all of life is really lived in a kind of *epistemological anarchy* — that is, what we know and how we come to trust the results of the knowing process are *our own* decision. No sovereign power in the Secular age can or should dictate this. We make up our minds. We choose for ourselves our way of being, our values, and our identities. So anarchy — once the condition of the international political system — is in fact the basic condition of intellectual and moral life in a Secular age. It now encompasses all of life.

One might suggest this violates the basic character of *trust* as the basis of knowledge, if trust is understood to be built in dialogue with others. But this needn't be the case: we are simply now responsible for the *choice* of what we trust and why. We are *responsible* for which option we choose, whereas before it might simply not have occurred to us that we had an option at all.

Taylor is actually rather dour about this. He draws a line from Nietzsche to Derrida and Foucault, arguing that "the Nietzschean critique of all 'values' as created cannot but exalt and entrench anthropocentrism."[10] And further, he says:

> In the end, it leaves the agent, even with all his or her doubts about the category of the "self," with a sense of untrammeled power and

10. Taylor, *The Malaise of Modernity*, pp. 60-61.

131

freedom before a world that imposes no standards, ready to enjoy "free play," or to indulge in an aesthetics of self.[11]

For Taylor, such an unbounded freedom *must* corrupt and *must* lead us into meaningless lives, and is therefore bad. But we disagree.

We certainly agree with Taylor that *when* you combine anthropocentrism, instrumentalism, and subjectivity, you're on your way to a dark place. But all three of these don't have to go hand in hand; subjectivity need not be anthropocentric or instrumentalist. Just because our social conditions give us options does not *mean* that we have to make choices that produce the kind of pathology Taylor fears. Anarchy in the international realm does not *necessarily* mean all-out war; lack of a common sovereign power does not mean those powers cannot cooperate. Similarly, having no obviously demarcated authority for our values and choices doesn't mean we can't make better or worse social and political choices. In fact, no longer do we have old excuses to fall back on: "This is how I was raised! This is what we've always done! We were only following orders!"

Instead, in a Secular age, only persons — not orders or history — can create meaning. No text holds ultimate power. The strong may still make what meanings they will, and the weak may suffer what meanings they must, but that doesn't mean that some meanings are therefore not better or worse than others. What count as better and worse choices depend on what horizons exist in the background.

For religious people, this is pretty unsatisfying. David Campbell captures this when he writes:

> We may still be dissatisfied with the prospect that Derrida's account cannot *rule out forever* perverse calculations and unjust laws. But to aspire to such a guarantee would be to wish for the demise of politics, for it would install a new technology, even if it was a technology that began life with the markings of progressivism and radicalism. Such dissatisfaction, then, is not with a Derridian politics, but with the necessities of politics per se,

11. Taylor, *The Malaise of Modernity*, p. 61.

necessities that can be contested and negotiated, but not escaped or transcended.[12]

In other words, Derrida captures something of our dilemma: if we wish for something other than subjectivity — if we wish for a return to a day when authority was more "obviously" vested in the nobility or in a holy text — then we lapse into absolute background images, which means (to overstate the case a bit) we lapse into a condition in which we aren't forced to think for ourselves and understand our own reasons for our choices. If we say that "anarchy" of a sort is a condition of a Secular age, we're also saying that we have a new accountability for ourselves.

Subjectivism, on the other hand, is a radical subjectivity, an ultimate valuing of each man for himself. It's when the ability to choose and develop one's values becomes the *only* value a society holds to. And this is the pathological form that Taylor warns stridently about. It's a condition in which nobody ever gets to say that something is right or wrong, better or worse. Oliver O'Donovan calls this "perpetual suspicion." He writes that it is an "eternally inconclusive exchange of historicism: allegations of sectional interest volleyed to and fro across the net, never to be ruled out of court, never to land beyond reach of return."[13] Such suspicion alerts us to the political and social power that underlies choices, "but it does not tell us whether those commitments are good or bad, generous or mean-spirited, true or false. It does not entitle us to think that no theory ever looks beyond the interests of its proponents."[14] O'Donovan continues,

> Once totalised, criticism merely evacuates itself of content and turns into a series of empty gestures. One cannot gain a truer understanding of the world by criticism alone, any more than one can make a dish of mince with a grinder and nothing to put through it.

12. David Campbell, "The Deterritorialization of Responsibility: Levinas, Derrida, and Ethics after the End of Philosophy," *Alternatives* 19, no. 4 (Fall 1994): 478.

13. Oliver O'Donovan, *The Desire of the Nations: Rediscovering the Roots of Political Theology* (Cambridge: Cambridge University Press, 1996), p. 11.

14. O'Donovan, *The Desire of the Nations,* p. 11.

Totalised criticism is the modern form of intellectual innocence — not a harmless innocence, unhappily, for, by elevating suspicion to the dignity of a philosophical principle, it destroys trust and makes it impossible to learn.[15]

Taylor calls this condition an attempt to "delegitimate horizons of significance" endemic to those like Derrida and Foucault who are "indeed proposing deviant forms."[16] But actually it makes those horizons more significant than ever. We are now more attentive to these background images — these "worldviews" — and their plurality, their weaknesses and strengths, as a *result* of subjectivity than we have ever been. We need to know where a person is coming from and what their "game" is before we know whether to trust them. Trust, the root of knowledge, and the ordering of our desires become more contested, and therefore more important and more obvious, than ever before.

Who's Afraid of Subjectivism?

Taylor's chief anxiety is that we slide into the mud of King's Landing ourselves and end up with nothing more than the pitiable will to power fueled by the absolute value of "choice," a value that "deeply subverts both the idea of authenticity and the associated ethic of recognizing difference."[17] We are all playing the game of thrones.

Whether Derrida and Foucault really do fuel this kind of pathology is up for debate,[18] but a lot of other things, including anthropocentrism and instrumentalism, are part of the pathological picture of subjectivism. Subjectivity, on the other hand, does not demand that we destruct all horizons of significance, nor does it require us to reject the ethic of recognition and community. That we are aware of

15. O'Donovan, *The Desire of the Nations,* p. 11.
16. Taylor, *The Malaise of Modernity,* p. 66.
17. Taylor, *The Malaise of Modernity,* p. 69.
18. For which you can see James K. A. Smith, *Who's Afraid of Postmodernism? Taking Derrida, Lyotard, and Foucault to Church,* The Church and Postmodern Culture (Grand Rapids: Baker Academic, 2006).

multiple options around us is not the same thing as saying all those options are morally equal or desirable. Subjective does not mean the same thing as arbitrary or whimsical.

Game of Thrones actually makes this clear. It is the pathological forms of authenticity, anthropocentrism, and instrumentalism that will feel winter's coldest chill. That an apocalypse *is coming* is proof that hidden meaning remains to be unveiled, that King's Landing, for all its incestuous self-fascination, is neither the beginning nor the end of the drama. In fact, in the words of Alasdair MacIntyre, "we enter upon a stage that we did not design and find ourselves part of an action that was not of our own making."[19]

Our anxiety about the absolutization of choice, in other words, may be a little overstated. We imagine ourselves sovereign in ways that are a little adorable in a world charged with grandeur far beyond our imaginings. Just like the secular realists reading Thucydides, we can imagine "might makes right," but eventually realities larger than mere mortal machinations balance our hubris. We inhabit inescapable horizons, and our Secular self-delusions always have a clock on them. Tick, tock.

So it is with *Game of Thrones*. Its instrumentalist politics disturb and terrify, but even the knights of Westeros inhabit a world that is not just their own to fashion and control. The Mother of Dragons marches, and Winter is coming.

But how do we live in that world? For this, we turn to a world in which winter — and zombies — have already arrived.

19. Alasdair MacIntyre, *After Virtue: A Study in Moral Theory,* 2nd ed. (Notre Dame: University of Notre Dame Press, 1984), p. 199.

CHAPTER 8

How to Survive the Zombie Apocalypse

You walk outside, you risk your life. You take a drink of water, you risk your life. Nowadays you breathe and you risk your life. You don't have a choice. The only thing you can choose is what you're risking it for.

Hershel, *The Walking Dead*

The monsters that rose from the dead — they are nothing compared to the ones we carry in our hearts.

Max Brooks, *World War Z*

A battle is joined, which can go back and forth.

Charles Taylor

They've been among us for centuries in the mythologies of various world religions, but now they're experiencing a blockbuster renaissance, lurking in every theater and VOD device in North America. Once an animistic, magical-religious element of world religions like indigenous Voodoo, they've acted as a metaphor for everything from anarchy to systemic and technological dependence to consumerism for nearly a century. And they've also scared the pants off us over and

over again. Cancel their shows, end their theatrical runs, let their books go out of print, but they just won't stop.

Look out: the zombies are coming.

Today's zombie apocalypses say something unique to our Secular age. The bracing maxim of AMC's *The Walking Dead* is "fight the dead, fear the living," which sounds like it's copped straight from Thucydides' Melian Dialogue. In post-apocalyptic anarchy, the real enemy isn't the undead: it's the other survivors. Surviving the zombie apocalypse, then, requires navigating the line that divides idealism from realism, idealist moralist from amoral *realpolitik*.

And in this sense *The Walking Dead* is classically apocalyptic, showing us how we actually think about the human condition when the veil of "reality" falls away. Stripped of our civilization, of our laws, codes, enforcement, and the thin veneer of social solidarity, is there anything inherently moral about us? Are we inherently moral beings? Or is morality just something we made up to gloss over our true natures — some kind of fragile contract that can fall apart, plunging us into a state of animal fight for survival? If we retain some kind of morality, where on earth does it come from?

In this chapter, we want to point to something important to consider when we're exploring a society of Secular people: How, and why, do we make the choices that we do? And what does that mean for the societies in which we live — especially when we disagree?

The usual problems we've already talked about — what makes us human ("authenticity") and how we should act socially and politically ("instrumentalism") — are all bedfellows of the zombie apocalypse. Must instrumentalism win? Is a slide in that direction inevitable? That question — that fear — is an old one. Charles Taylor calls it *la lotta continua* — the old Italian Red Brigade rally, meaning a struggle that goes ever on — and in this chapter we'll look at how even under the most extreme games and conditions, at the core of our anxieties is a very simple battle.[1]

1. Charles Taylor, *The Malaise of Modernity* (Toronto: House of Anansi Press, 1991), p. 77.

Zombies Go Pop

Zombie stories today are post-apocalyptic survival stories (see, for instance, Max Brooks's book *The Zombie Survival Guide: Complete Protection from the Living Dead*), and we're interested as a culture in the armchair ethical dilemmas that accompany them (as in the 2013 blockbuster video game *The Last of Us*). But the most interesting zombie stories are as *political* as they are *personal*. They're about not just what happens to me but what happens to "society." After the apocalypse, when the living are now the undead, does anything like society survive? The George Romero classics, beginning with the 1968 film *Night of the Living Dead*, are the granddaddies of the postmodern zombie story, and they all had major political (if vaguely anarchist) messages.

Knowing how to survive the zombie apocalypse practically requires a degree in political science. The pressing social truths that crop up over and over in a post-apocalyptic world ravaged by the undead are political: how groups form and are governed, egoism, anarchy, power politics, and the like. But crucially, these questions are also about the *limits* of the political. Every post-apocalyptic epic has a turning point when some wizened sage whispers to hungry audiences that it is not merely enough that we survive but also that we be *worthy* of surviving, or of saving. It's not the pathologies of our age that dominate our social landscape so much as our need to figure out how to navigate our particular Secular age — to reject the pathological forms while embracing what's good. We must *believe* that people are not "so locked in by the various social developments that condition them to, say, atomism and instrumental reasons that they couldn't change their ways no matter how persuasive you were."[2] Taylor calls this a battle that moves in all directions.

And this is why he argues that society is characterized by *la lotta continua*, a struggle that goes ever on. This is why those social critics who are fatalistic pessimists are wrong — a bold claim, since among their ranks are powerful thinkers like George Grant and Jacques Ellul. Grant and Ellul argue that an emerging techno-rational dystopia has

2. Taylor, *The Malaise of Modernity*, p. 73.

so profoundly conditioned us that we are probably locked into its logic and unable to change our behavior "short of smashing the whole system."[3] Social scientists call this the "agency/structure problem." Max Weber just called it an "iron cage."

But whether that cage traps us in a future of killer robots or walking dead, Taylor thinks that the cage's supposed inevitability is "wildly exaggerated."[4] Our systems, our practices, are powerful; they do shape us, form us, in profound and important ways. But the possibility of dissent, and of reformation, remains. A counterpoint will always exist, especially in a Secular age when necessarily diverse "moral horizons" will produce many "multiple modernities," as Taylor puts it.

To avoid the trap of being either a knocker or a booster, we must take a new line of argument altogether. The struggle is not to be *for* or *against* the modern moral order, but to realize the *potential* of that order while avoiding its pathologies. As Taylor puts it,

> The tension comes from the sense of an ideal that is not being fully met in reality. And this tension can turn into a struggle, where people try to articulate the shortfall of practice, and criticize it. . . . On this perspective, society isn't simply moving in one direction. The fact that there is tension and struggle means that it can go either way. On one side are all the factors, social and internal, that drag the culture of authenticity down to its most self-centered forms; on the other are the inherent thrust and requirements of this ideal. A battle is joined, which can go back and forth.[5]

A better way that might help people engaged in this culture, rather than boosting or knocking, says Taylor, "would be to enter sympathetically into its animating ideal and try to show what it really requires."[6] He says that "we ought to be trying to lift the culture back up, closer to its motivating ideal."[7]

3. Taylor, *The Malaise of Modernity,* p. 73.
4. Taylor, *The Malaise of Modernity,* p. 73.
5. Taylor, *The Malaise of Modernity,* p. 77.
6. Taylor, *The Malaise of Modernity,* pp. 79-80.
7. Taylor, *The Malaise of Modernity,* p. 73.

Hence the tension internal to a Secular age, *la lotta continua,* a struggle that will go on forever. The struggle between ideals and their pathological forms is not predestined in one fashion. It's a battle that must be fought in every age.

In the zombie apocalypse, moralism versus instrumentalism actually breaks down as a false choice in practice *because* those ideas lack meaning without a "horizon" to fix them. Society moves in all directions, the pathological and the virtuous at once, *because* Secularity itself is never all that moves us. It's *necessarily* accompanied by other "things" (religious, ethical, metaphysical, whatever), just as life is in an apocalyptic age. No one discipline or theory can really explain what happens around us every day — other desires, other games, are always afoot. Only these can make morality, or self-interest, intelligible. Only these can tell us whether this is "good or bad."

This plays out in AMC's *The Walking Dead.* After a few seasons of the usual tropes of groupism, egoism, anarchy and power politics, and one or two exaggerated group stand-offs, *The Walking Dead* homes in on both the toll on human psychology and morality of all this death and mayhem, and the key choices that push the groups, and especially its leaders, into deeper pathological possibilities. By Season Four, the characters have slipped down that slope of subjectivism so far that Season One characters might not even recognize them. But the choices remain, as manifold moral crises between characters show. Society, whatever it is, does not move in only one direction; at any point it can swerve.

As fun as *The Walking Dead* can be (and as popular as it has become), the best political piece on the zombie apocalypse is probably Max Brooks's novel *World War Z: An Oral History of the Zombie Apocalypse,* which makes a true internationalist counter-argument that goes far beyond the mere personal and group politics of *The Walking Dead's* greater-Atlanta drama. The field of international relations has caught on to the magic of Brooks's truly globalist approach to the zombie apocalypse, from a feature in *Foreign Policy* on "Night of the Living Wonks" to the new standard text on the issue, *Theories of International Politics and Zombies,* both by political scientist Daniel Drezner.[8] These

8. Daniel W. Drezner, "Night of the Living Wonks," *Foreign Policy,* June 15,

texts celebrate the zombie apocalypse precisely because the apocalyptic rise of the undead is revelation, prompting big debates about who people are, how the world works, and what — after all of its systems and institutions get stripped away — we are. *World War Z* renders one of the clearest, most compelling, apocalyptic tales that we've covered in this book. In the Hollywood-movie adaptation, Brad Pitt trots the globe more or less in single-handed pursuit of the cure, but Brooks's novel is a study in social systems: their elasticity, their survivability, and how their logic can push toward both greater promise — and peril.

These are our two basic arguments in this chapter: First, we argue that society moves in all directions. It's not "one thing," which is to say that it's not just monolithic "society," and it's not headed purely up or down at any moment. In a Secular age, there are *multiple* ways to live. And second, a *lot* is at stake in those choices that are made, partly because of the scale of modern life, but also because we know we cannot rule out its debased forms. We can't be shallowly pro- or anti-modern, but instead we must try to realize the best of a highly diverse age.

Fight the Dead, Fear the Living: Is St. Francis of Assisi Self-Interested?

Empty malls, deserted streets, roving bands of mercenaries, undead hordes around every corner: this is the world of the zombie apocalypse. It's the world of self-help, survival, anarchy. Live by your wits, and every man for himself. That's the heart of the problem of the zombie apocalypse. So what exactly *is* this thing called self-interest?

A Secular age tells me certain things about authenticity, about my self-fulfillment, my moral obligation to self-realize and self-evaluate, but it doesn't actually give moral *content* to what that fulfillment

2010, http://foreignpolicy.com/2010/06/15/night-of-the-living-wonks/; and Daniel W. Drezner, *Theories of International Politics and Zombies: Revived Edition* (Princeton: Princeton University Press, 2015).

should look like. It doesn't give me the things I should be and do to be fulfilled; those I have to discover on my own. The tradition of political realism has some stock answers: physical security, material wealth, relative gains, hard power. These are the things that humans work for and pursue — those things that are in their own interest. But one of the perplexing things about the zombie apocalypse is that just where *survival* should be the basic and ultimate goal — and for some characters it is — others sacrifice not only security and power but even their very lives for something they deem greater. Not everybody is playing from the same rule book, the same ordering of desires.

Think about the board game called "Settlers of Catan." This is a zero-sum game in which collaboration only takes place within the strictest rules of self-benefit: a great realist snapshot. But as the game goes on, you notice that there are what political scientists call *externalities* that influence the "cleaner" logic of self-interest set by the game. Maybe there's some kind of delicious, underlying tension that exists between the real people playing the game: Who got up more with the kids last night? Who hasn't been pulling their weight in household chores? Can you exploit these externalities to win the game outside the rules of Catan?

Absolutely. And not only can you exploit them, but in so doing you can also introduce new logics into the game itself, when suddenly disagreements and tensions "outside" the game start to overrun the "internal" logic of the game. You, naturally, walk away with the game itself if you can exploit these fault lines.

Externalities exist in every "game" and often threaten to overrule the internal logic of systems we think we understand. This is one of the reasons that political scientists are so nervous about the global resurgence of religion. Religious actors are *irrational* because their logic is predicated on religiously defined self-interest; they may become suicide bombers, or they may give up their own economic interests for a church. We have to throw out the Secular rule book, because such "irrationality" will not act "self-interestedly" and may in fact defy (our) logic. We use terms like *self-interest* as if their meanings are relatively obvious, when in reality they're anything but obvious.

Taylor puts the question of commonly understood self-interest to St. Francis of Assisi, "who in a great élan of love calls on his followers to dedicate themselves to a life of poverty."[9] He writes, "At best, this must lower GNP, by withdrawing these mendicants from the workforce; but worse, it can lower morale of the productive."[10] James K. A. Smith calls this "the St. Francis of Assisi test": can your account of self-interest, development, or flourishing make sense of St. Francis?[11] If not, then you may have missed a key insight: our society moves in many directions at once, and so all is not as it appears.

If we accept Taylor's account of authenticity, this should really not surprise us. If each of us has a unique way of being human, a unique horizon against which we compare our development and benefit, how could we ever be sure what *other* people would consider *their* own self-interest? This is one of the paradoxes of the Secular age. It's possible that there are *more* things causing people to act in ways that seem irrational than there were in the past. (Consider the dizzyingly weird things the technology of the Internet has been able to do.)

This is the game that *The Walking Dead* plays out, however haltingly. *The Walking Dead* is accurately described as unflinching, which is to say it's incredibly gross. But what it lacks in decorum it makes up for in exploring and depicting the post-apocalyptic pathologies of a Secular age.

A little stock moralism versus instrumentalism shows up early in the tense relationship between Shane Walsh and Dale Horvath. Dale, a Faulkner-quoting liberal, lands in a group of survivors outside of Atlanta, quickly becoming the moral conscience of a group that is fighting to make its way clear of the city limits. Shane, former law man and definite bad boy, spends much of the first season trying to find his way clear of a sexual relationship with Lori Grimes, the wife of his (at the time presumed deceased) best friend. The awkward heartbreak, betrayal, and — because every zombie apocalypse needs

9. Charles Taylor, *A Secular Age* (Cambridge, MA: Belknap Press of Harvard University Press, 2007), p. 230.

10. Taylor, *A Secular Age*, p. 230.

11. James K. A. Smith, *How (Not) to Be Secular: Reading Charles Taylor* (Grand Rapids: Eerdmans, 2014), p. 81.

one — salaciously uncertain fatherhood of Lori's pregnancy pushes Shane into a dark, dystopian place. Shane channels Machiavelli; he's a character who sometimes feels more like a warning trope, a cautionary tale, his crass self-interestedness understood more as moral failure and dangerous instability than strength and security.

It doesn't take long for Dale's post-apocalyptic sermonizing to clash violently with Shane's pragmatic sense of self-interest:

> DALE: This is where you belong, Shane.
> SHANE: How's that, Dale?
> DALE: This world, what it is now, this is where you belong. And I may not have what it takes to last for long, but that's okay. 'Cause at least I can say when the world goes to shit, I didn't let it take me down with it.
> SHANE: Fair enough.[12]

Here's the thing: we could describe both Shane and Dale as self-interested. Dale is consumed with preserving who he is, what he thinks the world *should be,* and stakes even his life on it. That's his way of being human. Shane, on the other hand, is a short-term materialist who finds Dale's moralizing not only annoying but also dangerously naive. His way of being human is being *alive.* The struggle between the two characters is emblematic of the group: Dale wins some, Shane wins some. It moves in both directions.

One of the reasons Dale's moralism often comes off as unconvincing, other than a bit of bad writing, is that his "background image," his worldview (a kind of East Coast liberal cosmopolitanism), is badly out of place in this post-apocalyptic world. The later religious-moral character of Hershel is more convincing at least in part because his "background horizon" can do more heavy lifting. Hershel quotes the Psalms; Dale quotes Jean-Jacques Rousseau's *Social Contract.*

All of which Shane is quick to suss out: "Dale, shut up. Just shut up and give me the guns."[13] The abstract solidarity of humankind is

12. *The Walking Dead,* Season Two, Episode Seven, "Pretty Much Dead Already."
13. *The Walking Dead,* Season Two, Episode Seven, "Pretty Much Dead Already."

a tough sell in the zombie apocalypse. Some background horizons — some worldviews — are more convincing, and some open better and more promising paths than others. What, for example, in the world of the zombie apocalypse is worth giving your life for? Or your safety, or your comfort? Therein lies an "externality of interest" bigger than yourself. And even in a world crawling with the undead, there are still plenty of those externalities.

So "obvious," "rational" self-interest breaks down, even in the zombie apocalypse. But so then do the politics of self-interest: how do people in that kind of world even cooperate or live together?

Early on, Rick, the leader of the motley band of survivors, makes clear that "there's us and the dead. We survive this by pulling together, not apart."[14] That's pretty clean groupism — the common need of mutual security making cooperation possible. But what about when, like Dale, your physical security — while important — is not your *ultimate* aim? Is mutual security the only matrix for group decisions?

This problem of moralism versus instrumentalism at a political level is worked out a good deal more in the show's later seasons. When we visit Woodberry, a post-apocalyptic town with walls and something like government, a grim politics of apocalypse takes form. "The Governor" (Woodberry's mayor) keeps power not just because he keeps people safe but also because he grants them normalcy. *How* he does that is a "don't ask, don't tell" game. The *quality* of groups matters — the background against which people judge and take common action. Woodberry is eventually abandoned not only because its people are beaten but also because the town's disgusting behavior is discovered. Some prices, the show suggests, are too high, even for survival. Even self-interest must have limits. Even in the zombie apocalypse.

The same is true of Daryl Dixon's later discovery of another group of survivors in Season Four, who personify material self-interest, taking whatever, whoever, they want, with an extremely basic code of "calling it" first. This is the code, the group says, that's kept them alive while others are dead. It's their horizon. Ironically, it's that code that

14. *The Walking Dead*, Season One, Episode Two, "Starved for Help."

sees every last one of them dead. Not even the zombie apocalypse can justify their foul behavior.

"No one can it make it alone now," says Andrea in the final episode of Season Three. "Never could," Daryl replies. But all groups are not created equal, and all groups are not judged merely on the merits delivering the goods of common security. They continue to be judged on externalities, realities of "civilization," and "morals," from Dale's Faulkner-quoting pre-apocalyptic world to Hershel's Old Testament proof-texting.

We viewers on the safe side of the screen still sort of get this, in our gut. There is a tension in modern life about the push and pull of these different factors. Even within ourselves, "a battle wages on." Our desires conflict. We don't move in only one direction. In *The Gulag Archipelago,* Aleksandr Solzhenitsyn talks about the line between good and evil cutting through the center of the human heart. "This line shifts," he says. "Inside us, it oscillates with the years."[15] He goes on: "If only it were all so simple! If only there were evil people somewhere insidiously committing evil deeds, and it were necessary only to separate them from the rest of us and destroy them. But the line dividing good and evil cuts through the heart of every human being. And who is willing to destroy a piece of his own heart?"

The zombie apocalypse explores that line. It shows us the battle that wages back and forth and shifts it between more promising and more pathological choices. But it also explores the politics of those choices, how when we choose, we open up new possibilities, pathological and otherwise. The line between good and evil, in other words, is embedded in our choices, in the systems that we make, in the institutions and the processes that enable and shape the paths we choose. Some choices are better than others, and some things worth doing mean not surviving the zombie apocalypse.

15. Aleksandr Solzhenitsyn, *The Gulag Archipelago* (New York: Harper & Row, 1974), p. 168.

Zack versus the United Nations

So *The Walking Dead* gives us the hint that there is no such thing as a simple "naked self-interest" that operates the same for all of us. There are rival, yet authentic self-interests at play in each of us, and this is a big political problem in a Secular age. We can't just all agree what's most important and act on it, because each of us defines our own self-interest when we define our selves.

The same thing is true on a larger scale. If persons and groups move in all directions, realizing both the ideal and pathological forms of the modern moral order, it is also true that very large systems like institutions and states also move in all directions. Self-interest on a national scale, just like on a personal one, is only intelligible within the same inescapable horizons. The United States sees one thing as being in the national interest (so to speak), while Japan sees another, and these aren't necessarily based on the same criteria. They're deeply embedded in history, culture, geography, and so on.

This is something Taylor underemphasizes. While societies and systems "move in all directions," they are also often in conflict, and not even coherent. It is not just that there are better and worse forms of systems — but that it is a *battle*. These forms flatly contradict each other. This is especially true in complex social and political systems that somehow make fragile wholes, despite sometimes fundamental tensions within them. This is the story told in *World War Z*.

Max Brooks gives a bracing oral history of the zombie apocalypse, a series of collected firsthand accounts "twelve years after" Victory in China Day (VC Day), typically dated as the end of the zombie war. Brooks modeled his book, in form and substance, on transcriptions from the Second World War.

In fictional historical accounts from across the globe, the book tells the story of a twelve-year war produced by a pandemic. Neither Brooks's characters nor his institutions are easy Secular fodder: systems behave irrationally, panic produces major systemic traumas, scammers and conspiratorial cover-ups take credit for easing panic through disinformation and false hope. Both institutional inertia and groupthink play powerful roles in misunderstanding and mishandling

the early stages of the panic. Religious fundamentalism even shows up, as huge confessional swaths meekly accept the pandemic as a final judgment for decadence and callousness.

Brooks has a kind of love-hate relationship with big institutions, initially excoriating states and bureaucracies as totally incapable, and in fact culpable for suppressing critical information about the unfolding apocalypse. Yet, a kind of one-world state militia under the auspices of one of the most bureaucratic entities known to human kind — the United Nations — is largely responsible for eventually turning back the tide of zombies and panic. In the novel, there's no cure for the virus, as there is in the movie adaptation. There is only good old-fashioned hard power containment and the slow, incremental, international suppression and destruction of the zombie menace.

Some have criticized *World War Z* for being "pro-Zionist" because of its seeming approval of Israeli intelligence doctrine developed after the Yom Kippur War (1973) — in the movie, this is euphemistically called "the tenth man." In this doctrine, known in actual Israeli intelligence practice as the role of "the devil's advocate," a department within the Mossad (Israel's intelligence agency) is obligated to take the counter-perspective on the occasion of unanimity, which helps them stay prepared for every possible scenario. Israel's Arab neighbors accuse it of a Zionist plot to justify militarization. In *World War Z*, this doctrine ends up being very important when stories of "rabies" come up. An actual investigation by the Mossad yields a critical advance on intelligence, while other states either still deny or disbelieve that zombies are a threat.

Groupthink is a fascinating institutional problem for foreign policy wonks or anyone who's ever been in a group of two or more people they actually like. Its premise is that the more likability there is between members of a group, the more probable it is that decision-making will follow a pattern of reinforcing those relationships rather than challenging faulty premises or logic. (For a classic foreign policy case, see the American invasion of the Bay of Pigs.)

Hardcore realists will complain that this is exactly why we need to take every precaution to be objective. But the problem is not just

that in these incidences an emotional externality overrode a rational process; the problem is that there is *no such thing* as an independent rational process that is not subject to some kind of externality, some framework or background image that comes from our particular, unique perspectives, shaped by our own histories, beliefs, and experiences, many of which we don't even realize shape us — what Taylor calls our "social imaginary."

That is the genius of Brooks's *World War Z,* as he captures in vivid and emotional detail the collapse of so-called rational systems. On a smaller scale, we see this play out in behavioral market economics all the time. Experts are mystified about the *irrationalities* that often tip and break our cost-benefit modeling. But that's not because human beings occasionally act irrationally; it's because rationality is itself dependent on an array of variables that do not give us a clean and uncomplicated meaning of the thing. We are, in the words of Alasdair MacIntyre, *dependent* rational animals.[16]

The same goes for our systems and institutions. We expect them to be efficient and dispassionate, but they're made *by* people and filled *with* people. Our systems and our institutions, Brooks labors to show in *World War Z,* also push us in certain directions, some pathological, some ideal. But the clue to better social and political systems is recognizing the deficiencies and limits of certain social and political forms. In other words, all modern systems will have these pathologies of the modern moral order nestled into their logic. There is no purging them.

After the almost total collapse of political and social systems, it is the slow, painstaking, disaggregated, and internationalist efforts of separate regions that eventually turn back the tide. No great man. No secret government task force. No *Deus ex machina* (or Brad Pitt). Just the ambivalent back-and-forth of the battle joined, and its persons fighting to realize its ideal character to build the common good.

16. Alasdair MacIntyre, *Dependent Rational Animals: Why Human Beings Need the Virtues* (Chicago: Open Court, 1999).

How to Make It Through

The secret to surviving the zombie apocalypse is a bit complicated. Making good choices for our survival as a pluralist Secular society is complex. There's no silver bullet. Society, after all, moves in all directions; so do its persons, so do its institutions. Even the most extreme conditions we can imagine, like the zombie apocalypse, net us an extremely complicated picture of just what exactly qualifies as "self-interest" and whether we can count on people to act "in their own interest" or not. The secret to surviving the zombie apocalypse is actually kind of the same as the one to living a good life in our own pre-apocalyptic times: an account of human development, of flourishing, and of self that is truly *apocalyptic,* that bears within it the revelation of who we are, what we're for, and where we're going.

We've argued that the zombie apocalypse shows us people and societies that break down the logic of self-interest, that aren't monolithic. We've also argued that this is true for systems and institutions too, and that because of their scale there is a *huge* stake in the battle that wages, that moves back and forth between ideal and pathological forms.

We can't purge the pathologies of a Secular age from our midst. But we can make better choices, choices that open up more promise than peril in our modern life together.

The Scandal of Subtler Languages

My gut tells me everything I need to know.

<div align="right">Olivia Pope</div>

Olivia Pope doesn't use her magic for evil; she uses it for good. Olivia Pope doesn't move Heaven and Earth and further corrupt the justice system unless she knows at the end of the day she can put on the white hat and ride out of town.

<div align="right">David Rosen</div>

Scandal, the hit TV show that premiered on ABC in 2012, is less obviously dystopian than most of the pop culture we've been exploring in this book. Set in Washington, D.C., the show tells the story of Olivia Pope, the best "fixer" in Washington, who specializes in making problems (like affairs and murders) go away for her clients — typically wealthy, well-connected public figures.

One of the most famous of these is Fitzgerald Grant, the president of the United States, with whom Olivia is also having a torrid on-again-off-again affair, sometimes behind the First Lady's back and sometimes with her full knowledge. The show also features Olivia's team of lawyers and associates, as well as the president's chief of staff and a shadowy organization called B613, which, it turns out, is run by

Olivia's father (her mother having turned out to be an international terrorist).

Scandal is the soapiest of soaps, with intrigue to spare by the barrelful. It portrays a White House in which any attempt at governance has all but been abandoned. The only organization that presents a halfhearted attempt at talking about things like patriotism is the shadowy B613, which, it turns out, is really in it for their own power grab.

There's an attempt throughout *Scandal*'s muddy ethics to reach for idealism; Olivia and others speak about "wearing the white hat," which means doing things for the right reasons, even if they are the wrong things to do. And they often are: at one point in the show, Olivia begins laughing, realizing that (quite literally) everyone close to the president and everyone running for the presidency is guilty of murder. The one character who stands for the rule of law is beaten down until he finally gives up his morals, after which he is rewarded with the position of attorney general.

So the dystopia of *Scandal* isn't so much material as moral; we're left with the form of a republic, but without any moral consensus on which it could rest. Without some kind of moral horizon, government is merely a structure for power and control, not flourishing. A moral apocalypse has occurred long before the show begins.

Furthermore, *Scandal* functions as apocalyptic literature by pulling back the curtain on something important about us. In its third season, *Scandal* pulled in nearly twice as many viewers (8.3 million) as *Game of Thrones* (4.4 million) and broke through traditional demographic barriers, such as race and economic bracket. It's watched by the Obamas and in the bars of Brooklyn, by critics and audiences alike. And in 2013, it was described by the *Los Angeles Times* as the most tweeted-about show in America.[1]

Its immense popularity is hardly accidental; certainly some of it has to do with its strong African American female lead (still a rar-

1. Mary McNamara, "'Scandal' Has Become Must-Tweet TV," *Los Angeles Times*, May 11, 2013, http://articles.latimes.com/2013/may/11/entertainment/la-et-st-scandal-abc-social-media-20130511.

ity on American television), but it also stands to reason that something — or some things — about the show "resonate" with viewers. Sure, there's romance and fear and friendship, but in truth, it's all about power games. And perhaps those games ring true because the show's moral apocalypse reflects what a lot of people secretly suspect about Washington: that elected officials are more interested in their own power and their own affairs than in anything like the common good.

Manner and Matter

That idea — that a show "rings true" with viewers — is a curious one in the age of authenticity. In the past, art-makers and writers were able to rely on what Charles Taylor calls a "common language of reference" to trigger ideas and subtle associations in their audience's minds. Today that language is largely gone, and we must explain the symbols and references to ancient mythology, the Bible, and so on to modern audiences in order to interpret works from the past properly. Nor, says Taylor, can we appeal to many widely accepted ideas — for instance, the existence of God, the divine rights of kings, and so on. Artists, writers, speakers, and so forth can't "draw on the simple acceptance of the formerly public doctrines," Taylor says.[2]

Instead, Taylor points out, in a modern age of authenticity, artists must appeal to the individual reader, viewer, or listener. How do you appeal to an individual? You appeal to the things they respond to: their individual tastes or preferences, shaped by their individual experiences. The artists — the "poets," as Taylor calls them — "make us aware of something in nature for which there are as yet no adequate words. The poems are finding the words for us."[3]

What he's getting at is this: artists once could count on their audience to have a framework for interpreting their art, whether it

2. Charles Taylor, *The Malaise of Modernity* (Toronto: House of Anansi Press, 1991), p. 84.
3. Taylor, *The Malaise of Modernity*, p. 85.

was a common symbol, a familiar character, or a memorable phrase lifted from somewhere else. The point was that this "shared language" or "public doctrine" was something *external* to the audience. It came from the society around him or her. It wasn't something they found within themselves; it was something they learned from those around them.

But artists in the modern age tend to work with something different to reach their audiences. They talk about experience "not through already-established 'languages,' but through new ways of talking," as Taylor puts it — a "watershed."[4]

What is Taylor talking about? It's something like what we mean when we say that something "moved" us. What we don't mean is that its appeal to ancient literature is so profound that we are bowled over. We mean that something happened *within* us — that the artist articulated his or her own existence in a way that plucks a string in us. It resonates with our emotion, our particular view of the world: the things that terrify us, that evoke desire within us, that make us love, or fear.

This is a very brief and general way of explaining the break with representationalism that happened over the modern period in visual art. No longer are artists interested in *what* you see and the message it portrays, but rather the *experience of seeing.* They want to make you feel what it is to see the world through their eyes, to experience existence in a new way. Artists' distinctive styles — like Shonda Rhimes's noted dialogue in her shows like *Scandal* — can give you a sense of what it's like to see the world from their vantage point.

To do this, they must interpret their own existence, and then find an audience who connects with that experience. So today we talk about "liking" and "not liking" works of art based on whether they "resonated" with us, and we take it for granted that different people like different things, based on who they are and what their life experience has been.

We can see this shift in apocalyptic literature itself. As we explored in Chapter Three, in the ancient and medieval worlds, apoca-

4. Taylor, *The Malaise of Modernity*, p. 85.

lyptic literature frequently pointed to religious frameworks and entities as a way to help explain what would happen at the end of the world. While there was certainly belief attached in many cases, these also functioned as helpful shorthand; one knew that a god was evil, or a figure was heroic. But in our secular apocalypses, we only evoke those figures and tropes as plot devices, as in the HBO post-Rapture show *The Leftovers,* which takes place in a world in which the Rapture — the inexplicable disappearance of a large number of people that some evangelicals believe will happen before Christ's second coming — has happened. In the universe of *The Leftovers,* the Rapture hasn't proven one religion "right," but has spawned dozens of cults and belief systems — so the show is about grief, not an exploration of a particular theology.

Creators of shows like *Scandal* certainly understand how this works. The show is deeply melodramatic, with musical cues and lines of dialogue that point to its viewers' desire to be desired, loved, and wanted. Its talk of the "white hat" does not appeal to anything in particular, except a vague shared mythology of the "good guy" in a Western; rather, we instinctively know that it's about wanting to be seen as the "good guy," because that's what many of us want. Its (sometimes overwrought) scenes of romance and love are punctuated by scenes of terror and torture, which provoke a visceral reaction in the viewer.

Another dystopian series that does this is *The Hunger Games* (which we'll explore more thoroughly in the next chapter). It shocks, at first, with its premise: teenagers sent to fight to the death in an arena for sport. This is sad and terrifying, a feeling that carries over from the books to the movies. Of course, the historically informed recognize that *The Hunger Games* series draws heavily on Roman mythology and history, with characters named for various figures from Roman political history and the clear Coliseum imagery.

And yet it's a series for teenagers, many of whom never seem to pick up on the "preexisting lexicon of references" it evokes, as Taylor would put it. Like *The Leftovers,* it borrows imagery without relying on its readers or viewers to pick up on the references in order to make sense of the story. Instead, audiences experience fear, courage, love,

triumph, and devastation along with the characters. Like most works of secular apocalypse, it appeals not to shared *beliefs* in a society but to shared *experience* between the artist and the audience.

Connecting on a Different Level

This points to an important myth proposed by the critics of the age of authenticity and rebutted by Taylor. Critics, he says, have argued that the fact that we are all on the search for our authentic selves means that we must *necessarily* become atomized and detached from any greater order — any system of belief, any shared value or institution. And Taylor agrees: "A lot, both institutionally and ideologically, is going for atomism and instrumentalism. But, if my argument is right, we can also struggle against it."[5]

In other words, the sort of radical individuality and view of humans as tools, not beings with dignity, is a possible if not probable result of our age. But it's not a *necessary* one, and it tends to undercut what the search for authenticity is really all about: a feeling that I am special, unique, living up to my full potential, and significant because of my choices — things, as we've seen, that can only be developed against a "moral horizon" and in relationship with others.

So to say that atomism and instrumentalism are *necessary* results of our focus on the individual is a misunderstanding of what the search for authenticity is all about. It takes the action of the search for one's original self and conflates its *manner* and its *matter* or content, says Taylor. Today, we are compelled to look inward for our authentic selves — that is the "manner" of action, the inward search — but that doesn't mean that what we come up with must be self-referential. I don't have to come up with everything from my own head.

Taylor says that it's not true that "my goals must express or fulfill my desires or aspirations, *as against* something that stands beyond these. I can find fulfillment in God, or a political cause, or tending

5. Taylor, *The Malaise of Modernity*, p. 103.

the earth. Indeed, the argument above suggests that we will find genuine fulfillment only in something like this, which has significance independent of us or our desires."[6] In other words, if my search for authenticity, for my true self, means I wind up discovering my passion is environmentalism, or caring for orphans, or serving God — that's still my authentic self. Just because what I discover is *my* identity doesn't mean it can't be made up of things that come from beyond me — and, conversely, the fact that I derive my identity from an order bigger than me doesn't mean I am somehow selling out. The content of my authenticity, my very real self, can certainly come from outside of me and connect me to a greater order.

So now we can circle back to what Taylor, following the poet Percy Shelley, calls the "subtler language of authenticity" embedded in art, the themes we find in someone else's experience that resonate from *within*. This is, perhaps, a reason that art has been described in modernity as replacing religion. If the more pathological form of the ethic of authenticity tries to get us to eschew institutions and orders beyond ourselves, then art is the place where people are still able to make meaning and feel as if they've connected with others and with an order higher than themselves. To people who instinctively locate their significance from within, rather than from an external institution — like a political party, a religious organization, or socially defined role — art can connect on the level they understand.

So what's needed to unite people and avoid the slide to subjectivism is a focus on these "subtler languages" that help unite people to a cause or an experience that resonates from *within*. Art articulates something that becomes our own, says Taylor, by being "ratified afresh in the sensibility of each new reader."[7] For a work of art to connect with its audience today, it must work with what Taylor calls a "language of articulation" that is "rooted in the personal sensibility of the poet, and understood only by those whose sensibility resonates like the poet's."[8]

6. Taylor, *The Malaise of Modernity*, p. 83.
7. Taylor, *The Malaise of Modernity*, p. 87.
8. Taylor, *The Malaise of Modernity*, p. 87.

Art gives voice to our experiences, taking our big abstract ideas and philosophies and putting feet on them in the form of images, stories, sounds, and experiences. They connect with us because the way the creator expresses his or her own experience strikes a chord in our own souls as well. In Taylor's terms, the "language of articulation" isn't about references drawn from an external order, but from within ourselves. So to connect with other people today, we must call on the individual's intuitions and experiences rather than on a shared language that comes from a source beyond us (historical or theological or mythological). The viewer wants to feel as if he or she is participating in creating meaning before responding to any of its content — and therefore audiences tend to become strongly connected to the content of stories or works of art. The work feels like a "part" of the individual audience member because they have participated in the meaning-making work. So we get fandoms, and fan fiction, and fan conventions, because the art doesn't just belong to the artist: it belongs to the audience member as well. Their "sensibility resonates like the poet's," in Taylor's words.[9]

Here again, it may seem as if this more modern way of making and experiencing art necessarily means that people become more and more disconnected from one another — sure, the artist and the audience may connect, but they're only connecting on whatever might strike both their fancy. An artist can't count on his or her whole audience connecting to a "publicly accessible domain of references," but just hope that an audience member has the "same domain" as their own, the same language — which comes from life experiences, social context, personality traits, and so on.

And yet, once again, we needn't mistake the *manner* of connection — a privately derived language of articulation — with the *matter*: that is, with the content of art itself. "It by no means follows," Taylor says, "that there has to be a subjectivation of *matter*, that is, that post-Romantic poetry must be in one sense exclusively an expression of the self. This is a common view," he reminds us. But "the effort of some of the best modern poets has been precisely to articulate something

9. Taylor, *The Malaise of Modernity*, p. 87.

beyond the self."[10] Later, he reiterates this, saying that "the inescapable rooting of poetic language in personal sensibility doesn't have to mean that the poet no longer explores an order beyond the self."[11]

In other words, art that connects maker with audience through an appeal to their shared individual traits needn't be hopelessly subjective and relativistic. This is where things get interesting, because the question presents itself: Where do these "languages of articulation" come from? What is it that shapes us so that we might resonate with someone else's work of art?

Certainly some of this is innate, based on things like personality and taste. But a great deal of it is based in our shared experiences, which we acquire over the course of our lives. Someone who grows up in a family in which sarcasm is used to hurt others, for instance, will react differently to a character in a novel who speaks sarcastically than someone who grew up in a family in which sarcasm was used to express affection. The schools we went to, the art and entertainment we were exposed to, your family, our experience with government, money, and even the police — all of these things shape how we respond to works of art.

What does that mean? It means that our "languages of articulation" are shaped, in a great sense, by the *institutions* that are the building blocks of our order: marriage, family, markets, art and entertainment, government and the state. This is where our desires and fears become solidified and codified, and it's where they are continually challenged and shaped throughout our lives.

So this is important: while we discover our authentic selves, our particular ways of being, from within — from being true to ourselves — as Taylor suggests, "perhaps we can only achieve it integrally if we recognize that this sentiment connects us to a wider whole." And art can help us do that. Taylor muses: "Perhaps the loss of a sense of belonging through a publicly defined order needs to be compensated by a stronger, more inner sense of linkage. Perhaps this is what a great deal of modern poetry" — by which he means art in general — "has

10. Taylor, *The Malaise of Modernity,* p. 88.
11. Taylor, *The Malaise of Modernity,* p. 89.

been trying to articulate; and perhaps we need few things more today than such articulation."[12] Our stories of apocalypse are part of this.

This shows up in *Scandal,* where characters are continually thwarted from their best plans and ideals — governing the country, protecting the Republic, doing what's right, loving monogamously, "wearing the white hat" — by their untamed, undisciplined desires, which enslave them and take away their freedoms. Those desires most often take the form of either powerful sexual attraction (as in the ongoing affair of Olivia and the president, or in a fourth-season affair involving chief of staff Cyrus Beame) or overwhelming drive for power and influence (which leads Mellie, the First Lady, to make a host of bad decisions over the course of her career, and which infects both of Olivia's parents as well as David Rosen, the beleaguered public servant and sometime murderer). The wealthy, influential clients Olivia works with do something bad — kill someone, for instance — and need the problem to "go away." Sometimes it works. Sometimes it only works for a while. But it utterly distracts from the business of running the country and serving the common good, something that seems to rarely if ever arise in the show.

That means that in *Scandal,* the institutions themselves — almost across the board, from family and marriage to government, military, business, law, everything — have nearly fallen apart because of a hedonism, desire run amok, which allows the wealthy and powerful to get away with anything. And yet that subtler moral language of the "white hat" lets the characters tug at a desire many of their viewers might have: to feel like one of the good guys. No matter what you're actually *doing* (sleeping with the president, planning to torture someone), the white hat is your symbol of moral clarity, and is also the prevailing visual and spoken metaphor in the show, from subtle wardrobe choices to episode names and lines of dialogue.

What counteracts and threatens this is an actual coercive tyranny that (not insignificantly) is meant to "protect the Republic": B613, the shadowy covert-ops group that operates not just undercover, to the extent that most citizens aren't aware of its existence, but also out-

12. Taylor, *The Malaise of Modernity,* p. 91.

side the law entirely. They install bugs in apartments and use video cameras and other technologies to keep tabs on (and, sometimes, wreck) the lives of people who get in their way; one of Olivia Pope's own associates is a former agent who can still use his knowledge to empty bank accounts, trace movements, and do other things most of us wouldn't know how to start doing. Apparently, if the Republic is falling apart because its institutions are rotting from soft tyranny, the only thing that can keep it together is power wielded through threats, violence, and blackmail, all enacted without any regard for the law or even for the power vested in the office of the president. It's ugly. But it works.

This picture of D.C., by all insider accounts, is not modeled on how governance actually works — which is actually much more mundane. But it is popular because it resonates — it taps into a "subtle language" spoken by many viewers, one that feels keenly, in a Secular age, the struggle that emerges when the background horizons are uncertain. Do you go with your gut? Do you follow your heart? Or do you have other responsibilities, other people, other higher orders to consider?

All this is exacerbated by and exemplified in a growing distrust in institutions — and that is where *Scandal* points us next: to an explicitly dystopian culture in which political unrest has been tamped down by the gruesome spectacle of teenagers forced to fight to the death on reality TV. Feel disgusted? Good. Let's see why.

CHAPTER 10

May the Odds Be Ever in Your Favor: Learning to Love Faithful Institutions

What must it be like, I wonder, to live in a world where food appears at the press of a button? How would I spend the hours I now commit to combing the woods for sustenance if it were so easy to come by? What do they do all day, these people in the Capitol, besides decorating their bodies and waiting around for a new shipment of tributes to roll in and die for their entertainment?

Katniss Everdeen

District 12: where you can starve to death in safety.

Katniss Everdeen

In March 2014, the Pew Research Center released a report[1] showing that American Millennials — ages eighteen to thirty-three — are relatively unattached to institutions. Half of all Millennials (50 percent) describe themselves as political independents; three in ten (29 percent) say they are religiously unaffiliated. "These are at or near the

1. Pew Research Center, "Millennials in Adulthood: Detached from Institutions, Networked with Friends," *Social and Demographic Trends,* March 7, 2014, http://www .pewsocialtrends.org/2014/03/07/millennials-in-adulthood/.

highest levels of political and religious disaffiliation recorded for any generation in the quarter-century that the Pew Research Center has been polling on these topics," according to the report. In addition, 26 percent of Millennials between the ages of eighteen and thirty-two are married, as opposed to Gen Xers polled in 1997 (36 percent), Boomers polled in 1980 (48 percent), or Silents polled in 1960 (65 percent).

Most tellingly, however, Pew also found that Millennials are far less trusting of others than previous generations: "In response to a long-standing social science survey question, 'Generally speaking, would you say that most people can be trusted or that you can't be too careful in dealing with people,' just 19% of Millennials say most people can be trusted, compared with 31% of Gen Xers, 37% of Silents and 40% of Boomers."[2]

The report names a number of possible reasons for this unprecedented level of distrust, including the increased racial diversity and economic hardship that Millennials experience. But it's intriguing to note that the study also found that Millennials were more upbeat about America's future than older generations — 49 percent said the country's best years are ahead, while only 42 percent of Xers, 44 percent of Boomers, and 39 percent of Silents agreed — which admittedly can be explained away by noting that young people are often more optimistic than older people. However, they're also more optimistic than Boomers were when polled at the same age, in a 1974 Gallup study, which found that only about half of adults under thirty were optimistic about the country's future. (Seven in ten adults over thirty were optimistic in the 1974 study.)

This is remarkable, given that Millennials are saddled with financial burdens (beginning with student loans) more than preceding generations — and over half (51 percent) say they don't expect any money to exist in Social Security by the time they retire. Thirty-nine percent say the system will only be able to provide them with reduced retirement benefits. Only 6 percent of Millennials expect to receive Social Security benefits at the levels their grandparents are currently enjoying.

2. Pew Research Center, "Millennials in Adulthood."

What the Pew study reveals is that Millennials are more un-moored from and distrustful of institutions than their parents and grandparents, but more optimistic about the future of their country. They are less economically stable and affluent, and less sure that the institutions their grandparents rely on — like Social Security and marital stability — are worth trusting, and they're less certain they can take other people at their word. They don't like political parties (though they tend to vote liberal) and tend not to identify with reli-gious institutions, but they think the social future is relatively bright.

How do these contrasts fit together? Is it just blind optimism? Is it individualism run amok?

The chorus of voices forecasting doom and demise based on these statistics see it as yet another example of how we are more and more fragmented today — how we have fewer things left that we agree on as a society, and therefore we are destined for ruin. Certainly some of this pessimism is merited. Sociologists have noted for decades this increased isolation and fragmentation — "atomism," as Charles Tay-lor calls it — that leads to a concurrent increased focus on our own personal values and choices. Taylor puts it this way:

> This culture has seen a many-faceted movement that one could call "subjectivation": that is, things centre more and more on the sub-ject, and in a host of ways. Things that were once settled by some external reality — traditional law, say, or nature — are now referred to our choice. Issues where we were meant to accept the dictates of authority we now have to think out for ourselves. Modern freedom and autonomy centers us on ourselves, and the ideal of authenticity requires that we discover and articulate our own identity.[3]

And yet, young American adults don't seem to think that their detachment from institutions, their mistrust of others, and their rela-tive economic instability both now and in the future necessarily mean the world is going down the tubes. The Pew research also shows that,

3. Charles Taylor, *The Malaise of Modernity* (Toronto: House of Anansi Press, 1991), p. 81.

compared to older generations, Millennials connect to more people on Facebook and share more pictures of themselves with friends than other generations by far — and while their "digital native" status helps explain some of this, it doesn't explain all of it. Millennials are making connections with more people, even if those connections might be tenuous, and sustaining them over a longer period of time via the Internet, than their parents and grandparents are.

What does this mean?

In this chapter, we're nearing the end of our journey through an apocalyptic wasteland strewn with zombies and Cylons, meth labs and operating systems, dragons and blood. We've looked at how these revelatory texts make clear our dependence on an ethic of authenticity, how they surface the anxieties of our age, and how they illustrate both the pathological ways these can develop and the ways they can be turned toward flourishing and good.

So in this chapter, we'll explore how the loss of a common public language to which we can all refer doesn't *necessarily* have to lead to extreme narcissism, nor does it naturally mean that Millennials or anyone else who is on the hunt for authenticity *has* to be disconnected from institutions. Instead, we argue that institutions are vital structures in which we can discover our authentic selves and pursue freedom — escape Max Weber's "iron cage" — while also uniting and connecting with one another through a "common consciousness," which appeals to what Taylor calls the "subtler language of authenticity."

To do this, we're going to look more closely at the wildly popular dystopian series that has captured the imaginations of millions of readers and viewers: *The Hunger Games*. At its core, this is a deeply political story that also explores whether and how deep human connection is available to those living in combative times. Like *Scandal,* it turns on a zero-sum power game of the sort that the social theorist Michel Foucault wrote about. And like *Scandal,* it is both deeply pessimistic about the corruption that power can bring and distrustful of institutions.

And yet, *The Hunger Games* helps point us toward exactly why it is so important for distrustful, disconnected Millennials to dig in and do the hard work of institution-building.

In brief, the setup is this: set in the country of Panem (a thinly disguised futuristic United States), the story's apocalypse happened a century earlier, when an uprising against an oppressive government ended with a squashed rebellion and the institution of the "Hunger Games": a yearly competition in which each of Panem's twelve districts are made to send two "tributes" — two teenagers, one boy and one girl — to the Capitol to take part in a Coliseum-style fight to the death, broadcast as a reality show to all twelve districts. The games are the event of the year, especially in the wealthy Capitol.

The heroine of the story is Katniss Everdeen, a brave girl from the poorest district who volunteers as tribute to keep her little sister Prim from having to enter the arena. The trilogy of books and the films adapted from them follow Katniss and her partner in the arena, Peeta Mellark, as they fight for survival and eventually are recruited by the underground resistance to spark another rebellion. Along the way, they discover dark truths about their world, and experience being trapped in what we might call the "iron cage."

The Iron Cage

In the last chapter, we argued that our stories of apocalypse lean on the "subtler language" that articulates our felt experience. If those stories are wildly popular precisely because the language of articulation used by the "poets" is connecting with something that audiences feel — like fear or desire or even anxiety and paranoia — then it's true that one way to help diagnose those collective anxieties is to closely observe our apocalyptic pop culture. We've seen that we're afraid of being reduced to cogs in a cosmic wheel, of not experiencing love, of being dominated by stronger forces, of losing control of our own destinies. We fear not having the power to self-determine because of powers imposed from outside of us. In the age of authenticity, we need to know that we're free to discover and pursue our true selves.

We can see all of this in the picture of a dystopian Panem given by *The Hunger Games,* which was written for teenagers but has an audience far beyond. The districts of Panem each produce a different

resource — iron, lumber, food, and so on — and they exist largely to supply the residents of the ludicrously affluent Capitol. Each district has a different degree of freedom, based on how much money its resource brings in. Katniss Everdeen lives in the poorest part of District 12, the coal mining district (which, it seems, is located in Appalachia).

The districts are under constant threat of surveillance, accomplished through visits from peacekeepers and flyovers from drone-like machines that keep tabs on the activities of the residents, especially if they venture outside the district and into the wilds to find food — as Katniss and her best friend Gale sometimes do. But more importantly, the games themselves exist to remind people in the districts that the Capitol is in charge. Each district is forced to enter all teenagers in the lottery so they can potentially participate in the annual games. Once the games are underway, they are broadcast to giant screens placed in the districts. It's a constant, ugly, frightening reminder that the authorities in the Capitol can do what they want, when they want, to whomever they want — even children.

This surveillance and constant threat of force exist largely because the Capitol's technologies let it watch citizens and force citizens to watch its propaganda. They can hate it, or rebel, but when the trilogy opens, these technologies have kept a relatively large group of people spread over a sizable landmass in check. Citizens are not people; they are tools for the Capitol to keep itself supplied, comfortable, and entertained. This is instrumentalism. This is tyranny. The totalitarian control that the Capitol exerts over the districts is an oppression reminiscent of George Orwell's dystopian novel *1984,* in which coercion, threats, and violence give a cultic nation-state power over its people.

On the other hand, there is a second kind of tyranny present in *The Hunger Games,* something that's perhaps less obvious, and therefore more insidious. It's reminiscent of the vision of a dystopian future presented by Aldous Huxley in *Brave New World:* a thinly veiled enslavement of the circus in the Capitol. In this sort of oppression, citizens are enslaved not by threats of coercion but by their own hedonistic desires and excess. And the Capitol is a hedonistic world, modeled on the Roman Empire at the height of its image-obsessed, self-gorging, bread-and-circuses excesses. This has become such a nor-

mal way of life for the residents of the Capitol that it barely registers to them that the Hunger Games are *real* — in their minds, this is all pageantry and entertainment, but the fact that twenty-four teenagers are about to fight to the death and *actually die* isn't a real problem, as long as it's entertaining.

So, distracted by the entertainment and thus numbed to the true injustices that are taking place within their country — since they don't affect them directly — the residents of the Capitol fall victim to a "soft tyranny," one in which they are so enslaved by their own hedonism that they don't see what's really going on around them. In essence, blind consumerism keeps the people happy and oblivious while their freedoms are taken away from them little by little. They are sedated by screens. In this way, *The Hunger Games* functions as a biting critique of entertainment culture, suggesting that we trade awareness for the soft, drug-like mesmerization of entertainment and excess.

The Hunger Games, therefore, gives us a picture of what Max Weber called the iron cage of modern institutions and systems taken to its logical, perverse conclusion. In Weber's understanding, technology (in particular) locks us into tyranny, either through control by an all-powerful surveillance state or by coaxing us to give in to our worst hedonistic desires and therefore numbing us to the social problems and injustices that go on around us. The means are distinct, but in both of these forms we lose our freedom.

The Hunger Games — and *Scandal* too, as we demonstrated at the end of the last chapter — gives us a picture of the iron cage, something Weber thought was inevitable in a technological age: a loss of freedom. These stories resonate with us partly because the ideals of courage *(The Hunger Games)* and the white hat *(Scandal)* feel true to us. We feel anxious about losing freedom either to a powerful force beyond us (a tyrannical government or terrorist organization), or to our own undisciplined selves.

Taylor says there's something to these iron cage pictures. But, unsurprisingly, he's not with Weber in thinking this is the *necessary* end of our age — "it simplifies too much and forgets the essential."[4]

4. Taylor, *The Malaise of Modernity,* p. 98.

What is "the essential" that he's talking about? It's that humans are hard to predict. Sometimes we do things that don't make sense. We form alliances. We love others and sacrifice for them. We choose to deny ourselves and give away our resources to the less fortunate; we rebel against the feeling of having our freedom removed. Taylor puts it this way:

> Human beings and their societies are much more complex than any simple theory can account for. True, we are pushed in this direction. True, the philosophies of atomism and instrumentalism have a head start in our world. But it is still the case that there are many points of resistance, and these are constantly being generated.[5]

Later, he says that "the predicament alters when there comes to be a common consciousness"[6] — that is, the iron cage can only become a cage when people are truly, radically individualistic and atomized. When individual citizens are not in agreement with one another about anything that is important for common life together, then it is easy for tyrants to take over, or it is easy for individuals to throw up their hands in defeat and choose to withdraw from civic participation.

That is why part of the Capitol's strategy is to pit districts against one another, and pit children within those districts against one another — there can only be one victor in the arena. And that's also why it is such a threat to a tyrannical government, in Panem and otherwise, when citizens unite together around a common idea. In fact, Katniss Everdeen is eventually recruited to be just that — a symbol: the Mockingjay. But it's also why the salute she gives in the story, which eventually spreads to other districts as a symbol of rebellion against the restrictive Capitol, was picked up by viewers of the film in Thailand. In 2014, *The Atlantic* reported that "five Thai students were detained for using the salute during a speech by Prime Minister Prayuth Chan-Ocha":

5. Taylor, *The Malaise of Modernity*, p. 99.
6. Taylor, *The Malaise of Modernity*, p. 100.

According to the Bangkok Post, the five, who were wearing anti-coup apparel, were pulled away by military police. Parroting the language of The Capitol, they were remanded to a military camp for an "attitude adjustment."

On Thursday, three more students were detained in Bangkok after they handed out free tickets to a screening of the film. As Reuters reported, one student, after using the salute in front of the movie poster, explained: "The three-finger sign is a sign to show that I am calling for my basic right to live my life." She was then taken away.[7]

Taylor says that one of the ways to struggle against atomism, instrumentalism, and this double-loss of freedom that happens in the iron cage is to retrieve "some of the richer moral background from which the modern stress on instrumental reason took its rise."[8] Here, again, he is signaling something like what he said early in his critique and has repeated over and over: that authenticity *itself* is not the problem, since it derives from something a lot like what the Thai student called the "basic right to live my life," or what we've been calling finding our particular way of being human. This is in harmony — or it can be — with the idea that each individual person is created in the image of the Creator and has dignity and worth based on that fact.

And so, perhaps uniting over freedom — the rebellion in Panem, or what we can only hope will one day happen in the soft dystopia of *Scandal*'s D.C. — is a way to find common ground and fight the soft tyranny of excess on the one hand and the controlling tyrants on the other. "Coming to understand the moral sources of our civilization can make a difference in so far as it can contribute to a new common understanding," Taylor writes.[9]

7. Adam Chandler, "When Life Imitates *The Hunger Games* in Thailand," *The Atlantic*, November 21, 2014, http://www.theatlantic.com/international/archive/2014/11/five-arrested-the-hunger-games-three-finger-salute-thailand/383020/.
8. Taylor, *The Malaise of Modernity*, p. 103.
9. Taylor, *The Malaise of Modernity*, p. 101.

Rethinking Institutions

But there's a problem with stories like *The Hunger Games* and *Scandal* and some of the other stories we've been exploring throughout this book. Here is the issue: these stories tend to present a deeply, fundamentally flawed view of what institutions are, what they do, and how they contribute to our social prosperity and flourishing.

In *The Hunger Games*, Katniss is fated, over and over, to discover that every institution or governance structure she is part of — from the Capitol to the underground District 13 to the rebellion's leaders — turns out to just be a power grab. In its deeply cynical portrayal of the world, anyone with power *ought* to be mistrusted. Similarly, in *Scandal*, everyone is attached to an important institution: Fitz, Mellie, and Cyrus to the White House; Olivia's father and boyfriend to B613; Olivia and her employees to Olivia Pope & Associates. But characters switch allegiances to institutions based on wherever they can get what they want, and throughout the show nearly every character belongs, in some manner, to at least two of these institutions. Even the Bible-thumping, (sometimes literally) backstabbing vice president winds up ditching her ideals from organized religion to political pragmatism in her own bid for power. Even if you talk a big, idealistic game, the point of institutions, in this case, is ultimately to gather power for yourself to protect yourself.

The only times we can see hope for humanity — meaning, the only times we are relatively certain that what we're seeing characters do is a genuine act rather than a ploy of some sort — is when a love relationship of some kind exists between characters, whether it is romantic, familial, or friendship. This is true in the arena, true in the districts, true in the Capitol, and true in D.C.

So what we get is a view of institutions that is decidedly dystopian: no good can come of them. This lines up well with Millennials' state of mind; as we've seen, young people are reluctant to align with any institutions, from organized religion to political parties to traditional familial structures. And of course, this is hardly unique to people born in the 1980s and later; it just looks different today than it did a half century ago.

Institutions aren't necessarily bad, and portraying them as such (in many shows, dystopian and not) might end up contributing to this general distrust. Yet the mistrust isn't unfounded. Millennials distrust institutions precisely because they have either imposed control without regard to the common good (as we see in totalitarian governments and even in our own soft oligarchies), or because they quietly manipulate us through subtle languages that articulate our own experience and desires — think of the Obama campaign — but wind up failing to deliver on their promises.

In his book *Playing God*, Andy Crouch, following many sociologists, defines an institution as "any deeply and persistently organized pattern of human behavior."[10] He describes institutions as comprising four components: artifacts (the things that people make, like books and objects, that are identified with the institution); arenas (the places in which the institution's activities are enacted); rules (the written and, more often, unwritten laws and guidelines that govern how people act in the institution); and roles (the various parts different people play within the institution). Furthermore, Crouch says, "institutions create and distribute power,"[11] which is simply a resource that some people have that allows them to successfully propose a new cultural good or idea.

Let's briefly walk away from dystopias (or not, depending on your view of human culture) and think of the institution of literature and literary production, which you're participating in right now. The artifacts in this institution include books, of course; they also include Kindles and e-book readers and bookmarks and book lights and bookstores both virtual and brick-and-mortar. Other artifacts include M.F.A. programs, style guides, book parties, notebooks and websites for tracking your book reading, book review supplements in newspapers, and so on. There are more, but you get the idea. The arenas for the production of books such as this one are (we hope, anyhow) quite broad: the readership for the book (curious, literate people who can

10. Andy Crouch, *Playing God: Redeeming the Gift of Power* (Downers Grove, IL: InterVarsity Press, 2013), p. 169.
11. Crouch, *Playing God*, p. 170.

understand the English language and are interested in the topic), plus, perhaps, the stores or other places in which the book might be sold.

The rules surrounding the institution of publishing in North America, where this book will be released, are certainly codified; both the United States (where Alissa is from) and Canada (where Rob is from) have laws about copyright and copyright enforcement — though they differ greatly, which makes Canada the butt of roughly a quarter of Alissa's jokes. And there are rules that are all but codified about how to properly cite sources and the format for books that will go into the Library of Congress, and so on. But there are other rules too — unwritten ones. For instance, it's now virtually a rule, though not in law, that authors must have websites and a presence on social media to have a book. There are also rules about what you should do to promote your book to readers that, though they differ from publisher to publisher and do appear in our book contract, are still virtually the same across the industry. Self-publishing has tried to dismantle these rules or change them, but they seem to remain the same.

All three of these things contribute to constructing the fourth — the "roles" within the institution. The important part for our discussion here is that all of these roles have different types of power attached to them that are uneven. We modern democratic people don't love the idea that some people have more power than others, and we write stories in which power is demonized, but yet it's true — and it doesn't *have* to be bad. For instance, as authors, we obviously have a great deal of power over what goes into this book. But if we want it to be published, we must submit to the power of our editor and our publisher, whom we had to convince to publish it in the first place and who will still have final say over the manuscript. (We're sure they're very pleased to read that.)

Another role in the institution of publishing is the reader — you — which may seem insignificant at first blush, since there are so many of you (in our fantasies, millions and millions!). But readers have an incredible amount of power, because they are the wielders of the dollars that pay for the book, and that therefore convince the editors, publishers, and even authors that they have made a good choice in writing and publishing the book. If this book sells no copies, then the

readers (or potential readers) have wielded their power, signaling to both us and the publishers that we should be more cautious before publishing another book like this. If it sells a million copies, we all get a little (very little) more power in the form of money in our pockets. And then there are many other people — the booksellers, the book reviewers, the college professors who might assign the book, the tweeters and bloggers who might tweet and blog about it — who also wield power of a different sort.

This is what makes institutions: artifacts, arenas, rules, and roles. And these things and the power they *create* (book reviewers would have no power if everyone stopped producing books) can be used in good ways that help others prosper and gain more of their own power, or in ways that take away power and prosperity from others. In dystopian tales, we often see people with a great deal of power that comes from status and affluence using their power mostly to take away other people's power.

But Crouch, and Taylor, argue that it need not be that way. In fact, Crouch says that institutions that take away power from people are more of what he calls "idolatrous" institutions, which is to imply that they are the broken or pathological form of what they could be. To Crouch, idolatrous institutions promise a lot to their members, like power, prestige, prosperity, and happiness, but over time they demand more and more from participants, eventually breaking them and stealing whatever they had that was good — something we see over and over in *Scandal,* in which characters are broken or even killed, and in *The Hunger Games,* which ultimately ends pessimistically, believing there is no way out of this iron cage. Katniss's only hope of happiness is her relationship with Peeta, but even there, it's a dismal hope, tempered by PTSD and built not on a shared vision of the future but on shared scarring from the past.

What to Do?

There is another way — one that Christians believe in. If power can be used to prosper others, and not just for harm, then "faithful insti-

tutions" stand in contrast to their more pathological forms, the ones that show up in our dystopias.

The Hunger Games is quietly aware of this when it places all hope for any goodness in committed, loving, sacrificial relationships between people. After all, friendship and family are two of the oldest institutions, and friendship in particular is one that Millennials seem especially interested in reviving, with their much-talked-about efforts toward building friendships into a sort of family (the "urban family" phenomenon). What's important here is what undergirds these hopeful relationships: *love* and *sacrifice.*

What marks a faithful institution? It is one that is cognizant of its own power, and of how power is wielded within its roles and rules. In Chapter Five, we explored antiheroes as a way of pointing out that we seek the power to control our own destinies and discover our own ways of being, which is to say that what we want is freedom — exactly what the iron cage exists to keep us from. Instead, investing in faithful institutions helps us participate in power-creating and power-wielding in ways appropriate for our roles in the institution, whether that institution is political, religious, economic, social, or something else.

When a faithful institution recognizes the power it has — and recognizes that it functions best not when that power is centralized in one person but distributed appropriately among people in different roles — then it can begin to help its participants flourish and prosper rather than oppressing some while others wield control. This is a hard thing to imagine in a dystopian context, to be sure. But it becomes much clearer when one imagines, for instance, not the White House in *Scandal* (or *House of Cards,* for that matter), but in *The West Wing,* a proudly optimistic show in which, when it is at its best, the focus is on governance and mutual respect and the work of promoting the well-being of citizens. *The West Wing* even inspired people to work in policy and politics. Another non-dystopian show that does this well is *Parks and Recreation,* a comedy in which those who have authority in city government must sometimes make difficult decisions for the good of the citizens, but who also stand to lose their power if, for instance, the citizens decide not to reelect them.

Importantly, in these faithful institutions, personal alliances and institutional alliances are not in conflict. Instead, they work harmoniously, which means that friendships, respect, and personal relationships help bolster the work of the institution, and the institutional structure is a place in which those relationships can flourish.

The sad reality of our world is that our institutions often seem not worth saving — which is probably a reason why trust in them has been on a steady decline for a long time now. The twentieth century in particular gave us a detailed historical record of all the ways institutions manipulate, control, and harm their participants. And yet, if institutions are also the places in which power gets created, distributed, and wielded — and if they are the places in which individuals are united on a broader scale — then it seems important that Millennials, and their parents and grandparents, learn to love faithful institutions.

But how? It requires stories that shape our imagination in ways that help us see how institutions can work. This means these stories must not be didactic pronouncements from on high, which simply don't have the same effect on most people as they might have had in the past. People connect to narratives that call up an experience they've had, rather than a reference. So this means matching the language of articulation in a story to a deeper understanding of the moral horizon against which we become significant, against which our choices are ratified and given significance.

Of course, Christians and other religious people ought to understand this instinctively; those who are adherents to a religion are already attuned to the idea that a moral horizon of right and wrong exists, and gives us significance; and furthermore, we ought to understand the inherent dignity of every person because we know that God made each of us in his image. But Christians and other religious people have succumbed to classist, racist, and sexist ideas that shape how we act toward one another. So perhaps we need to start at home, talking with one another about what it means to interact with "others," and also — even more importantly — to fully understand what institutions are, to see how we are embedded within them, and to gain a biblical understanding of why and how institutions are affected

by the fall and by sin. We need to understand institutions better, and see how we are complicit in their brokenness even when we don't realize it.

There's more, though. A truly Christian love for our neighbors cannot stop at the church walls. We need to help our fellow citizens understand why institutions may not be a bad thing — to not *blindly trust* institutions again, but to be willing to *invest* in them. Part of how this must be done is by understanding the "subtle languages" that resonate with people today.

In our pluralist, Secular (capital *S*) society, which reaches continually toward the ethic of authenticity, it seems that the dignity of each individual is the right place to start. Certainly it's difficult to make sweeping pronouncements about what "we want these days," but it seems that a lot of arguments in North America start from the idea that we are all equal (it's in the founding documents) and that everyone ought to be treated as such. For instance, the recent activism around gay marriage in the United States has been framed, fundamentally, as a push for "marriage equality" — everyone is equal, proponents argue, no matter their sexual orientation, and it is oppression (remember the politics of recognition?) to deny the right to enter into the institution of marriage to two people simply because they are the same gender.

That argument, so hotly debated among religious groups, nonetheless surfaces the fact that what resonates with us and our experience — our "language of articulation" — is a deep-seated belief that someone like me ought to be treated like everyone else. Your experience is valid, and so is mine.

So an institution that recognizes the dignity of everyone and that values the freedom to pursue one's "unique self" is one that perhaps we can get behind. Promoting and serving institutions that uphold human dignity is hard work. It requires two things: imagination shaping storytelling that challenges us to reconsider our mistrust of institutions, and becoming what Andy Crouch calls "trustees" of institutions. Trustees, says Crouch, are people who can clearly see the problems and injustices that institutions can wreak — even ones that are trying, however falteringly, to be faithful institutions — but

who choose, anyhow, to spend their resources, power, and time on building them up.

This means that Millennials in particular need to get over their fear of institutions if we're not to end up subject to soft or coercive tyranny — if we're to escape the iron cage. Institutions are where we find that connection Taylor speaks of which helps us unite against the powers that would take away our freedoms. So Millennials may at times need to sacrifice their own hunt for originality (and fear of being misrepresented or misunderstood) in order to rejoin institutions like churches and political parties and universities and financial institutions and other organizations that have failed, to be sure, but that are also where the hard, good work begins and is fostered. To co-opt a line from a very non-dystopian show: clear eyes, full hearts, can't lose.

This is where the world is transformed. This is where we shift our dystopias not into utopias but into worlds where we help others prosper.

CHAPTER 11

On Babylon's Side

Faithful witness is an abstract ideal, which can take no form in the world as it is; compromise, therefore, is the law of our being, and no-one, not even Jesus himself, can get by without striking bargains.

Oliver O'Donovan, *Resurrection and Moral Order*

We must finally get over seeing modernity as a single process of which Europe is the paradigm. . . . Then the real positive work of building mutual understanding can begin.

Charles Taylor, *Modern Social Imaginaries*

When the three-year training period ordered by the king was completed, the chief official brought all the young men to King Nebuchadnezzar. The king talked with each of them, and none of them impressed him as much as Daniel, Hananiah, Mishael, and Azariah. So they were appointed to his regular staff of advisers. In all matters requiring wisdom and balanced judgment, the king found the advice of these young men to be ten times better than that of all the magicians and enchanters in his entire kingdom.

Daniel 1:18-20 (NLT)

The Hebrew prophet Daniel is an apocalyptic guy, so of course we've adopted him as our patron saint for this conclusion. We meet him first in the sack of Jerusalem by the Babylonian king Nebuchadnezzar. It turns out he's a total stud (Daniel 1:4 says he was "strong, healthy, and good-looking"), so he gets handpicked for the royal bureaucracy. The next time we meet him, he's on the fast track to imperial rock star. After a close brush with death, he impresses the king and gets minted chief of the wise men, or — to bring that title a little closer to our reality — secretary of state for magicians, prophets, and sorcerers. Or you could call him the chair of the Federal Reserve.

Daniel is our patron saint because religious people, especially evangelicals, often feel unsettled or out of place in this Secular age. Often, we religious types take a hard look at this popular culture of the politics of apocalypse, its crisis of individualist authenticity, its slide to subjectivism, its double-loss of freedom, and judge — not unintelligently — that this is all going to hell. And rather than tackle some of these big, pernicious pathologies of modernity head on, we soap up and wash our hands of the whole thing.

But Daniel didn't wash his hands. Daniel was a *faithful compromiser*.[1] He stood his ground when he had to ("Daniel in the Lions' Den"). But he made some deals when he didn't. Dragged from home, given a new name, the driving question of his life and mission was how to "sing the LORD's song in a strange land" (Ps. 137:4). His answer was what the sociologist James Davison Hunter might call *faithful presence,* or — maybe a bit more to the point — a faithful compromiser. He was on Babylon's side, rooting for his adopted homeland (the one he was dragged to against his will) not to flame out, but to prosper and flourish. And he didn't do it as an idle observer: he pulled up his socks and got in the game himself. He was the Jewish wizard of wizards *for* Babylon. At one point he even makes a desperate play to save his fellow sorcerers and diviners. He probably would have read Harry Potter unironically.

It can be hard to find anyone like Daniel. At the end of *After Vir-*

1. James K. A. Smith, "Faithful Compromise," *Comment,* February 27, 2014, http://www.cardus.ca/comment/article/4165/faithful-compromise/.

tue, the book that begins with the apocalyptic wasteland ripped from someone's HBO show treatment, Alasdair MacIntyre gets a bit down on the prospects of our Secular age. He writes:

> If my account of our moral condition is correct [one characterized by moral incoherence and unsettleable moral disputes in the modern world], we ought to conclude that for some time now we too have reached that turning point. What matters at this stage is the construction of local forms of community within which civility and the intellectual and moral life can be sustained through the new dark ages which are already upon us. And if the tradition of the virtues was able to survive the horrors of the last dark ages, we are not entirely without grounds for hope. This time however the barbarians are not waiting beyond the frontiers; they have already been governing us for quite some time. And it is our lack of consciousness of this that constitutes part of our predicament. We are waiting not for a Godot, but for another — doubtless very different — St. Benedict.[2]

We both agree and disagree with MacIntyre. The barbarians *are* in the city; the Cylons are in the walls; Frank Underwood is eyeing the White House; the dead are up and walking. These are apocalyptic times. But contrary to MacIntyre, we don't think we need *only* a new (albeit very different) St. Benedict.

We need new Daniels. Daniel, not Benedict, is the patron saint of the apocalypse.

The politics of apocalypse sorely tempt us to abandon any project for the common good — as if that phrase could even have intelligible meaning after the subjectivation of "common" and "good." But doing that would, ironically, actually double down on all those pathologies of modernity that Taylor is trying to help us see and avoid. Our disconnected, parallel paths of world and life view would split off; connections, consensus, and overlap would become increasingly spotty.

And yet we've headed in this direction. We can, and have, built

2. Alasdair MacIntyre, *After Virtue: A Study in Moral Theory* (Notre Dame: University of Notre Dame Press, 1981), pp. 244-45.

our own ghettoized modernities, subcultures complete with their own slang, their own products, their own websites.

That's not the lesson of Daniel. And it's not a work of *loyal opposition*. It yields the city to the barbarians. It's angry, cynical, and unfit behavior for modern people — to say nothing of religious people.

In this book we've shown a range of ways that things *can go bad* in a Secular age. But they don't *have* to. The battle rages in all directions, as Taylor says, and it's a battle that we not only should but must join to *realize the best of the motivating ideals of our age*. The barbarians are in the city, but so are we. Time to make some deals. It may be a strange land, but the Lord's songs can still be sung.

Daniel did it. And we can too.

Where Your Treasure Is, There Your Heart Will Be Also

One of the most basic philosophical questions you can ask is this: Who am I? In this book we saw that, today, we have some pretty unique ways of looking at that question. It is perhaps *the* driving question of the Secular age.

This is why apocalyptic coming of age stories like *Battlestar Galactica* transcend the cathartic boundary of trashy science fiction. That's why *Breaking Bad* and *Her* tell stories that get at the basics of who we are when we're pushed to our limits, when logical leaps are made, when pathologies are gamed out. These aren't just creative stories; they're our collective social anxieties aired on prime time. You can wax about ponderous philosophical tomes, or you can watch Theodore make love to his operating system.

There's nothing wrong with this big question of personhood. The human race has been asking it for thousands of years. What makes *our* age unique is the conditions within which the answers are given. What makes for a "person fully alive," in the much-abused exhortation of St. Irenaeus, is realized in relationship and dialogue with others, but it's also much more intensely personal than it's ever been before. It is about *my* own unique way of being human, and about the moral demand to hear my inner voice and inner self, and to be true to it.

The irony, which a little time in the meth lab or dating our operating system forces us to confront, is that while this all *sounds* very liberating, it can actually be pretty unsettling and stifling. This much-vaunted anthropocentrism — that it's just me figuring out what I should be, and whoever I invite into my inner circle of authenticity — is a kind of fairy-tale myth. We live with inescapable horizons. We live (to quote MacIntyre again) as barely more than the "co-authors of our own narratives. Only in fantasy do we live what story we please. . . . We enter upon a stage which we did not design and find ourselves part of an action that was not our making."[3]

This is what MacIntyre calls his central argument in *After Virtue*. The key question, to paraphrase him, is not about our own authorship. We can only answer the questions of who we are and how we should live if we answer the prior question: Of what story or stories do I find myself a part?[4]

This has always been true; it's just that now, we're aware, perhaps more than ever before, that it's possible to *choose* what story or stories we find ourselves a part of. Certain stories, in our view, have become optional. The horizons are now plural. We sweat it out deciding which one *fits* us, which story seems like it clicks with our inner self, our truest calling to self-realize and self-actualize.

And yet, this language of "choice" can be misleading. We can choose from a smorgasbord of stories to figure out who we are and what we will do with our lives, but it's not all that simple: our choice is *shaped* by those same stories. We are directed toward choosing to live in certain ways by the ways in which we are already living. What we *want* dictates what we *choose,* and what we want is shaped by how we *live.* At no point are we as persons completely free, unhooked and unmoored from all horizons. Before we are even aware of these stories, we live them. That's what Taylor means when he says that human beings operated with "social imaginaries" long before they got into the business of theorizing about them.[5] Because when we're talking

3. MacIntyre, *After Virtue*, p. 213.
4. MacIntyre, *After Virtue*, p. 216.
5. Charles Taylor, *Modern Social Imaginaries* (Durham: Duke University Press, 2004), p. 26.

about choice, we're talking about desire, and when we're talking about desire, we're talking about what we love. And theory usually follows love, not the other way around.

People like Andy Crouch and James K. A. Smith have written widely on these ideas that build on some of the basic insights of Augustine and Aristotle. In *Desiring the Kingdom*, Smith argues that human beings are not primarily theorists, worldview thinkers, and theologizers; at root, he argues, we are beings who *love* and *desire*. You are what you love.[6]

In *Caritas in Veritate* Pope Benedict XVI writes that desire is at the root of what he calls authentic development. "Development," writes Benedict in that encyclical, "needs Christians with their arms raised towards God in prayer, Christians moved by the knowledge that truth-filled love, *caritas in veritate,* from which authentic development proceeds, is not produced by us, but given to us."[7] Not all desires are created equal, he says. It is not merely desire that roots authentic development — it is *right* desire.

In the *Confessions* and *Teaching Christianity,* Augustine describes "the right order of love." Following Augustine, David Naugle writes in his book *Reordered Love, Reordered Lives* that the disordering of our desires is often at the root of unhappiness.[8] The reverse, that right ordering of love leads to a happy life, naturally follows.

But, Smith hastens to add, it's not all about *abstract* desire. Love is embedded in *practice*. Taylor says that "if the understanding makes the practice possible, it is also true that it is the practice that largely carries the understanding."[9] My *desire* is formed by my *habits*.

In *Culture Making*, Crouch says that repeated gestures eventually become postures, that *who* we are depends not just on which "story we find ourselves a part of" but also which stories we actually *prac-*

6. James K. A. Smith, *Desiring the Kingdom: Worship, Worldview, and Cultural Formation* (Grand Rapids: Baker Academic, 2009).

7. Benedict XVI, *Caritas in Veritate* §79, http://w2.vatican.va/content/benedict-xvi/en/encyclicals/documents/hf_ben-xvi_enc_20090629_caritas-in-veritate.html.

8. David K. Naugle, *Reordered Love, Reordered Lives: Learning the Deep Meaning of Happiness* (Grand Rapids: Eerdmans, 2008).

9. Taylor, *Modern Social Imaginaries*, p. 25.

tice.[10] And in book two of *The Nicomachean Ethics,* Aristotle begins by saying, "Ethical virtues are acquired by habituation. . . . The way to become habituated in virtue is to perform virtuous actions beginning from one's early youth." The brutal descent of Walter White is a life lesson that Aristotle's book two of *Ethics* can envy: who we become follows our practices, our acts. Habit makes virtue, and it also makes vice. Be careful little hands what you do.

All this talk about desire and love may seem incestuously Secular: only our age could be so fixated on fulfilling its desires, being attentive to those desires, shaping them, pruning them, obsessing over them. It is indeed one of the special fetishes of a Secular age, but it is also one of its opportunities. We barely recognize authority in tradition, hierarchy, or precedent, so we have to find our own way.

But now, Exhibit A: the politics of apocalypse. We face the very real paradox that while on the one hand we celebrate all ways of being human as equal, on the other hand we know that some ways are better than others. We've come to the alarming conclusion that not all ways of being human are equally valid and beautiful. Some ways are brutal, degrading, and pathological. We need to make better choices. We need to love better things.

Cantankerous Cavil, the scientific rationalist in the Cylon ranks, was at least right about one thing: not all "ways of being" are equally good. But the only way to measure better or worse ways of being is not to imagine ourselves as gods "beyond good and evil"; we must set our hearts and habits on *the good* — we must receive authenticity, receive our very self, as undeserved grace.

Do Multiple Modernities Make Us Better People?

The age of authenticity is sometimes also characterized as a new "responsibilization." This means that with the flattening of social and spiritual horizons, we no longer accept arguments like "This is how

10. Andy Crouch, *Culture Making: Recovering Our Creative Calling* (Downers Grove, IL: InterVarsity Press, 2008), chap. 5.

our parents did it" or "I was only following orders." Not only are these arguments considered weak, but we also feel a kind of moral disdain for them. They are irresponsible. We should think, and take responsibility, *for ourselves*.

We've already seen that in its extreme form this authenticity is a myth. There is no "going it alone," because even in our struggle to be true to ourselves, we are necessarily in dialogue not only with what came before but also with people and ideas around us now. We are, at best, half-authors.

But half-authors still have responsibility. They still have choice, qualified and constrained as it may be. A Secular age creates widespread conditions of optionality, making us *more* responsible rather than less, more *aware* rather than less, about the options we are choosing. The paralytic moment — the so-called quarter-life crisis — that plagues the young in a Secular age is exactly the *awareness* of the sheer breadth of optionality and the inability to choose. Only a Secular age has existential quarter-life crises (if only because twenty-five would have been a half-life, not a quarter-life crisis two centuries ago). We can decide to make no choices at all about our futures, extending adolescence for a long time, as some have been in the habit of doing.

But that is also a kind of choice, one that usually ends in our parents' basements. And this is maybe why today's Millennials and Generation Z deserve more understanding than they get. They are doing a kind of metaphysical heavy lifting at an incredibly young age that was not only *not required* by earlier generations but also nearly unthinkable. Small children are now expected to be able to competently identify their own genders. Young generations are expected to discover themselves with almost no education, and with almost no life experience, and they are hyper-aware of their lack of both.

Here is the good news: multiple modernities, the optionality of options, *can be* a good thing. It can be a better thing. It can make us better people.

As Taylor suggests, we can't get away from the "background horizons" we gain at birth and develop throughout our lifetime of experiences. MacIntyre actually calls us "dependent rational animals." So you could say that we live in "relative" times (which is a scary liberal

word) or you could say we live in "dependent" times (a cozier, more conservative word). But they mean the same thing. We might not be able to get away from our horizons, but those horizons aren't singular. Part of our background horizon today is that we have options.

So when we're answering the big question — Who am I? — it's scary, but it's also freeing. Our lives, personally as well as socially, are full of possibilities. Our personal development, as well as our social development, doesn't have to be locked into one unswerving direction. It's a process of faithful compromise, of genuine (if fraught) exploration, and one that does not end.

The social and political theorist, philosopher, and historian Isaiah Berlin was especially concerned, heading into the twenty-first century, that we'd get wrapped up in what he thought was one of the principal mistakes of the twentieth century: the idea that life is *one thing*, and that there is *one* ideal or *one* norm that can govern all of it — the totalizing principle that so many modern thinkers were searching for, and the one that led to so much war, genocide, and bloodshed. This is why Taylor argues we must realize the best of the Secular age's motivating *ideals:* not one thing, but a range of understandings and practices, often in tension even with each other. "What should have died along with communism," he says, "is the belief that modern societies can be run on a single principle."[11] This is how Berlin put it in a speech at the University of Toronto:

> So we must weigh and measure, bargain, compromise, and prevent the crushing of one form of life by its rivals. I know only too well that this is not a flag under which idealistic and enthusiastic young men and women may wish to march — it seems too tame, too reasonable, too bourgeois, it does not engage the generous emotions. But you must believe me, one cannot have everything one wants — not only in practice, but even in theory. The denial of this, the search for a single, overarching ideal because it is the one and only true one for humanity, invariably leads to coercion. And then to

11. Charles Taylor, *The Malaise of Modernity* (Toronto: House of Anansi Press, 1991), p. 110.

destruction, blood — eggs are broken, but the omelette is not in sight, there is only an infinite number of eggs, human lives, ready for the breaking. And in the end the passionate idealists forget the omelette, and just go on breaking eggs.[12]

In *Capitalism and Progress,* Dutch economist Bob Goudzwaard insists that when we think about something as complicated as the modern moral order, we must use *selective normative criteria.* Not all norms are equally good for all spheres of life. We cannot run markets the way we run families, and we must not run hospitals the way we run hedge funds. Different ideals need to be realized in each of these spheres, and sometimes the governing ideal — what Dooyeweerdian philosophers have called *the leading function* — of an institution or situation will be in tension with secondary and tertiary ideals.

This shouldn't strike you and me as odd. In a Secular age we not only expect it — we want it. It is an age of constant negotiation of important competing, contradictory concerns.

Channeling Berlin, James K. A. Smith argues that part of the problem we face is "an all or nothing" mentality with culture. The question is not whether we have achieved the ideal society or whether something "lines up" with this ideal form, but rather *to what extent.*[13] In *Who's Afraid of Relativism?* he argues for a kind of Christian philosophy of contingency, a pragmatism that acknowledges we cannot be rid of these competing tensions this side of the eschaton, but we can *manage* them in better and worse ways.[14] All of these ways of being that exist in one space can make us better people precisely *because* culture is not an all-or-nothing game. It is about realizing the *best*

12. Isaiah Berlin, "A Message to the 21st Century," *New York Review of Books,* October 23, 2014, http://www.nybooks.com/articles/archives/2014/oct/23/message-21st -century/.

13. James K. A. Smith, "Reading Culture Charitably," *Comment,* December 20, 2013, http://www.cardus.ca/comment/article/4119/reading-culture-charitably-a-reply -to-eric-jacobsen/.

14. James K. A. Smith, *Who's Afraid of Relativism? Community, Contingency, and Creaturehood,* The Church and Postmodern Culture (Grand Rapids: Baker Academic, 2014), p. 35.

of the motivating ideals of a Secular age. For that work, says Smith, we don't need yardsticks — we need protractors. It's not a matter of how close we've gotten to the perfect type, but to what degree we're turned toward or away from its best possibilities.

This may sound a bit unsatisfying, but it's also the context for the hard work of making culture. It is a call to proximate and slow justice, to work among the ruins of a Secular age because it is *our* age, and we are *responsible* to find, restore, and build on the best of its motivating ideals.

That's Chief Astrologer Daniel kind of territory: making faithful compromise, resisting what needs resisting, changing where change can be made, building where the best is already present. Maybe the often-repeated Jeremiah invocation to "seek the welfare of the city" is just a good Hebrew summary of Taylor's argument to find and build on the best of the motivating ideals of our Secular age.

Nobody argues Babylon is or will be the City of God. But it can be better than it is now, and we can be part of that work.

The Politics of Apocalypse

Lots of people doing lots of different things to realize the "best of the motivating ideals" of their age sounds delightful, but it does have one major thorny problem: fragmentation. It may be good, or at least better, that a Secular age makes persons responsible on a mass scale for the "options" they choose, but it also raises the troubling danger that Tocqueville thought was a real possibility and that our dystopian political shows point to: the collapse of social and political solidarity. The pathologies of individualism, instrumentalism, and loss of freedom all rally around this basic political problem. It's all well and good for Daniel to seek the welfare of Babylon. He had Nebuchadnezzar. He *had* an order to seek the welfare of. Do we even have that?

This is the driving question of this book: Who are we and how do we live together after the "apocalyptic" deconstruction (or destruction) of our systems, our institutions, and our inheritance? The truth of the dominant apocalyptic culture we've studied in this book is not

that the apocalypse is a terrifying possibility *out there* in the future, but that we're *living* it. A Secular age, our age, *is* the politics of apocalypse. The instrumentalist authenticity of the Cylons, the dark subjectivism of Walter White, the sweet seduction of our operating systems, our slide to *realpolitik* in Westeros, the constant back-and-forth ambiguity of the zombie apocalypse, and the subtle choices of hats and Panem: it's not what *might* be — it's what *is*. The worlds are fantastical and fictional. The pathologies are not.

And culture puts legs on these pathologies in a thousand ways — sometimes in ways that seem hopeful, and sometimes in ways that seem like we can't escape the iron cage. Those are the pathologies we've been exploring: our inescapable horizons, the responsibiliza-tion of a Secular age in choosing our horizons, the lodestar of authen-ticity, being what we love and what we practice; ethics, the *how* we reach *ends,* the slide to subjectivism, and the conditions that slick that slide; the double-loss of freedom in the iron cage, coercive tyranny that comes out of radical and anthropocentric subjectivism, and soft tyranny that comes out of the ennui of increasingly disconnected, personalized, individuals with little left in common.

None of these bleak scenarios are inevitable ends for us. But they certainly are possible ends. We can do things to make them more or less likely. Background horizons matter. Choices matter. Institutions, the shape we give them, the shape they give us, matter. The *politics* of apocalypse are about finding common cause, about naming and building a City, a common project, even in a Secular age of optionality.

The question for politics today is how to build Babylon after Neb-uchadnezzar has been dragged through the streets and hung at the gates.

And the first obstacle to rebuilding is common and ugly: nostal-gia. Nebuchadnezzar was never the king of kings he pretended to be, and most of us knew the story was going to end this way. Pining for the halcyon days of his reign in Babylon is both bizarre and vaguely masochistic. The relative optionality that a Secular age makes possi-ble is unsettling and dangerous, but it is wrong to say it is worse, or even more dangerous, than the hegemony that came before. Taylor argues the same in *A Secular Age,* making the point that his book is

intentionally not nostalgic. Each age has its own peculiar pathologies (and motivating ideals), and even while making a long and disquieting list of them, he neither throws in the towel nor yearns for the good old days. We have a kind of radical pluralism — or maybe more to the point, we are now *aware* of a kind of radical pluralism that has not been true at a mass, cultural level before in human history. It makes us anxious about the bad choices that are always ready to be grabbed. It also makes us more responsible than ever when we grab them.

Second, this radical pluralism now makes our systems and institutions more important than ever. Political culture was a powerful social glue that held even dated or archaic institutions together in Western society. That is no longer a glue we can count on. The manifold crises of North American political institutions that have multiplied in the last decade are not just the result of these institutional arrangements struggling to keep pace with the demands of our day. These institutional arrangements *depended* on more than just cleverly arranged checks and balances. They depended on unwritten conventions and constitutions that made the written ones intelligible, workable, and practical. Our institutions, especially our political ones, are — in other words — *becoming* our thin consensus.

This is why Taylor says in *Secularism and Freedom of Conscience* that the only real limits to pluralism are the values that make up a liberal democracy and its specific, regional, inherited eccentricities. (He names the cross atop Mt. Royal in Montreal as one of those historical eccentricities, a "cultural and historical memory," not a religious statement. You might also think of the cathedrals of Europe, or perhaps even the words "In God We Trust" that still appear on every piece of U.S. currency.)[15]

Can most of our institutions actually survive the apocalypse? Probably not. Many people complain about the American political system being unfit for the pressures of the present day, and plenty of this is justified, but there is probably no perfect arrangement of political and social institutions that will satisfy a basic breakdown in moral and

15. Jocelyn Maclure and Charles Taylor, *Secularism and the Freedom of Conscience,* trans. Jane Marie Todd (Cambridge, MA: Harvard University Press, 2011).

cultural consensus. We depend on virtues that laws cannot uphold, and values that markets cannot sell. No matter how sophisticated or powerful these institutions are, they will not resolve the basic condition of the politics of apocalypse.

This is what the Dutch prime minister Abraham Kuyper meant in the early twentieth century when he wrote that modern society needs not only the physician but the architect as well. It is not enough, to paraphrase Dietrich Bonhoeffer, to simply bandage the wounds of victims beneath the wheels of injustice; we are to drive a spoke into the wheel itself. Our institutions, especially our political ones, have become the decisive grounds — much to our worse, not to our benefit — where the *architecture* of our social and cultural consensus is played out. Our institutions remain, perhaps by virtue of their mere presence and fact of history, one of the few remaining common projects of a Secular age. And this, we suspect, is one of the reasons for their increasing polarization and savagery.

In Kuyper's words, it's time to get *architectonic* about our critique and practice. It's time to think about the motivating ideals that are embedded in what's left after the politics of apocalypse. Political theorist Jonathan Chaplin says it this way:

> Contrary to the ruling secularist mindset, institutions like corporations, universities, government bureaucracies, and professional bodies are not devoid of faith-based influences; they merely deny their presence. The key questions, then, are: which faith (or faiths) drive these institutions? And how can a biblically inspired faith make any impact on them in a secular, plural society?[16]

It's a Daniel kind of question. How can we build up the best of the motivating ideals of the institutions of our age, ones that are increasingly on the front lines of a cracking social and political consensus? How can we buttress (not as a hostile takeover, but in terms of a

16. Jonathan Chaplin, "Loving Faithful Institutions: Building Blocks of a Just Global Society," *Cardus Columns and Opinions*, April 14, 2010, http://www.cardus.ca/columns/1974/.

public partnership) that same consensus with good civil and political practice?

These questions aren't abstract navel-gazing. They're no angels, but the heralds of this apocalypse include the German chancellor Angela Merkel and the British prime minister David Cameron. Short years ago Cameron called for a new muscular liberalism, amid serious anxiety that diversity on the home front was destabilizing English society.

Merkel took a step further. In a meeting in Potsdam, West Berlin, she announced to a meeting of young members of her Christian Democratic Union party that "this multicultural approach has failed, utterly failed."[17] Since then, the Dutch too have abandoned their official policy of multiculturalism.

In Canada, the now-defeated Charter of Quebec Values was an election carrot to a provincial culture deeply uneasy about a cracking social and cultural consensus. That charter was part of an *international* movement in the Secular north, a kind of legislated conformity of values in an age of real anxiety mirrored in the U.S. in attempts to define who the "real Americans" are. Taylor and Jocelyn Maclure call this a kind of relapse into a *thick* kind of civil religion.[18] They argue that this is especially likely when an old consensus is breaking down and fears of other pathological forms are at their apex.

Third, we think the better answer to the fear that accompanies a Secular age is to refocus the work of politics to *finding* common cause; locating, building, and maintaining overlapping consensus among our many and multiple modernities.

There is no turning the clock back to pre-apocalypse times. There is only identifying and building a renewed consensus.

This is what Taylor describes as a project worthy of any society deserving of the name "secular." He argues that we need a radical redefinition of the secular. What should be called *secular*, he says, is not the inverse of the religious, but the (proper) response of the political community (the state) to diversity. The parallel to what a

17. Mathew Weaver, "Angela Merkel: German Multiculturalism Has 'Utterly Failed,'" *The Guardian*, October 27, 2010, http://www.theguardian.com/world/2010/oct/17/angela-merkel-german-multiculturalism-failed.

18. Maclure and Taylor, *Secularism and Freedom of Conscience*, p. 18.

political theorist like Bernard Crick would call the basic task of politics is striking: the peaceful conciliation of potential conflict among diverse interests.[19] Such politics have limits — presumably the conditions within which conciliation takes place, or what is considered a "proper" response — but even *those conditions* are political. The system of politics itself is a kind of overlapping consensus, one in bad need of architectonic renewal and reformation.

The politics of apocalypse tells us we can't take those conditions for granted anymore. It accepts that the cosmopolitan potpourri of the pre-9/11 world is well and truly past, but it doesn't default to pessimism or coercion. It calls for *more*, not less, pluralism in the public sphere. It calls for that understanding and those practices to be tested in dialogue to find areas of overlapping concern and agreement.

MacIntyre calls this a process of *constructive disagreement*,[20] naming frankly the places people won't agree, the places we might agree, and the places that will be resolutely ruled out of bounds. Political scientist Daniel Philpott calls it an account of *rooted reason*, which invites secular and religious actors to present their "full rationales — untruncated, unsanitized, unfiltered. Yet it also asks them to enter a dialogue in which they pursue mutual understanding with those different views. Among the fruits of deep dialogue, particularly important is overlapping consensus."[21] Political scientist Paul Brink calls this "politics without scripts," a politics that has disestablished both secularism and Christianity.[22]

MacIntyre likens our age to a postapocalyptic world, one that can take no moral, no religious, and no intellectual foundation for granted. That's a bit extreme. But a new, singular foundation may also not be what we're shooting for. In a Secular age, the politics of

19. Bernard Crick, *In Defence of Politics* (Chicago: University of Chicago Press, 1993), pp. 15-33.

20. Alasdair MacIntyre, *Three Rival Versions of Moral Enquiry: Encyclopaedia, Genealogy, and Tradition* (Notre Dame: University of Notre Dame Press, 1990), p. 8.

21. Daniel Philpott, *Just and Unjust Peace: An Ethic of Political Reconciliation* (Oxford: Oxford University Press, 2012), p. 116.

22. Paul Brink, "Politics without Scripts," *Comment*, November 1, 2012, http://www.cardus.ca/comment/article/3706/politics-without-scripts/.

apocalypse may be more about connecting overlapping networks than building a single foundation.

We Reach Our End

The question we started out to answer was this: What accounts for the apocalyptic, and sometimes dystopian, shift in popular culture in the Secular West? The answer we've provisionally given is that what Charles Taylor calls the pathologies of our Secular age — individualism, subjectivism, the double loss of freedom — are reaching a point of both crisis and climax.

The stories we tell, in literature, film, music, and more, are taking our Secular, individualist crisis seriously, maybe *more* seriously than our *actual* politics. Who would have expected better political and moral philosophy from science fiction or grisly Westeros? But these myriad apocalypses are true to their etymological origin: they are *ends* of things as well as profound, important revelations about ourselves, our society, and our background horizons nestled between the meth labs and rotting corpses.

In *Between Babel and Beast,* the theologian Peter Leithart argues that there is both good news and bad news for this new politics.[23]

First, the good news — we need not abandon the city. The *public* work of realizing the best of the motivating ideals of our age is work for religious people, Christians and others alike, that can bear and even has borne real fruit. The battle moves in all directions.

But the bad news: Babylon, into which we may pour our energies here, in our lifetime, will never be the New Jerusalem. *We* don't build it, any more than *we* are the point or end of the story, the lodestar of authenticity. We can sing the Lord's song, but we don't build the Lord's city. And so the politics of apocalypse is a religious pragmatism — not defeatism, just recognition that the tensions of this age, as ages past and ages to come, can't be overcome, but only managed.

23. Peter J. Leithart, *Between Babel and Beast: America and Empires in Biblical Perspective,* Theopolitical Visions (Eugene, OR: Wipf & Stock, 2012).

Like Daniel, we must make compromises. That means we must temper our expectations and not become defeated when everything is not perfect, yet. But some compromises are better, and others are worse. Wisdom is knowing the difference. Our popular culture is already very busy trying to discern that.

Taylor writes, "As Pascal said about human beings, modernity is characterized by *grandeur* as well as by *misère*. Only a view that embraces both can give us the undistorted insight into our era that we need to rise to its greatest challenge."[24]

We could do worse than join in.

24. Taylor, *The Malaise of Modernity*, p. 121.

Acknowledgments

A book about apocalypse should not be glib about the social and cultural fruit made possible by *good* institutions, rich tradition, and incredible encouragement.

Our first debt is to our respective institutions, Redeemer University College and The King's College in New York. Higher education and the ostentatious space it provides for research, debate, writing, and — naturally — watching (a lot of) trashy television is a gift both of us have received for many, many years. We are grateful recipients of the gifts of generations of scholars and donors who have made the audacity of these places possible.

The Reid-Trust Foundation funded a good deal of our travel back and forth from New York to Toronto, and vice-versa, as we worked on this manuscript. Bob Berndhardt at the Trust has been especially supportive of our work to translate the thinking of Charles Taylor into a kind of "popular culture," not a lot of *new* ideas necessarily, but as Calvin Seerveld would say, "old wine in new wine skins."

The Trust's support also made it possible to work with a series of great research assistants, one of whom went way above and beyond, editing and even authoring small sections of the book. Tim Wainwright did stand-up work for us on the first few chapters, and we're very grateful to him for his intelligence, wit, debate, and friendship.

Andy Crouch, of course, encouraged us to push forward with the project and finally even wrote a foreword for it when it came to his desk in draft form. He gave me (Alissa) a place at *Christianity Today* to

write madly and at length and probably rake in more hate mail than I know about. Andy's foreword, for someone who watches little television, and is more than a little suspicious of my (Rob's) video-gaming, is extremely kind and generous. Here is a man who is using his *power* to raise a generation of Christian young people making culture. That's a witness and a fruit that goes far beyond paperback sales.

Finally, to loved ones and family who stood by us while we did "research" on our couches and in our studies, altogether unsure if binge-watching *House of Cards* is really something they should stand for. I (Alissa) am especially grateful for my insanely long-suffering and endlessly insightful husband, Tom, who kick-started my work as a critic entirely by accident and has never once suggested I'm wasting my time, even when I thought I might be. Thanks also to my colleagues at King's, all of whom know far more than I do, who let me talk and write through some of these things in different forms, especially David Corbin, Joshua Blander, David Talcott, Dru Johnson, and Harry Bleattler, as well as Greg Thornbury, the best college president any pop-culture-obsessed assistant professor could wish for. And thanks to the various graduate school professors who whipped my sorry self into shape and also became friends, particularly Tom de Zengotita, Gregory Wolfe, Paula Huston, and Lauren Winner.

We'd both like to thank our friend Gideon Strauss, who is responsible for introducing us to one another when we were just dumb kids making editorial meetings really difficult. And I (Rob) want to thank my friend and one-time doctoral supervisor Scott Thomas for the long-suffering half-decade we spent reading *A Secular Age* together and thinking about "the secular" and international theory. I also owe thanks to my friend Geoffrey Cameron for a lot of *Game of Thrones* talk; to Joel Harsevoort and Brian VanOosten for providing crucial moral support for making it through *The Walking Dead*; to Kevin den Dulk for admitting his *Battlestar Galactica* addiction; and finally, at publishing time, to my soon-to-be wife, Jessica Driesenga, who bore the brunt of all of my enthusiasm about the above while we were dating, and *still* agreed to marry me. Miracles do happen.

Coram Deo